The Aesthetics of Power: Essays in Critical Art History gathers together the key articles and essays by Carol Duncan, one of the pioneers of a new social-political approach to art history and criticism, and one of the strongest feminist voices to emerge in the 1970s and 1980s. These essays, many of which have become classics, explore a wide variety of subjects: images of mothers, fathers, and children in eighteenth-century art and culture; the image of the female nude in the context of the modern museum; and the role of modern art criticism in today's art market. Other essays examine the contexts in which art is seen, taught, and made. Whatever her theme, Duncan treats art as a working part of a larger social reality and a pathway to understanding its deepest tensions, fears, and desires. A final section of this book is devoted to the life and collected critical writings of Cheryl Bernstein, a fictitious writer created by Duncan as parody, but who was taken as a real, and eventually influential, critic.

THE AESTHETICS OF POWER

The Aesthetics of Power

Essays in Critical Art History

CAROL DUNCAN
Ramapo College of New Jersey

CAMBRIDGE
UNIVERSITY PRESS

Published by the Press Syndicate of the University of Cambridge
The Pitt Building, Trumpington Street, Cambridge CB2 1RP
40 West 20th Street, New York, NY 10011–4211, USA
10 Stamford Road, Oakleigh, Victoria 3166, Australia

First published 1993

Printed in the United States of America

Library of Congress Cataloging-in-Publication Data
Duncan, Carol.
The aesthetics of power : essays in critical art history / Carol
Duncan.
p. cm.
ISBN 0–521–42044–X. – ISBN 0–521–42187–X (pbk.)
1. Art and society. 2. Feminism and art. 3. Art – Political
aspects. I. Title.
N72.S6D775 1993
701'.03 – dc20 92–20448

A catalog record for this book is available from the British Library.

ISBN 0–521–42044–X hardback
ISBN 0–521–42187–X paperback

CONTENTS

CONTENTS

vi

ILLUSTRATIONS

PREFACE

I hope that these essays, singly or together, will communicate some of the sense of purpose I felt when writing them. They represent almost twenty years of my work, and although they were not all written for the same kind of context, my ambition for them was constant. I wanted to write about art in a way that shows it to be integral to a larger historical experience; to engage with the moral and political meanings that works of art have held in the past; and to look critically at the institutional settings within which art is produced and interpreted.

If, as I believe, art objects become more intelligible when considered in historical context, then so do the writings of art historians. Gathering together these essays has led me to reflect on the historical context in which I wrote them, and those reflections seem the best way to introduce them.

For most of the sixties—and that is where the context of my work begins—I was a graduate student in art history at Columbia University, more or less buried in my doctoral research on art and culture in nineteenth-century France. In 1968, as I was finishing my thesis, students closed down the university with a strike. Their demands were sparked by the Civil Rights movement and the anti–Vietnam War movement—the university was behaving badly in relation to the African-American ghetto next door and, at the same time, was involved with defense industry research. For many of us, the disruptions of 1968 also brought to life broader issues, especially after the university authorities unleashed the full fury of a police riot on demonstrating students. Like others, I was shocked that a great liberal arts institution chose to settle what had become a campuswide debate—about education, democracy, institutional authority and the role of ideology—with police clubs. Equally disquieting was the reaction of some of my professors, who clearly felt that the

political role of the university was beyond the legitimate concerns of students and urged us to return to business as usual in classrooms and the library. With many of my classmates, I was disturbed that these scholars—renowned for the humanistic breadth of their learning—could so willingly turn their backs on the moral and political role of the university and so resolutely deny the contradictions of their own situation. Indeed, I felt profoundly uneasy at the thought that the discipline I was assimilating could leave some of its most accomplished disciples so ill-prepared to consider their own social role. More than ever, the crisis exposed art history's striking lack of a developed self-critical tradition, a tradition in which the discipline could articulate its social values and what relation they bore to its scholarly practices.

Eventually, the campus calmed down and resumed its usual business. But the questions kicked up by the crisis did not go away. On the contrary, they became more compelling as time went by. The appearance of a new wave of feminism—a feminism that brought together university women from many fields—sharpened and complicated those questions, opened new facets and gave to those of us pursuing them a sense of personal urgency.

In these years—the late sixties and early seventies—within and without the university, other people, women and men, students and artists, academics and other professionals had similar concerns. It was a time of burgeoning study groups, editorial collectives, consciousness-raising groups, radical caucuses and Leftist activist groups. For those of us slated to be educators, it was also a time to think critically about the student–teacher roles we were supposed to perpetuate. But we also felt ourselves to be part of a larger history, a history we thought we could help make. Many people shared a sense that we were living in a moment that was full of possibility, of changing values and social attitudes as well as changing institutions. One could feel connected, no matter how vaguely, with other people in other situations, not only artists and intellectuals, but also organizers and unionists who felt the possibility of social change and worked to bring it about. The mood I sensed so often was one of radical democracy, and the theme was often that of empowerment—the empowerment of the many—of the poor, of women, of African-Americans and other minority groups. It was not difficult to believe that the space in which we academics wrote and taught communicated with a larger world, one that had a real chance to rethink its values and remake itself along better, more

humane lines. It was therefore all the more urgent to rethink the past and to consider how it was used in the present. It seemed to me that art history, a field that looked precisely at social-cultural objects, had much to contribute to this broad critical process—that is, if it could open itself to new ideas and cross disciplinary and institutional barriers.

Nothing seemed more remote from such concerns than academic art history in the late sixties and seventies. The discipline was largely given over to the authentication and celebration of artistic genius. The most rewarded scholarship devoted itself to documenting instances of (usually formal) originality. Normal scholarly problems consisted of such tasks as tracking the sources and development of one or another master, detailing the obstacles he had to overcome to realize his genius, distinguishing his style from that of his contemporaries or earlier masters and otherwise demonstrating his unique qualities of mind or style. It was entirely admissible to introduce aspects of cultural history into all of this; but if you dwelt too much on social, political or economic history, if you thought of art too much as a response to historical forces or as a social or political strategy in its own right, you ran the considerable risk of marginalizing yourself in relation to the mainstream of academic art history and hurting your career prospects. Too much of the wrong kind of history could even earn you the unenviable reputation of being a "social historian." Which is to say that the field policed itself effectively enough (as academic disciplines normally do) and took special care to maintain the boundary between "art" and "society." The art side of this boundary was understood as belonging to a realm of freedom and value—proper objects of humanistic study—while the other side was presumably driven by impersonal historical forces, best left in the hands of social scientists.

There were, however, a few scholarly alternatives in sight. Meyer Schapiro, on the eve of retirement, but in the sixties still lecturing at Columbia, was one; another was Linda Nochlin, then at the beginning of her career and, fortunately for me, a visiting professor at Columbia in 1968. Schapiro's lectures—I heard the ones on Impressionism—brilliantly opened the discipline to political, philosophical and ideological interpretation and drew from a rich variety of evidence—everything from the social psychology of urban Paris to the structure of a paint surface. Nochlin, too, reached beyond the discipline's conventional narrowness, claiming for it the scope of intellectual history and insisting on its political and

ideological import. There was, besides, outside of art history, a rich tradition of critical cultural analysis in English, French and German, including the writings of Raymond Williams, Simone de Beauvoir and (increasingly in English) the Frankfurt School. I sought in these and other critical writers many things, not least, a general moral support for my own project as a writer and teacher, but also theoretical tools with which to frame issues I felt had a political urgency about them (motherhood, patriarchy, female nudity in art as an erotic power play, and so on).

It was only when I began hearing other people refer to me as a Marxist that I read *Capital*. I found the philosophical depth and richness of Marx's writing breathtaking. I did not attempt to pull from this brilliant analysis of capitalism a blueprint for art-historical practice, let alone a consistent, all-embracing Marxist-feminist theory of knowledge and history in general. Nevertheless, reading Marx and the Marxist tradition—along with a developing feminist tradition—helped me turn away from conventional art history. This reading helped me think about the world in terms that included clashing interests, complex social relations between the sexes as well as classes, changing ideological needs, and changing uses for art; a world in which art is not a neutral or placid reflection of historical experience but a part of the action. Above all, Marxism and feminism insisted on the connectedness between things, between the history of subjective experience and the history of the objective, social world of which that experience is a part. Not that I ever wished to work these ideas into a complete, authoritative theoretical system that could fully account for all the data and be rigorously applied to any situation. I am sure that my theoretical tools are neither as refined nor as researched as they could be. But it is also true that sometimes the best instrument is a blunt instrument, especially when one faces a seemingly solid wall of prejudice that, in the name of "objectivity" or "scholarship" or even "theory," is blind to the moral and ideological implications of its own project.

I wrote the several essays in this book for a variety of contexts and a range of readers. Some, like "Fallen Fathers" or the essay on Ingres's *Vow of Louis XIII,* appeared in scholarly publications and were more slanted toward academic colleagues. At other times, I addressed artists and critics as well ("When Greatness is a Box of Wheaties"); and sometimes I wrote more with non-specialists or non-academics in mind ("Who Rules the Art World?" "In the Eye of the Soldier").

Cutting through all these categories was the pressure I felt (more at some times than at others) to identify my concerns as those of a woman and a feminist. Whatever the context, however, I have always hoped that students—both graduate students and interested undergraduates, women and men— would find the ideas in these essays accessible. I still hope that they can help readers situate themselves in a field where their moral and political values and their "art" values, their professional identities and their identities as gendered subjects, are made to confront each other.

I have so far spoken of my concerns only as rooted in a broader outlook belonging to the seventies. I find it more difficult to speak of the eighties. When the seventies ended, when its political hopes became less possible to sustain, I felt less certain of my own project as a writer. To be sure, the rise of an academic culture interested in the critique of art has made the university's traditional role as a refuge for dissenting opinion as important as ever. Concerns that marginalized one as radical twenty years ago have today become commonplace in academic discourse, and scholars debate them with more sophistication and theoretical precision than was usually possible then. In that sense, things have gotten better. But other things have gotten worse. Times have been bad politically. It has been difficult for anyone, let alone scholars, to feel connected to anything beyond the parameters of their immediate working lives. If academia is today more open to the critique of values, it is also, as a community, more closed in on itself, more specialized in its language, and more driven by the competition for jobs, promotions, foundation grants and other visible signs of success and status. It is less able and, given the political pessimism of the times, understandably less willing than ever to consider its own social practice. It was, I believe, a piece of good fortune to have been alive and thinking in the sixties and seventies and to have experienced the political convictions and passions of those days. Nor am I willing, in these more difficult times, to dismiss the social ideals that animated so many people then. At the least, I must hope that we can keep our discipline alive to its own moral uses and that we can do so in language that is able to reach across the boundaries and barriers of academic interests.

I have arranged these essays into three groups: articles of a more historical nature (all dealing with French art of the eighteenth and nineteenth centuries); articles and criticism concerning female imagery and feminist issues; and a group

of essays and critical writings concerned with the institutional settings in which art is seen, bought, sold and taught. An additional section is devoted to the phenomenon of Cheryl Bernstein, whose stranger-than-fiction tale demands its own introduction.

New York City
April 1992

ACKNOWLEDGMENTS

It is probably not possible to acknowledge all of the intellectual debts I incurred over the years I wrote these essays. Some of those to whom I am indebted are named in notes to various chapters. Others, especially Josephine Gear, Alex Potts and Adrian Rifkin, are owed general thanks for helping me think through ideas so often and over so long a time. Thanks also to Moira Roth, who first insisted on the possibility of this collection, and to my many colleagues at Ramapo College of New Jersey, for years of support of all kinds. Finally, and most of all, my gratitude to Andrew Hemingway, whose interest, encouragement and thoughtful comment helped me shape this project and see it through.

MOTHERS, FATHERS AND MONARCHS

Part One

HAPPY MOTHERS AND OTHER NEW IDEAS IN EIGHTEENTH-CENTURY FRENCH ART

In the late eighteenth century, French artists and writers became enamored of a set of characters whose virtues and attractions were still new to the public. These characters, the happy or good mother and the loving father, appear fully developed in Greuze's *The Beloved Mother* (Fig. 1.1), one of the most popular attractions at the Salon of 1765. To the twentieth-century viewer, Greuze's painting has many features suggesting not only earlier French and Dutch genre scenes and family portraits but Holy Families as well. To his French contemporaries, however, Greuze was saying something fresh and new. As Diderot so tirelessly repeated, Greuze's pictures were not simply pleasant to look at, they also spoke to present vital moral issues. Indeed, the very forms of *The Beloved Mother* energetically signal the presence of a message; gesturing figures, dramatic lights and shadows and busy, bunched-up masses of people and drapery promise the eye a drama. What occasions such excited form and moves these characters to such emotional display? Nothing more than the fact of the family, for the scene represents a most commonplace event: the entrance of a farmer into his own home where he beholds his own wife and six children. Yet the content of this work was far from commonplace in 1765.

Mothers, fathers and their children were hardly new to secular art. Nor were scenes portraying the peace or the charm of simple domestic life. Chardin's *Saying Grace* (Fig. 1.2), painted around 1740, is such a scene. Compared to the highly detailed naturalism of Greuze's figures, however, this mother and her children seem almost doll-like, their expres-

This essay was first published in *The Art Bulletin* LV (December 1973), 570–583. It was reprinted in *Feminism and Art History: Questioning the Litany*, ed. Norma Broude and Mary Garrard (New York, Harper and Row, 1982), 200–219. It is reprinted here by permission of The College Art Association, Inc.

sions merely pert. The modest subject was not original and struck no one as especially significant. What made Chardin's reputation was not *what* he painted, but *how* he painted. He was famous not for any ideas he conveyed but for his mastery of color and light effects, his ability to suggest real atmosphere and his artful balance of volumes and voids. Chardin was appreciated as a master, but only within the confines of genre painting, a field where no one thought to find any but the most limited concepts.[1]

In Greuze, on the other hand, the eighteenth century recognized a moralist, a brilliant observer of human nature and behavior. His art, wrote Diderot, is "dramatic poetry that touches our feelings, instructs us, improves us and invites us to virtuous action."[2] The difference between *Saying Grace* and *The Beloved Mother* confirms Diderot's judgment. Although *Saying Grace* is based on the assumption that domestic life is pleasant, *The Beloved Mother* emphatically states that it is blissful. In almost magnified detail, it examines the very emotions of family relationships themselves (as Greuze conceived them, that is), namely, the joy of being a husband and

1.1 Jean-Baptiste Greuze, *The Beloved Mother* (*La Mère bien-aimée*), 1765. Formerly De Laborde Collection (photo: *Gazette des Beaux-Arts*, LVI, 1960).

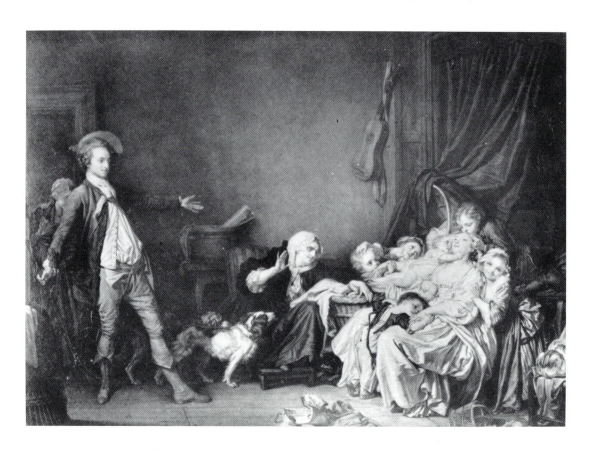

father and the delicious contentment of being a mother so well beloved by her husband and six children. Even the grandmother and, it appears, the dogs, too, are visibly stirred by the spectacle of family love. What is new here are a mother and a father who are consciously and ecstatically happy about simply *being* a mother and a father, a husband and a wife. The parents of neither gods, saints nor kings, they exemplify a new idea: simple motherhood and fatherhood in blissful conjugal union.[3] Thus wrote Diderot of this painting: "It says to all men of feeling and sensibility: 'Keep your family comfortable . . . give [your wife] as many [children] as you can . . . and be assured of being happy at home.' "[4]

Even more than Greuze, Fragonard devoted his art to the ideal of the happy family.[5] In *The Return Home* (Fig. 1.3), he suggests the warmth and intimacy of conjugal life. Bathed in golden, glowing light, father, mother and infant are com-

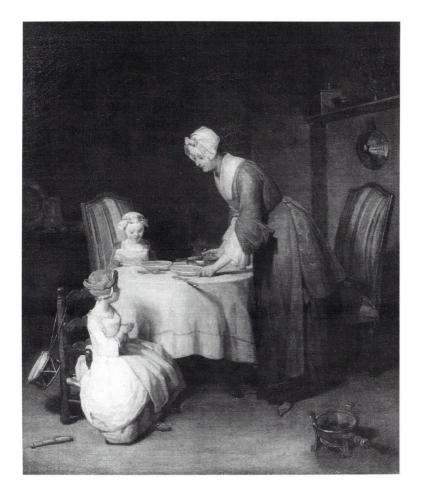

1.2 Jean-Baptiste Chardin, *Saying Grace* (*Le Bénédicité*), c. 1740. Louvre (photo: Les Musées Nationaux, Paris).

5

CHAPTER I

positionally bound into a harmonious unit, an arrangement that stresses not only the mother's position as a living, mediating link between father and child, but also the special closeness of the parents alone, who gaze lovingly into each other's eyes and tenderly touch hands. It is this strong suggestion of sexual gratification that most distinguishes this work from traditional Holy Families, which it resembles in so many other ways.[6]

The association of motherhood with sexual satisfaction was frequent in eighteenth-century imagery. In 1766, the poet André Sabatier published an ode to mothers in which he describes "a tender and jealous mother rocking her baby— token of her fires. . . . It is Venus who charms and caresses Cupid."[7] The same conceit enlivens a witty engraving by Moreau le jeune, *The Delights of Motherhood,* 1777 (Fig. 1.4). In a verdant park, a conventional setting for amorous encounters, a husband and wife play with their baby beneath a statue of Venus and Cupid. Like his counterpart above, the child reaches for an enticing object; but it is his father, not his mother, who imitates the Venus overhead. Although more playful than the Fragonard and perhaps with tongue in cheek, this print, too, portrays marriage as a state that satisfies both sexual instincts and social demands for stability and order.[8] Greuze's painting also carries this message, although it is less overtly stated. A sketch for the mother's figure alone struck Diderot as disturbingly erotic. He observed that with-

1.3 Jean-Honoré Fragonard, *The Return Home* (*Le Retour au Logis*), 1770s. Paris, private collection (photo: G. Wildenstein, *Fragonard*).

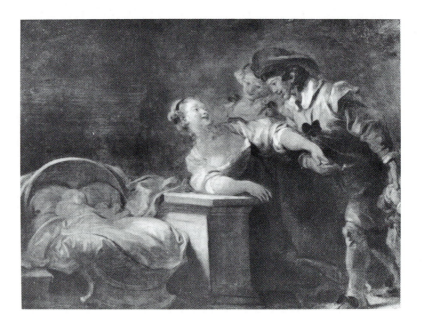

out "the accessories of motherhood"—as he referred to the children—her smile appears voluptuous and her languid, exposed body wanton.[9]

What these images of happy families and contented mothers reflect is not the social reality of the eighteenth century, nor even commonly accepted ideals. Rather, they give expression to a new concept of the family that challenged long-established attitudes and customs.[10] Traditionally, the "family" meant the "line," the chain of descendants who each in turn held title to estates, properties and privileges in the family name. Marriage was a legal contract negotiated between heads of families, whether kings or wealthy peasants, not between the bridal couple. The contract itemized in detail what each family would settle on the new bride and on her husband. The lowest classes, those with title to nothing, did

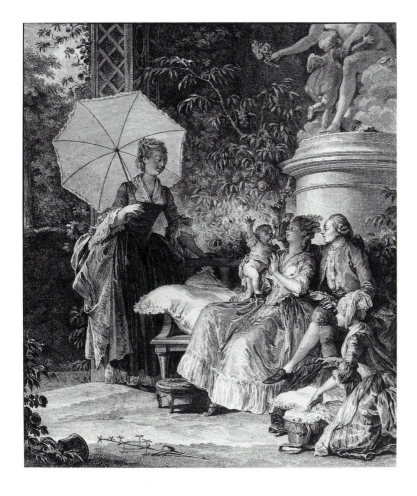

1.4 After Moreau le jeune, *The Delights of Motherhood* (*Les Délices de la maternité*), engraved by Helman, 1777. Paris, Bibliothèque nationale (photo: Bibl. nat. Paris).

not marry legally. Even in the propertied classes, only the few married, and those who did were rarely consulted about the choice of their mates. Marriage was normally expected only of the oldest son, usually the sole heir, upon whom parents lavished all their interest and centered their pride. The marriage of a daughter required a dowry and would be arranged only in the absence of male heirs or when her father judged such an alliance to be in the interests of the family.

Households were rarely limited to the immediate family. From the large estate of the aristocrat to the homestead of the wealthy peasant or artisan, the domicile swarmed with unwed relatives, apprentices, servants and retainers, all of whom were under the rule and protection of the father or legal male head. In these busy, crowded, domestic societies, human relations were largely determined by one's relative rank or status within the household hierarchy. Rules of decorum guided individual behavior in every rank. Relationships between husbands and wives and parents and children were no exception; according to later notions, these were decidedly cool and distant. However, people generally did not expect emotional rewards in conjugal and parental relationships. Fathers and husbands stood for authority, not companionship. Especially in bourgeois and peasant families, where paternal authority was absolute, the father was a severe figure. He ruled his wife—and her property—and decided the fates of his children with full legal sanction. Veneration and obedience, not love and affection, were his traditional due.

Marriage was rarely thought of as a means to personal happiness. Rather, its purpose was to perpetuate the life and identity of the family group and its holdings. This is not to say that married couples did not sometimes develop cordial relationships and even a measure of companionship—the family could engender strong bonds between its members. A seventeenth-century group portrait by Antoine Le Nain (Fig. 1.5) represents a convivial-looking family group. It is, however, a portrait of an old household, not the modern conjugal family of Fragonard's *Return Home*. Seated on the right are the old father and his wife, above whom stands either an unmarried daughter or a female relative. On the left stands the next generation, the son (or son-in-law), who will be the next head of the household, and his wife and children. Seated near them is a young boy playing a pipe, an apprentice or a servant and as such a member of this wealthy bourgeois household. If this painting has a voice, it is that of the old

father, whose will is the will of the group. It speaks of family pride and loyalty, of prosperity and orderly succession. It also appears to speak with respect and affection of the wife. However, neither patron nor artist intended to suggest individual happiness or conjugal love, concepts that were not available to them. Even so, the work expresses what in the seventeenth century was a progressive bourgeois ideal in that it finds conscious, positive values in marriage and the family society.[11]

The more widespread view of the marital relationship in both the seventeenth and eighteenth centuries was negative.[12] The figure of the husband was a popular butt of jokes and mockery, and wives were generally thought of as deceptive, crafty and willful: the cuckolded husband and his faithless spouse were stock characters in stories and prints. Among the wealthy, bachelorhood was often a chosen state. Even in the later eighteenth century, when forced or arranged marriages were under increasing attack by moralists, parents per-

1.5 Antoine Le Nain, *Portraits in an Interior*, 1649. Louvre (photo: Les Musées Nationaux, Paris).

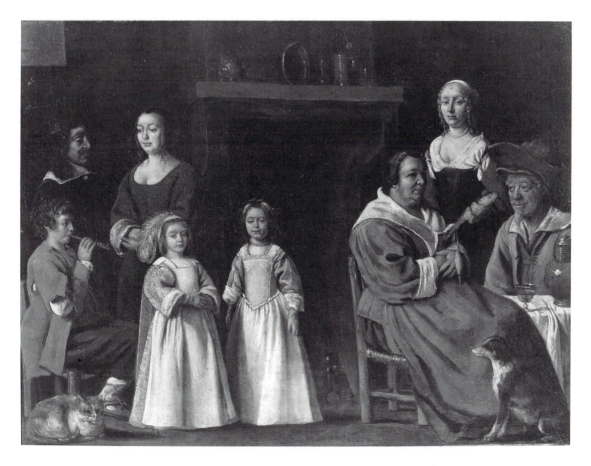

sistently opposed marriages of love and continued to arrange the traditional, "sensible" match that furthered family interests without regard to the individual emotional and sexual needs of their children. The right of parents to choose the mates of their children could be ignored only rarely. At the risk of disinheritance, couples occasionally managed elopements, but the more popular—and acceptable—alternative was adultery. Especially in the cities and among the rich, women felt little compunction about breaking lifelong vows that had been forced upon them. Their husbands, who did exactly the same thing, had neither the grounds nor the inclination to complain. For the fashionable woman, marriage in effect meant independence. After presenting her husband with one or two children, she had ample leave to pursue her own pleasures. So-called natural children were produced in abundance—and often acknowledged—at all levels of society.

Illicit love was openly celebrated in French eighteenth-century art, often by the same artists who illustrated the joys of conjugal love. In fact, in the second half of the eighteenth century, both libertine and moralizing subjects enjoyed a marked—and equal—increase in popularity.[13] Baudouin's *The Indiscreet Wife,* engraved in 1771, and L.-L. Boilly's *The Favored Lover* (Fig. 1.6), executed in the more sober forms of the 1780s, are typical of these *scènes galantes,* in which only forbidden pleasures are pursued and enjoyed. The charming adulteresses and soubrettes who abound in these scenes were not banished from the stalls and shops of printsellers by pictures of happy mothers and beloved wives. The competing views of individual happiness that these two kinds of scenes present had at least one thing in common: directly or indirectly, they both opposed the conventional eighteenth-century marriage that at best ignored individual needs and at worst frustrated them.[14]

The new ideal of the family also challenged popular notions of children and child-rearing. The modern view of infancy and early childhood as attractive and important stages of life is an Enlightenment discovery that was still new in the eighteenth century.[15] It had yet to overcome vestiges of older attitudes that regarded small children sometimes as greedy and willful creatures in need of severe constraints, sometimes as defective adults, and sometimes as charming little pets to be spoiled or ignored as one pleased. Babies and very young children were still received with a certain measure of indifference, if not hostility. Through most of the eighteenth cen-

father, whose will is the will of the group. It speaks of family pride and loyalty, of prosperity and orderly succession. It also appears to speak with respect and affection of the wife. However, neither patron nor artist intended to suggest individual happiness or conjugal love, concepts that were not available to them. Even so, the work expresses what in the seventeenth century was a progressive bourgeois ideal in that it finds conscious, positive values in marriage and the family society.[11]

The more widespread view of the marital relationship in both the seventeenth and eighteenth centuries was negative.[12] The figure of the husband was a popular butt of jokes and mockery, and wives were generally thought of as deceptive, crafty and willful: the cuckolded husband and his faithless spouse were stock characters in stories and prints. Among the wealthy, bachelorhood was often a chosen state. Even in the later eighteenth century, when forced or arranged marriages were under increasing attack by moralists, parents per-

1.5 Antoine Le Nain, *Portraits in an Interior*, 1649. Louvre (photo: Les Musées Nationaux, Paris).

9

sistently opposed marriages of love and continued to arrange the traditional, "sensible" match that furthered family interests without regard to the individual emotional and sexual needs of their children. The right of parents to choose the mates of their children could be ignored only rarely. At the risk of disinheritance, couples occasionally managed elopements, but the more popular—and acceptable—alternative was adultery. Especially in the cities and among the rich, women felt little compunction about breaking lifelong vows that had been forced upon them. Their husbands, who did exactly the same thing, had neither the grounds nor the inclination to complain. For the fashionable woman, marriage in effect meant independence. After presenting her husband with one or two children, she had ample leave to pursue her own pleasures. So-called natural children were produced in abundance—and often acknowledged—at all levels of society.

Illicit love was openly celebrated in French eighteenth-century art, often by the same artists who illustrated the joys of conjugal love. In fact, in the second half of the eighteenth century, both libertine and moralizing subjects enjoyed a marked—and equal—increase in popularity.[13] Baudouin's *The Indiscreet Wife,* engraved in 1771, and L.-L. Boilly's *The Favored Lover* (Fig. 1.6), executed in the more sober forms of the 1780s, are typical of these *scènes galantes,* in which only forbidden pleasures are pursued and enjoyed. The charming adulteresses and soubrettes who abound in these scenes were not banished from the stalls and shops of printsellers by pictures of happy mothers and beloved wives. The competing views of individual happiness that these two kinds of scenes present had at least one thing in common: directly or indirectly, they both opposed the conventional eighteenth-century marriage that at best ignored individual needs and at worst frustrated them.[14]

The new ideal of the family also challenged popular notions of children and child-rearing. The modern view of infancy and early childhood as attractive and important stages of life is an Enlightenment discovery that was still new in the eighteenth century.[15] It had yet to overcome vestiges of older attitudes that regarded small children sometimes as greedy and willful creatures in need of severe constraints, sometimes as defective adults, and sometimes as charming little pets to be spoiled or ignored as one pleased. Babies and very young children were still received with a certain measure of indifference, if not hostility. Through most of the eighteenth cen-

tury, the tasks of nursing and caring for babies were regarded by both men and women as debilitating, obnoxious and coarsening. The arrival of an heir brought honor to the mother, but tending to its infant needs and earliest education was the work of servants. French families with any means at all customarily handed their infants to peasant wet nurses, popularly regarded as disreputable, who kept them for about four years.[16] At this point children entered their homes for the first time, often to an indifferent reception. At seven, they were put into adult clothes and—if they were boys—sent away to school or an apprenticeship. Children could grow up barely knowing their parents. These attitudes and customs were still sufficiently alive at the end of the century to draw angry words from Bernardin de Saint-Pierre, the follower of Rousseau:

If, with us [as opposed to wise and gentle savages], fathers beat their children, it is because they love them not; if they send them abroad to nurse as soon as they come into the world, it is because they love them not; if they place them as soon as they have acquired a little growth in boarding schools and colleges, it is because they love them not . . . if they keep them at a distance from themselves

1.6 After Louis-Leopold Boilly, *The Favored Lover* (*L'Amant favorisé*), engraved by A. Chaponnier, c. 1780s. Paris, Bibliothèque nationale (photo: Bibl. nat. Paris).

at every epoch of life, it must undoubtedly be because they look upon them as their heirs.[17]

Authoritarian or libertine, these traditional family relationships increasingly struck the eighteenth century as rigid, immoral and against the laws of nature. As the century wore on, and as enlightened segments of the bourgeoisie and then the aristocracy adopted the new ideal of the family, the old ways were increasingly rejected or attacked. Many parents, remembering the coldness of their childhood homes, developed more affectionate relations with their children, kept them at home longer and took more pains to find them compatible mates in marriage. After at least two centuries of ridicule, marriage began to enjoy a degree of popularity.[18] Enlightened thinkers of the eighteenth century—men such as Buffon, Holbach, Rousseau and the Encyclopedists—almost unanimously regarded marriage as the happiest, the most civilized and the most natural of states, the institution that could best satisfy and conciliate social and individual needs. They generally agreed that in the marital relationship husbands should have final authority, but they also believed that only relationships based on mutual consent could work. Accordingly, the more they praised marriage the more they attacked the tyranny of greedy fathers who forced their children into unhappy marriages or threw their daughters into convents rather than give them dowries. To the material interests of the family they opposed the rights of the individual to personal happiness.[19] Their greatest anger, however, was reserved for the indifference and severity with which children of all classes were treated.

French philosophers, doctors and educators of the eighteenth century advanced concepts of child care and education that radically reversed common notions and practices. Profoundly influenced by Locke and English philosophy, they argued that the moral and psychological make-up of the adult is largely if not wholly shaped by his childhood environment.[20] Fénelon, Buffon, Rousseau and other French thinkers popularized the idea that the nature of childhood is essentially different from that of the adult. Since children cannot reason, they explained, rules, constraints and punishment can actually harm them; rather, good education flows from an understanding of the nature of children and the way their minds work. They advised parents to build upon and channel a child's need for affection and approval, his natural tendency to learn by imitating and his love of free play and movement. The custom of favoring the oldest son and heir while ne-

glecting the other children was vehemently denounced. Above all, they attacked the custom of sending babies off to wet nurses for the first few years of their lives as immoral and unnatural; only loving parents and especially nursing mothers could provide the kind of care and environment in which a healthy and virtuous child could grow. They promised the parents who would adopt these innovations a rich reward; awaiting them were pleasures and emotional satisfactions without parallel in other human relationships.

The promotion of these new ideas—the idea of childhood as a unique phase of human growth and that of the family as an intimate and harmonious social unit—became a major activity, a veritable cause, of Enlightenment writers.[21] In novels, on the stage and in educational, medical and philosophical treatises, the new ideals of the happy and healthy family were dramatized and explained. Rousseau's *Julie, or Nouvelle Heloïse* and his *Emile,* published in 1761 and 1762, respectively, lyrically plead them and probably did more to popularize them than any other works. Diderot's *Salons,* Greuze's *The Beloved Mother* and Fragonard's *The Return Home* equally belong to this Enlightenment campaign.

Artists other than Greuze and Fragonard also gave expression to the new ideas—some from personal conviction, some with an eye to the market: The painter Etienne Aubry (1745–1781) won critical praise from moralists when he took up these issues in the 1770s.[22] His scenes of family life explore questions of child-rearing with seriousness and dignity. They are rendered with a graceful naturalism that was influenced by Greuze's style but relies less on dramatic devices. His *Fatherly Love,* 1775, sold as a Greuze in 1961, shows a gentle, rustic father about to pick up his youngest son. His own father and wife watch with pleased and approving smiles. Here is an ideal environment for the young, where adults of both sexes show love and affection to all of their children. In his portrayal of the paternal role, Aubry was more advanced than Greuze, whose noble old patriarchs (as in *The Ungrateful Son*) are apologies for the traditional, authoritarian father.[23] In another painting, *Farewell to the Nurse,* 1776 (Fig. 1.7), Aubry again argues for fatherly love and close ties between parents and children. On the right a wealthy father who has left his baby with peasants holds himself apart and aloof from the moving scene before him. He stands in marked contrast to the peasant, who openly expresses his paternal attachment to the baby. Meanwhile, the unhappy baby squirms to get out of the arms of his natural mother and into

those of his wet nurse. Aubry teaches that environment and social behavior mean more than simple blood ties and that good parents nurse and keep their children at home.

In *The Nursemaids,* Greuze gave the same lesson, but with a more conventional argument and without his usual sympathy for rustics. Unlike Aubry's good peasant woman, this is a slovenly, crabby-looking nurse, surrounded by ill-behaved children. Neither she nor her companion seem to care about the children in their charge, some of whom must be their own. The point again is that the environment makes the child and the child makes the man. These badly behaved youngsters can only become morally weak adults. Rousseau had stressed this idea in *Emile,* where he claimed that the whole moral order of France had degenerated because the wealthy refused to nurse and raise their own children.[24]

Although the exemplary parents of eighteenth-century art were usually represented as rustics, artists also explored the rewards of parenthood among the more affluent, as in a set of colored engravings by Debucourt, executed in the late 1780s. Here, good parents have become happy grandparents, and the fuss they make over their grandchildren is thoroughly modern. *Grandmother's Birthday* was dedicated to mothers, while *New Year's Visit* was dedicated to fathers, who traditionally blessed their families on January 1.

Commissioned portraits of real families increasingly re-

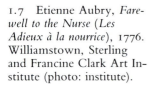

1.7 Etienne Aubry, *Farewell to the Nurse* (*Les Adieux à la nourrice*), 1776. Williamstown, Sterling and Francine Clark Art Institute (photo: institute).

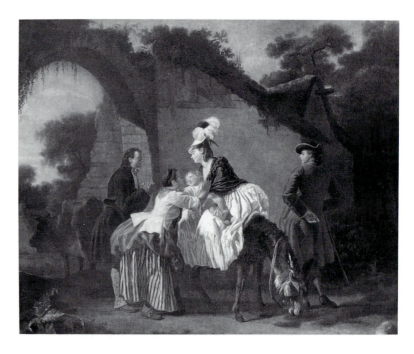

flected the new concept of conjugal love and family harmony. A family portrait by Drouais (Fig. 1.8), dated 1756 when these ideas were still relatively novel in France, goes to some lengths to assert them. The aristocratic couple who commissioned this work and who unquestionably suggested or approved its every detail had a very exacting idea of how they wanted themselves represented. It is their conjugal relationship, their affection for each other, and not their separate identities or ranks that they chose to emphasize. The prominent clock tells the late morning hour and the scene is set in the wife's dressing room, an hour and a place usually reserved for intimates. An inscription gives the date as April 1, a sort of Valentine's Day on which gifts and love letters were exchanged—the paper in the husband's hand must be such a letter. Like the family in Fragonard's

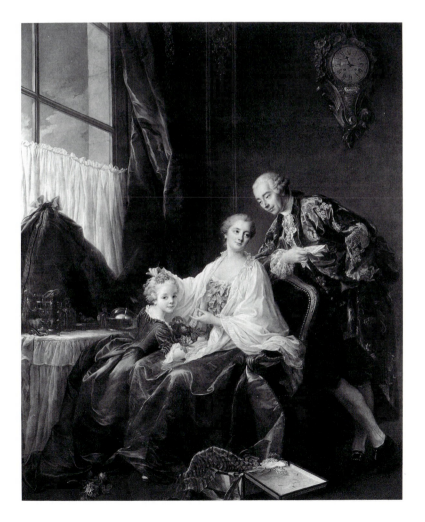

1.8 François-Hubert Drouais, *Group Portrait*, 1756. Washington, National Gallery of Art, Samuel H. Kress Collection (photo: museum).

Return Home, the mother is situated in the center of the gracefully related group—between her attentive husband, toward whom she inclines her head, and her daughter, over whom she leans and fusses. Thus did bourgeois concepts penetrate aristocratic culture. Increasingly, women of noble rank would have themselves painted in their roles as mothers and wives.

Even the prestigious heights of art, the realm of mythology, responded to the new interest in conjugal love, letting this essentially middle-class idea enter through the front door of aristocratic culture. In the late eighteenth century, Hymen, the god of marriage, enjoyed a new popularity and increasingly joined Venus and Cupid in pictorial representations. Prud'hon's *Venus, Hymen and Cupid* (Fig. 1.9) reverses the logic of conventional wisdom. Tradition taught that love, because it blinds and impairs the judgment, is the enemy of sound, advantageous marriage. But in Prud'hon's painting, the three divinities smile in happy accord. The very classicism of their forms seems to confer upon their union the sanction of antiquity. Moreau's *Delights*

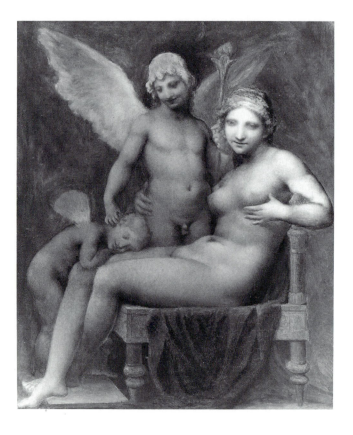

1.9 Pierre-Paul Prud'hon, *Venus, Hymen and Cupid,* Paris, Louvre (photo: Les Musées Nationaux, Paris).

of Motherhood (Fig. 1.4), with its reference to Venus, conveys
the same idea—that sexual gratification, marriage and par-
enthood come in a single package suitable for elevated tastes.
A verse by Helvétius, published in 1772, went even further.
It argued that sexual desire is heightened when Hymen and
Cupid work as partners:

> Enchained to both Hymen and Cupid,
> Happy loving couple, what a blessing is ours...
> I was scorched by Cupid who was consuming
> my soul;
> Hymen, far from quenching the flames, fanned
> them up.[25]

The educational and psychological functions of the new
family help to explain its profound appeal to the feelings and
imagination of the eighteenth century. For it appeared as a
forceful idea just when modern bourgeois culture was be-
ginning to take shape, and it answered particular needs which
that culture created. The commercial, financial and profes-
sional activity of the *ancien régime,* although limited to a small
sector of the population, was expanding enough to change
people's life expectations and experience. As economic op-
portunities increased, it made sense to more people to limit
the size of their families and to educate more of their children
for higher positions in the world than the ones to which they
were born.[26] The large traditional family was not geared to
the new society; its logic presupposed stable social and eco-
nomic conditions. Accordingly, it passed on its means intact
to a single heir and taught its members family, not individual,
identity, collective, not personal, ambitions. In contrast, the
new family, a small and harmonious social group, could di-
rect its unified energies toward all its children's futures. More
child-centered, it was better organized to equip its sons with
the mental skills and psychological strengths of the new
man—the independent, mobile, reasoning citizen of the en-
lightened age. Rousseau, arguing the necessity of modern
education, wrote: "If no one could be dislodged from his
present station, then existing modes of education would, in
some respects, be sound; a child would be brought up for
his station, he would never leave it and he would never be
exposed to the difficulties of any other. But we [must] con-
sider the instability of human affairs [and] the restless and
changeful spirit of the age, which reverses everything with
each new generation."[27] And again: "In the case of the rustic
we think only of the class; each member does the same as
the rest. . . . In the case of men living in civilized communi-

ties, we think of the individuals; we add to each everything that he can possess over and above that possessed by his fellows; we let him go as far as he can to become the greatest man alive."[28]

The new family, more intimate than the old, also served the psychological needs of adults. The emerging world of business was less personal and more active than the old and affected the quality of daily life. People developed a new consciousness of private versus public life, and a pressing new need for a secure and tranquil sanctuary removed from the impersonal and competitive relations that increasingly marked commercial and civic affairs. The home, the family, came to be looked upon as a haven, a place of intimacy, warmth and personal well-being opposed to the harsher world outside.[29] These associations helped to make the new ideal of the family such an attractive and emotionally resonant subject for the eighteenth century, even though—or perhaps because—most people still lived in traditionally arranged domestic situations.

The unifying element of the new family was the wife-mother. From her primarily was to flow that warmth and tranquility that Enlightenment bachelors like Diderot so ardently eulogized as the central attraction of family life. She is Rousseau's Julie and Sophie, the happy mother of Fragonard and Greuze and the virtuous wife of numerous eighteenth-century playwrights and novelists. Pretty, modest and blushing, her happiness consists in making her husband happy and in serving the needs of her children. Indeed, everything in her make-up, including her personality, is determined by her situation in the conjugal family, a situation from which eighteenth-century writers deduced the "nature" of woman. She is coquettish for her husband, whose physical and emotional needs she fulfills and to whose will she gladly submits; she is thrifty, skilled in the domestic arts, and a good mother and nurse to her children. She is the traditional bourgeois wife, but with a difference: she has been educated to find personal and emotional fulfillment in the execution of her duties. This is the difference between the good wife of old and the happy mother of eighteenth-century art and literature. The latter is psychologically trained to *want* to do the very things she *must* do in a middle-class family society. According to Rousseau, this is the goal of women's education: since it is their natural lot to be subject to the will of men, girls should become accustomed from the first to restrictions and constraints. Their own fancies must be crushed in infancy

so that they will become habitually docile and feel that they were "made" to obey.[30] Needless to say, in the eyes of Rousseau and his followers, the aristocratic woman, who organized her life around her own pleasures rather than around the needs of her husband and children, violated the laws of nature. So did the intellectual woman, the *femme-philosophe.* Wrote Rousseau: "From the lofty elevation of her genius, she despises all the duties of a woman and always begins to play the man. . . . [She] has left her natural state."[31]

Julie, the heroine of *La Nouvelle Heloïse,* is the perfect embodiment of the new feminine ideal. Although she married a man she was not in love with (out of love and duty to her parents), she is a contented wife and mother. Her husband is enlightened to the laws of nature, and Julie finds pleasure in winning his approval. She organizes her life largely around the needs of her children, nurses and personally cares for her own infants, and undertakes the complete education of her daughter, who by imitation will become like Julie. The education of her son, however, is another matter; when he reaches the age of reason he is handed over to his father. "I nurse children," says Julie, "but I am not presumptuous enough to wish to train men. . . . More worthy hands will be charged with this noble task. I am a woman and a mother and I know how to keep my proper sphere."[32] Thus does Julie contribute to two major functions of the conjugal family: the creation of active, independent males and of submissive, service-oriented females.[33]

The image of the mother fulfilling herself as she tends to the needs of her children was a compelling one to eighteenth-century writers. Indeed, the cult of motherhood conquered male writers before it significantly changed the lives of women. The joys of maternity became a fashionable literary theme, its every aspect eloquently told in prose and poetry, from the sensual rewards of breast feeding to the unequaled pleasure of receiving a child's caresses and kisses.[34] Even pregnancy was exalted. As one writer declared in 1772: "A woman is almost always annoyed at being pregnant, [but] this state should be regarded by women as the most beautiful moment in their lives."[35] The notion that motherhood is the *only* emotionally fulfilling role for a woman was fully developed. As another of these male authorities assured his readers: "The sensations experienced by a woman when she becomes a mother are of a kind superior to anything she feels in other circumstances."[36]

Among the favorite arguments for motherhood advanced

in this literature was the appeal to Nature, whose laws could be read in the mores of peasant or exotic cultures, or in more virtuous eras of the past.[37] French women were exhorted to imitate happy rustic mothers, noble savage mothers or the mothers of antiquity, all of whom nurse or nursed their own young. The campaign for motherhood, however, found its most urgent voice when it turned to the population problem. Frenchmen in the eighteenth century mistakenly but fervently believed that the French population was shrinking and in danger of extinction.[38] At the same time, the use of contraceptive practices was becoming widespread among middle- and upper-class women, whose subculture was bent on avoiding the debilitating physical effects and the economic burden of the large, biological family. Although evidence indicates that some fathers privately welcomed this trend, male public opinion was scandalized. The idea that women might exercise choice in this area, that they might choose to limit or avoid childbirth, alarmed respectable men of letters, who produced a torrent of pamphlets extolling the joys of motherhood, proclaiming it the only natural state for women and condemning the immorality and selfishness of those who would deprive the state of its population.[39] In this light, Di-

1.10 Fragonard, *Mother's Kisses*, Switzerland, private collection (photo: Wildenstein, *Fragonard*).

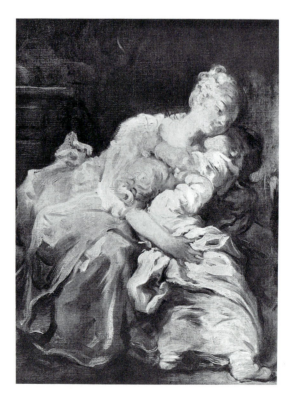

20

derot's verbal paraphrase of Greuze's *The Beloved Mother,* addressed as it is to men only, deserves to be quoted more fully: "It preaches population, and portrays with profound feeling the happiness and the inestimable rewards of domestic tranquility. It says to all men of feeling and sensibility: 'Keep your family comfortable, give your wife children; give her as many as you can; give them only to her and be assured of being happy at home.' "[40]

The call to motherhood, however, probably had deeper roots in the psychological needs of the time than in concerns for population size. In any case, artists portrayed it more frequently than they did the theme of the larger family. Along with the writers, they explored its every facet. Young rustic mothers, their nursing breasts virtuously exposed, became a staple of the printseller; Freudeberg's *The Contentments of Motherhood* is typical. From Fragonard's atelier came a whole series of happy and good mothers. Two of these, *The Joys of Motherhood* and *The Beloved Child,* celebrate with Rococo exuberance the pleasures of a peasant and a fashionable mother respectively. *The Beloved Child* is probably in large part the work of Marguerite Gérard, Fragonard's student and sister-in-law and a specialist in this genre.

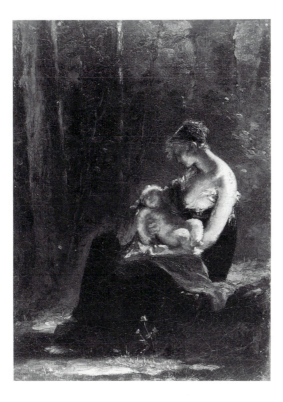

1.11 Prud'hon, *The Happy Mother,* sketch, c. 1810. London, The Wallace Collection. Reproduced by permission of the Trustees of the Wallace Collection (photo: collection).

Another Fragonard, *Mother's Kisses* (Fig. 1.10), painted in his boldest, most spontaneous style, treats a theme that writers also liked: the joys of a mother who receives the fervent embraces of her children, an experience, claimed the moralists, justly denied to women who ship their infants off to be tended by others.

The image of the happy nursing mother—an image of generosity and charity with a long history in religious art—was also popular. Among the paintings that David sent to the Salon of 1781 was *A Woman Nursing Her Infant* (now lost), which was duly praised by Diderot.[41] In Prud'hon's *The Happy Mother* (Fig. 1.11), the theme is treated with unusual subtlety. In a still, shadowy wood, a hazy light picks out the motionless figures of a nursing mother and her infant. The child asleep, the mother watching him, each seems to experience a perfect contentment and tranquility. The dark shadows, the simple, harmonious composition, the highlighted bare flesh—everything in this work suggests feelings of intimacy and sensual satisfaction shared by mother and child. In contrast to Prud'hon's poetry is a print

1.12 After Augustin de Saint-Aubin, *The Happy Mother, (L'Heureuse mère)*, engraved by A. F. Sergent-Marceau. Paris, Bibliothèque nationale (photo: Bibl. nat. Paris).

L'heureuse Mère.

by Augustin de Saint-Aubin of exactly the same subject, *The Happy Mother* (Fig. 1.12), executed around the turn of the century. This extraordinary mother, who apparently can nurse two infants at a time, displays her maternal attributes with the clarity and the frontality of an archaic goddess. The message that motherhood is happiness is nowhere more blatantly stated.

With images such as these, the cult of motherhood and the concept of the conjugal family found vehicles of popularization. Expressions of a new, child-centered culture—still a minority culture in 1800—they would become familiar ideals throughout French society in the course of the following century.

NOTES

1. G. Wildenstein, *Chardin,* Manesse, 1963, pp. 17–20.
2. D. Diderot, *Salons,* ed. J. Seznec and J. Adhémar, Oxford, 1957, Vol. I, p. 233.
3. That Greuze took this rustic mother's smile from the face of Marie de Médicis as Rubens portrayed her in *The Birth of Louis XIII* (Diderot, op. cit., Vol. II, pp. 35–36) only underscores the novel content of this eighteenth-century work. Marie's is the smile of a queen mother who has just given birth to a dauphin, heir to the throne by divine right. The work is officially addressed to subjects of that throne. *The Beloved Mother,* on the other hand, is theoretically addressed to humankind in general and embodies more purely secular ideas. It asserts that family relationships as such can be the sources of a happiness that is generically human.
4. Ibid., Vol. II, p. 155.
5. Like Greuze, Fragonard also learned from the precedents of Dutch and Flemish art. Rubens's *Helena Fourment and Her Children* is a notable example of the kind of art that anticipated and informed Fragonard's paintings of women and children. *Mother's Kisses* (Fig. 1.10) appears to have borrowed directly from it.
6. Rembrandt's Holy Families are especially called to mind. Fragonard loved the work of this artist.

 No hard and fast line can be drawn between the older imagery of the Holy Family and that of the secular, eighteenth-century one. The suggestion of conjugal love—one of the main features of the latter— is not unusual in representations of the Holy Family, and both kinds of families supplied images of exemplary mothers, fathers and children. Philippe Ariès discusses this aspect of Christian imagery in Renaissance and post-Renaissance art in *Centuries of Childhood,* New York, 1962, pp. 339–64. In seventeenth-century France, for example, Le Brun's *Saying Grace (Le Bénédicité)* was thought to be a picture of the Holy Family, which, in turn, was regarded as a model family (ibid., pp. 360–62). However, by their nature, pictures of the Holy Family are to some degree devotional. The image of the child around

whom this family is organized cannot be entirely disassociated from his unique and extraordinary mission. The idea of the family that Fragonard painted, on the other hand, whatever it borrows from older, religious art, is completely secular. In contrast to the transcendent purposes of the Holy Family, the exclusive concern of this family is the individual happiness and well-being of its members. The image of the Holy Family, insofar as it is a picture of a family, could suggest this Enlightenment idea, but only to a point, beyond which it risked loss of its traditional Christian content. At the same time, the complete expression of the new ideal demanded ordinarily conceived human beings without special destinies: man in general. The terms of the new ideal were in fact those of eighteenth-century secular philosophy, and the iconography of the happy family thus reflects the contemporary secularization of French culture.

7. In R. Mercier, *L'Enfant dans la société du XVIII^e siècle (avant l'Emile)*, Dakar, 1961, p. 101.

8. The print, which appeared in the album *Monument du costume*, is part of a series of prints illustrating the life of a fashionable woman. A few scenes later she has tired of the delights of motherhood and is pursuing those of adultery.

9. Diderot, *Salons*, Vol. II, p. 151. The model for this figure was Mme Greuze, whose adulterous affairs were a source of continual vexation for her husband.

10. The traditional attitudes and family relationships to which I refer, sketched in this and following paragraphs, generally date from the seventeenth century and persisted through most of the eighteenth century. Moreover, this picture of family life is drawn from French society primarily. It will not necessarily hold for either the rest of Europe or for earlier periods in France. I have relied mainly on the following sources: Philippe Ariès's pioneering book *Centuries of Childhood*, which largely inspired the present essay, treats the Middle Ages to the eighteenth century, with emphasis on the seventeenth century; D. Hunt, *Parents and Children in History, The Psychology of Family Life in Early Modern France*, New York, 1970; W. D. Camp, *Marriage and the Family in France Since the Revolution*, New York, 1961; L. Delzons, *La Famille française et son évolution*, Paris, 1913; G. Duplessis, *Les Mariages en France*, Paris, 1954, pp. 1–27; J. Hajnal, "European Marriage Patterns in Perspective," in *Population in History: Essays in Historical Demography*, ed. D. V. Glass and D. Eversley, London and Chicago, 1965, pp. 101–43; Mercier, *L'Enfant*; E. Pilon, *La Vie de famille au XVIII^e siècle*, Paris, 1941; and R. Prigent, ed., *Renouveau des idées sur la famille* (Institut national d'études démographiques, XIV), Paris, 1954, pp. 27–49 and 111–18.

11. This progressive attitude is the subject of Ariès, *Centuries*, pp. 339–404.

12. See especially Hunt, *Parents*, pp. 68–74; and Pilon, *La Vie*, pp. 55–69.

13. E. Dacier, *La Gravure en France au XVIII^e siècle; La Gravure de genre et de moeurs*, Paris and Brussels, 1925, p. 33; J. Adhémar, *La Gravure originale au XVIII^e siècle*, Paris, 1963, p. 158; and L. Hautecoeur, *Les Peintres de la vie familiale*, p. 45f.

14. Both the thesis and the antithesis—that a woman's happiness lies in

marriage, motherhood and sexual fidelity on the one hand and in libertinism and illicit love on the other—continued to delight the fashionable public well into the nineteenth century. See M. Melot, " 'La Mauvaise Mère,' Étude d'un thème Romantique dans l'éstampe et la littérature," *Gazette des Beaux-Arts,* ser. 6; 79 (1972), pp. 167–76, for an analysis of how nineteenth-century art struggled with the contradictions raised by these conflicting feminine ideals. Romantic continuers of eighteenth-century *éstampes galantes* and the absorption of aristocratic tastes and social patterns into nineteenth-century bourgeois culture are major themes in my *The Pursuit of Pleasure: The Rococo Revival in French Romantic Art,* New York and London, 1976.

15. Ariès, *Centuries,* pp. 15–49; and Hunt, *Parents,* Chs. 6 and 7.

16. See especially Hunt, *Parents,* pp. 100–09; and Mercier, *L'Enfant,* pp. 31–37.

17. Bernardin de Saint-Pierre, *Studies of Nature (Études de la nature),* trans. by H. Hunter, Philadelphia, 1808, p. 413.

18. Prigent, *Renouveau,* pp. 34–49; and Duplessis, *Les Mariages,* pp. 14–15.

19. This issue was dramatically developed at the end of the century. The Revolutionary National Assembly, carried away by liberal idealism, swept the old marriage laws off the books and legislated new ones, favoring consensual matches, restricting paternal authority and allowing for easy divorce. Napoleon's Civil Code of 1804 reversed almost all of these laws—laws that ran counter to the traditional interests of the bourgeois family—and reinstituted marriage along the old lines (Delzons, *La Famille,* pp. 1–26).

20. See especially Mercier's study, *L'Enfant,* for eighteenth-century theories of child-rearing.

21. Prigent, *Renouveau,* pp. 34–49; and Mercier, *L'Enfant,* pp. 145–61.

22. Florence Ingersoll-Smouse, "Quelques tableaux de genre inédits par Etienne Aubry (1745–1781)," *Gazette des Beaux-Arts,* ser. 5; 11' (1925), pp. 77–86; and Diderot, *Salons,* Vol. IV, pp. 260–61 and 291.

23. This ennobling of authoritarian fathers is a conservative element in the art of Greuze and a response to contemporary criticism of the traditional paternalistic role. David's *Oath of the Horatii,* 1784, and *Brutus,* 1789, similarly idealize the traditional authoritarian father and husband. While the women in these pictures are shown to be ruled by their emotions and family feelings alone, male virtue consists in conquering these sentiments with the aid of reason, a faculty women were thought to lack. See my "Fallen Fathers: Images of Authority in Pre-Revolutionary French Art," *Art History,* 4, June 1981, pp. 186–202, reprinted in this volume, pp. 27–56.

24. R. L. Archer, ed., *Jean-Jacques Rousseau, His Educational Theories Selected from Emile, Julie and Other Writings,* Woodbury, N. Y., 1964, p. 73.

25. In Prigent, *Renouveau,* p. 37.

26. Ariès, *Centuries,* p. 404; Camp, *Marriage,* pp. 99 and 126; Prigent, *Renouveau,* pp. 111–14; and H. Bergues, P. Ariès and others, *La Prévention des naissances dans la famille, ses origines dans les temps modernes* (Institut national d'études démographiques, XXXV), Paris, 1960, pp. 311–27.

27. Archer, ed., *Rousseau,* p. 63.

28. Ibid., p. 34.
29. Ariès, *Centuries,* pp. 398–400 and 404–06.
30. Archer, ed., *Rousseau,* pp. 218–27.
31. Ibid., p. 253.
32. Ibid., p. 46.
33. It should be noted, however, that the virtuous ideal embodied in Julie was in some ways a step up for women, whose capacity for virtue of any kind was still widely doubted and whose contribution to society was largely ignored (see Hunt, *Parents,* pp. 72–73). Moreover, at least in principle if not in substance, Julie demonstrated that individual happiness was a female as well as a male pursuit.
34. Mercier, *L'Enfant,* pp. 97–105.
35. In Bergues, *La Prévention,* p. 283.
36. In ibid., p. 282.
37. Mercier, *L'Enfant,* pp. 118–22.
38. Bergues, *La Prévention,* pp. 311–27. In fact, the population of France was growing. See W. L. Langer, "Checks on Population Growth: 1750–1850," *Scientific American,* 226, February 1972, pp. 92–99.
39. See Bergues, *La Prévention,* pp. 253–307, for a collection of these texts.
40. Diderot, *Salons,* Vol. II, p. 155.
41. Ibid., Vol. IV, p. 378.

FALLEN FATHERS: IMAGES OF AUTHORITY IN PRE-REVOLUTIONARY FRENCH ART

The French Revolution moved quickly to abolish not only the old monarchy but also the near-absolute power of fathers.[1] The spectacle of overthrown kings and fallen fathers, however, was already familiar to the educated French public. For many years, artists had been exhibiting pictures of them in the Salons—the biannual art exhibitions organized by the Royal Academy. Financed by the crown and held in the Louvre itself, the Salon was a public ceremony attended by crowds of men and women and carefully controlled by royal officials. Certainly no one would expect to find in the works displayed there attacks on the ideology of monarchy or its underlying concept of patriarchal authority. On the contrary, the paintings I shall be discussing were encouraged by the government and given privileged status. Yet, despite all intentions, these paintings bear witness to a growing ambivalence toward established authority. Whatever their acknowledged intent, as images, they could silently communicate feelings that were not easily spoken. My concern is, first, with the contradictory meanings of these images in relation to the social experience they mediated; and second, with their function in the ceremonial space of the Salon and the kind of public discourse they occasioned.

In the second half of the century, Salon painters became increasingly preoccupied with figures of old men—fathers, generals and kings. Old men were always prominent in Western artistic traditions. As gods, prophets, saints and rulers, they are time-honored symbols of patriarchal authority. What is remarkable in late eighteenth-century French painting is not merely the presence of so many old men, but the ex-

This essay was first published in *Art History* IV (June 1981), 186–202. It is reprinted here by permission of Routledge Chapman & Hall, Ltd. My gratitude to Elizabeth Fox-Genovese for her valuable comments.

traordinary trouble they have holding on to their powers—their political, physical and even their mental powers. Their existence almost always centers on a single issue: the obedience, loyalty and respect of their subordinates and, above all, of their sons.

The patriarchs in Salon paintings are often honored and obeyed; but their relationships to their sons are just as likely to be troubled or in crisis. Rebellious sons appear in these works with high frequency and in both ancient and modern dress. Authority, in the person of a pathetic or angry old man, is often challenged outright: an ungrateful son leaves home against his father's wishes (Greuze, 1765); Manlius Torquatus has to execute his son for disobeying orders (Berthélemy, 1785); Oedipus reproaches Polyneices (Peyron, 1785). Even without rebellious sons, Salon patriarchs are prone to sorrow, suffer and die, or to be near death. Other people also die in eighteenth-century art but, even amidst a fairly high death rate, patriarchs are especially vulnerable. And, if not near death, they are often convalescent, weak, in need of rescue or at the mercy of their dependants. In many paintings, filial piety consists largely of *not* allowing one's father to perish when the opportunity to do so arises. Thus the noble Metellus is saved from execution by his son (Brenet, 1779); a paralyzed old man is cared for by his son (Greuze, 1763); a defeated Priam begs Achilles to give him the body of Hector, reminding him of his feelings for his own father (Doyen, 1787); an old man taking some air is supported by his son and daughter who help him walk (Wille, 1777). Pity, fear and guilt, alone or in combination, are the feelings these old men are most likely to inspire.

Subjects like these were already frequent before 1789. In the 1790s, the Salons would exhibit even more images of suffering, embattled old men. A painting by Harriet of 1797, *Oedipus at Colonus,* portrays the blind patriarch in extreme destitution. He has lost not only his kingdom and his sight but his mental powers as well; and now, having wandered to a gloomy, lonely place, even his daughter Antigone, his eyes and his guide, abandons him in a moment of sleep. As the art historian James R. Rubin has noted, the Oedipus theme appeared with exceptional frequency in the 1790s.[2] In those post-Revolutionary years, Oedipus was a symbol for émigrés in particular and the pre-Revolutionary social order in general. After the Revolution, Oedipus was probably the most often-used symbol of the old regime, although other old men and their sons—Daedalus and Icarus, Jacob and Jo-

seph—could also suggest the relationship between the old order and the new—the rightness of one or the wisdom of the other.[3] But pathetic or victimized old men, including Oedipus, appeared in paintings and on the stage before there were émigrés or a Revolution. Harriet's *Oedipus* was inspired by a modern version of the tragedy, Ducis', first performed in 1778. And the history painter Peyron had already exhibited an *Oedipus* in 1785. Before it was possible to employ them consciously as symbols of traditional social relations, noble but suffering old men had long been at work expressing complex and partly submerged feelings about authority.

The advantage of this theme was precisely its ability to give objective shape to ambivalent feelings without forcing those feelings into full consciousness. The image of the vulnerable old man specifically addressed eighteenth-century social and psychological experience. Throughout the social hierarchy of pre-Revolutionary France, authority was normally located in the person of a patriarchal figure whose will was the law. The experience of subordination to patriarchal authority thus prevailed throughout the society, from the court down to the modest household. Kings and fathers were not the only embodiments of this authority, but they embodied it most perfectly and could stand as representatives of social authority itself. As historians have noted, the king and the father had analogous obligations and powers in their respective realms, and the image of one could evoke that of the other. The king was often represented—on coins for example—as *père de famille,* a symbol of benevolence, protection and justice that also implied an obligation to feed and provide for the necessities of life. Conversely, fathers were commonly likened to wise or tyrannical rulers. As the proverb went, each is king in his own household.[4]

The patriarchal figure, be he king, father or patron, could inspire conflicting feelings—dependency and respect on the one hand, and resentment and hostility on the other. Individuals could both love and fear him, long for his benevolent protection but also hate him for his power. These negative feelings, however, could not be openly expressed. They were inhibited by internal controls and prohibited by custom, law and the real threat of punishment.[5]

In the second half of the eighteenth century, traditional attitudes of deference and respect were becoming more difficult to sustain and the expression of hostility more difficult to repress. Historians have given various explanations for the marked increase in tension. Among the factors often cited

are a growing population and a consequent scarcity of jobs and privileges, resulting in greater demands for family discipline.[6] In general, a gap was developing between the promises of patriarchal ideology and what the social structures could really deliver. Whatever the historical causes, the old system of privilege and personal patronage was put under increasing pressure from all sides, and social authority, within the family and beyond, was both attacked and defended more vigorously than ever. For most people, traditional attitudes toward authority were deeply ingrained and would not be openly repudiated. But, as the historical evidence suggests, the ambivalence always inherent in patriarchal relations must have been lived with more intensity and strain in the second half of the century. The painting of the time strongly suggests that negative feelings pushed for greater expression and, on that account, begged to be concealed all the more. Images of sympathetic but weakened old men could perfectly express the forbidden impulses but also keep them hidden beneath conscious feelings of love and respect.

The same ambivalence found expression in the writings of the first generation of philosophes. The philosopher kings and enlightened despots that recur so often in their work also conceal images of fallen patriarchs. According to the philosophes, the ideal monarch, having embraced enlightened ideas or acquainted himself with 'natural law,' is compelled by reason to bring about exactly the social and political changes that do away with his personal power. The king himself simply wills the Revolution, eliminating the necessity for anyone else to. He encounters no opposition. As a literary device, the philosopher king enabled the philosophes to construct and furnish revolutionary utopias, but it also prevented them—or rather protected them—from thinking of Revolution and the social disorder necessary to achieve it.[7]

This ambivalence contrasts with the self-conscious Jacobin vision of William Blake, whose work I refer to here in order to focus more sharply the particular content of these French pictures. In Blake's art, patriarchal authority is a central issue, and its symbol is almost always an old man.[8] Bearded patriarchs, like the tyrant Urizen, stand for repressive law and domination. Their constricted and constricting spirit is conveyed by hunched, squatting, downward-looking poses. In the tiny emblem "Aged Ignorance" (1793) (Fig. 2.1) one of these old men clips the wings of a young Eros, reproducing his own internalized repression as well as that of the external patriarchal order. These old men are also overthrown

periodically by rebellious youth—an Eros grown strong enough to overcome his own fear. In contrast, the old men who appear in French Salon paintings, even in the midst of the Revolution, are never as lucid or unambiguous in symbolic meaning as Blake's bad old men. Blake's more conscious and overtly aggressive opposition to patriarchal authority is no doubt rooted in the English tradition that, in the previous century, prevented the growth of absolute monarchy in England.[9] In any case, French Salon patriarchs pacify—and testify to—emotional needs that Blake could consciously reject, especially dependency and the wish to idealize the father. In contrast to his fearful and fearsome tyrants, the French old men are emphatically deserving of pity—even while they are murdered, deranged, destitute or, like Oedipus and Belisarius, symbolically castrated (blinded).

Such conflicting feelings were not necessarily directed specifically or exclusively toward fathers. They were aimed more broadly at institutionalized authority in general. But fathers, as heads of families and salient representatives of that authority, surely excited both the respect and the repressed hostility these images suggest. In most of France, law and custom gave fathers of every class almost absolute power and custody over all members of the household and control of all family property. In some parts of France, a man could be kept a minor as long as his father lived, unable to marry or sign contracts.[10] The law also gave fathers the right to have disobedient dependants imprisoned at state expense. The famous case was Mirabeau, whose father at one moment had his entire family—wife and children—put away. In later

2.1 William Blake, "Aged Ignorance," from *The Gates of Paradise*, 1793 (photo: author).

31

eighteenth-century art and literature, the traditional role of the father was increasingly analyzed and attacked. Fathers were sharply criticized as stern, remote tyrants who cared more about the family's material interests than the well-being of its individual members.[11]

The artist Jean-Baptiste Greuze was probably the most acclaimed French painter of the 1760s and 1770s. Independent and rebellious, he eventually broke away from the academy, exhibiting his work outside the Salon and selling it on the open market. His specialty was scenes of family life, officially ranked below history painting by the academy but extraordinarily popular among critics and the public. While history painters looked to the French classical theatre for their themes, Greuze invented his own bourgeois melodramas. And, like Rousseau and other philosophes, he preached reform by idealizing the simpler, presumably more natural and uncorrupt ways of modest, old-fashioned households. Indeed, his genre scenes, ultimately inspired by the art of middle-class, seventeenth-century Holland, imply an ideal society composed of small, independent households. But if Greuze looked backwards for a political model, the emotional content of his images speaks directly to eighteenth-century experience. In his portrayals of mothers and the mother-child relationship, he projected a progressive bourgeois concept of conjugal love and maternal joy. In his paintings, good mothers are happy mothers, tending to the emotional and educational needs of other members of their families.[12]

Fathers seem to have been on Greuze's mind even more than mothers. When fathers are present in his work, they are almost always the center of emotional attention, and the underlying issue they dramatize is patriarchal authority, its rights and obligations. Greuze defends the traditional father with remarkable urgency. According to his paintings, the answer to the abuse of patriarchal authority is more and better patriarchal authority of the good, old-fashioned kind.

The old father in *The Village Engagement* (1761) (Fig. 2.2) is typical of his stern but kindly looking patriarchs. The head of a modest but comfortable household, he expects and deserves veneration. Greuze shows him making a speech in the midst of an important legal ceremony—the delivery of his daughter's dowry to his new son-in-law. The viewer may imagine the sage advice the old rustic gives the young man, who will no doubt rule a large roost of his own one day—as the chickens in the foreground suggest.

However, Greuze's fathers do not always receive their due

of love and respect. One of his best-known works tells the story of an ungrateful son in two separate paintings. Exhibited in 1765 as a pair of sketches, the paintings were completed in the following decade. The first, *The Father's Curse* (Fig. 2.3), is an image of rebellion. A son is leaving to go off with the army. His father curses him for abandoning the family—he is the oldest of five children and the obvious successor. Here the rights of the king take precedence over those of the father; enlistment in the military was one of the few things a son could do legally without paternal consent. The drama is concluded in *The Son Punished* (Fig. 2.4). Many years have gone by (a sixth child has appeared), and the son, now a disillusioned and disabled veteran, comes home at last. But too late to be forgiven: his father has died but a moment before.

Part I, the rebellion itself, is the richer, more complex image. Both father and son are visibly torn by conflicting emotions. The son especially is a tour de force of mimetic

2.2 Greuze, *The Village Engagement* (*L'Accordée de village*). Salon of 1761. Paris, Louvre (photo: Les Musées Nationaux, Paris).

expression. With one side of his body he is all anger and determination, pushing toward the door and freedom with clenched fist and a firm step. But the other half hesitates, turns back to the father he loves and—as he hears the curse—is overcome with fear. The father is also in conflict with himself. His attempt to rise appears half-hearted, and his outstretched arms suggest equally a desire to embrace and an impulse to attack his son. The rift between these two has thrown the other members of the family into turmoil, and their various gestures and expressions, along with the overturned chairs, augment the central conflict. Only one figure stands apart—the army recruiter at the door. This representative of the king, a slovenly, dishonest-looking man, is an intruder in Greuze's family society. Through him, the world beyond the father's rightful realm—what for the son is a realm of freedom—is disparaged. He has filled the youth's head with tales of fortune and adventure and now laughs behind his sleeve at the boy's gullibility. There can be no doubt that the son is in the wrong.

2.3 Greuze, *The Father's Curse* (*La Malédiction paternelle*), 1778. Paris, Louvre (photo: author).

Overtly, the work's intention is clear enough: it argues the virtue of filial duty. Yet the image is charged to the utmost with hostility, barely repressed by the overt moral content. Stripped of that morality, the image alone visually amounts to parricide. The youth rebels and finds his father dead.[13] The viewer is invited to both enjoy and denounce the crime, to identify secretly with the criminal while consciously condemning him. Exciting and dangerous feelings which, if brought to light, would contradict morality, are stirred up but not allowed conscious expression. The overt moral content both contains and smothers them. Yet the repressed content leaks out around the edges. Patriarchy is simultaneously defended and opposed. The king's rights are portrayed as an intrusion on the father's. And while the father's rights and righteousness are affirmed, his moral victory results in his own death and the ruin of everyone else. Thus, even the apparent resolution is flawed.

When Diderot saw the sketches in the Salon of 1765, he pronounced himself deeply moved. He described them at

2.4 Greuze, *The Son Punished* (*Le Fils Puni*), 1779. Paris, Louvre (photo: author).

35

length in his Salon review, interpreting the gestures of every figure (including the dog) and dwelling much on the 'insolence' of the ungrateful son and the reaction of his 'good father.' Greuze's sketches, he concluded, are masterpieces of simple and natural truth.[14] Diderot, if anyone, was in a position to know. A real-life disobedient son, he was at one point confined in a monastery on his father's orders (for wanting to marry a woman of his own choice). Having escaped, he struck out on his own and, like many in his generation, sought a life and a profession far removed from that of his cutler father. It is no wonder that he found Greuze's drama of filial rebellion so moving. The same conflict and even the same image appears in his own work. In one of his plays, *Père de famille* (1758), a rebellious son is cursed by his father; and in another, *Fils natural* (1757), the hero's father, having been captured by the enemy and stripped of his fortune, is thrown into prison. In yet another play, *The Sheriff of Kent* (unfinished), the main character is a noble old judge whom Diderot himself identified with his own father. The old judge is finally murdered in prison.[15] However fantastic the plots, the basic conflicts in these plays were rooted in lived experience that was by no means unique to Diderot. So, too, in Greuze's paintings, the real conflicts of life struggle to become visible even while they strain to keep within the bounds of traditional patriarchal morality.

According to progressive critics of the eighteenth century, the quality that made a work of art truly great was precisely its ability to stimulate such powerful and uncomfortable feelings. Works that excited but also resolved such feelings in terms of traditional moral beliefs were termed *sublime*. The term has a long history in literary criticism and would continue to evolve new meanings.[16] At this moment in France, it was associated with the experience of overwhelming, but deeply sublimated feelings, feelings that are not easily explained and that could be frightening but which are nevertheless resolved by the actions represented and turned into morally inspiring moments.[17] The experience of the sublime was thus like the catharsis of classical tragedy. Indeed, for eighteenth-century critics, a sublime work of art was an instant tragedy: it compressed into a single image the dramatic conflict and resolution of the classical stage. Sublime art was thus a kind of silent ritual experience in which dangerous and conflicting feelings were lived so that they may be purged— assimilated to some higher truth. According to the theorists, this experience, the noblest of which art is capable, results in

moral elevation and enlightenment—a strengthening of beliefs and a reaffirmation of higher, eternal values. In other words, art, when it fulfills its highest potential, is a process of sublimation producing in the viewer a greater internalization of ideological controls.

In their writings, critics testified to the presence of the sublime by verbally recreating their own experience before a work. The greatest critical successes were those works that barely managed to resolve the terrible desires they brought to life. In the 1760s and 1770s, Greuze was probably the most acclaimed master of the sublime. But the sublime required a precise balance between expression and repression, and not everyone could resolve the feelings his work touched off. When the sketches for the *Ungrateful Son* were first exhibited, one critic advised the artist not to complete them. 'They are too painful to look at,' he said. 'They poison the soul with a feeling so profound and so terrible that one is forced to look away.'[18] But most critics could not look long enough at either the sketches or the finished work. Like Diderot, they marvelled at the expressiveness of the figures, identified with each one in turn, declared their sympathy for the father and pronounced the work as sublime as that of any old master.

At least one critic, Carmontelle, understood very well that the power of *The Father's Curse* depended upon dark and sublimated feelings. The observation was prompted by one of Greuze's imitators, Aubry. In his painting, *A Repentant Son Returning to His Father's House* (Salon of 1779), the father, although blind and decrepit, is alive enough to embrace and forgive his son—who (as the official catalogue explains) at this moment feels his very entrails torn apart by a sharp pang of guilt for having caused his father's condition. This painting, wrote Carmontelle, is inferior to Greuze's. The subject of a son coming home to his father is not very interesting. A guilty son coming home immediately excites lively interest and curiosity. 'But should he arrive at the moment his father dies! a father who has cursed him! *There* is sublime pathos . . . !'[19]

Greuze's genre pictures treated patriarchal authority in the context of the family. History painting would develop the issue in the realm of politics. History painting was a creature of the royal government and very much an expression of the Royal Academy of Fine Arts. This privileged corporation was controlled and financed by the crown and openly conceived as a servant of monarchical interests.[20] From its be-

ginning under Louis XIV and Colbert, it promulgated an aesthetic code that classified painting according to a hierarchy of genres. In the highest genre were paintings illustrating religious history and subjects drawn from classical literature, with a heavy emphasis on political history. Seventeenth-century artists like Poussin and Le Brun had practiced this genre with great distinction. But in the eighteenth century, without royal direction, the academy drifted from its original function. The most renowned artists worked mainly for the very rich, financiers and urban aristocrats who cared only for flattering portraits and frivolous, usually erotic, mythologies—Rococo nymphs and goddesses. Rousseau and other critics pointed to this art as evidence of the decadence of the social order. The patronage of the ruling classes, they argued, made art a corrupt and corrupting thing and kept it from its true mission, moral education.[21]

Around the middle of the century the crown reasserted its direction of the academy. A new policy was introduced in the reign of Louis XV but was refined and enforced with much more vigor and financial support under Louis XVI. In essence, the new policy was intended to revive history painting and rededicate it to its higher educational purpose. Art would once again inspire virtue, above all, the feeling of patriotism. A series of new educational and professional measures were introduced, ensuring history painters the highest prices, the best prizes and the greatest material privileges. The prices of portraits, for example, the most lucrative genre in the open market, were artificially kept down, while those of history painting, a genre used almost exclusively by the crown, were raised. Art students were ordered to study the classics and made to copy the grand manner of the old masters. The academy not only defined history painting as the highest genre, but also propagated its theoretical rationale (through authorized critics), controlled its production (suggesting appropriate subjects and styles) and organized its presentation to the public (in the official academy Salons).[22] The government thus made itself the most prestigious patron of high art, although high-ranking government men and—eventually—knowledgeable connoisseurs also bought or commissioned history paintings individually.

Modern art historians have often regarded the new policy as simply a reflection of a new 'taste,' 'influenced' by ideas argued by the philosophes, or an expression of the king's

individual predilection for art with a moral message.[23] Certainly taste was changing and the king's Academy was adopting some of the philosophes' critique. But if the crown was responding to calls for the reform of art, it was doing so in the context of its own campaign to strengthen the image of royal authority and to establish a new and enlightened identity for the monarchy. The revival of history painting comes at the time when the French parlements, led by the parlement of Paris, were increasingly challenging the king's authority. The political struggle has been well documented by historians: successive attempts by the government to create a more efficient state, and especially to reform taxation and finances, threatened the privileges of the aristocracy and their allies among the commoners. The parlements—the ancient law courts—successfully blocked almost every attempt at reform, stirring up and giving a voice to that new force in eighteenth-century life, public opinion. In their propaganda, the parlementaires harped on the despotism of the king and represented themselves as the rightful guardians of 'the nation,' the true defenders of liberty and human rights. In short, the parlements defended entrenched privilege with radical ideas and revolutionary language (although they also claimed to be 'fathers' of the people and embodiments of patriarchal authority). In defending itself, the crown could hardly base its appeal solely on the belief in divine right, now so ridiculed and attacked. Thus the government, too, would claim the language of the Enlightenment. While its enemies labeled it despotic, the crown represented itself as an enlightened, humane and benevolent social force. Moreover, monarchy could also recall the old tradition of kingship in which the king appears as provider for his nation-family—a generous father who protects the many from the self-interest of the few.

These are the circumstances in which the revival of history painting must be understood. Indeed, history painting was an important expression of the crown's political defensive.[24] As it evolved in the previous century, this genre was an instrument ready made to meet the new ideological needs of the crown. It had the right tone and carried strong associations of the great seventeenth-century king. Its monumental, classical look and heroic figures, the legacy of Poussin and other masters of the grand tradition, and its capacity to magnify the significance of individual moral choice could translate the ideology of monarchy into vivid,

sublime experience. History painting could evoke the grandeur and authority of monarchy and also suggest the state as a supreme, rationally understood authority.[25]

Now, in the late eighteenth century, academy officials developed it further, tuning it more finely to the specific needs of the present. Eighteenth-century history painting speaks more of the state than of the church. Relatively few religious themes were commissioned, and subjects were drawn predominantly from Latin and Greek history and, occasionally, from French history. The heroes of these scenes are more explicitly preoccupied with civic virtue, its duties and obligations, and the terrible sacrifices the state demands.

From the perspective of the Revolution, the iconography of some of these paintings may seem to contradict the crown's campaign to identify itself as the rightful, supreme authority. Could not the sufferings of Belisarius, a virtuous and innocent victim of an unjust emperor, or the death of Socrates, a martyr to truth and reason (both subjects appeared in history painting before David treated them)—could not these subjects be taken as indictments of an absolutist, intolerant state? In fact, an expression of parlementary propaganda? And the patriotism of a Brutus sacrificing his sons to the Republic, the subject of David's great painting of 1789, did it suggest more than simply loyalty to the state? With the experience of the Revolution, the liberal ideas these themes could suggest would become fully apparent. In the Salons of the 1790s, paintings made for the crown or for high officials before the Revolution would be hung as emblems of Revolutionary ideas. Until that time, however, the liberal aspirations they incorporate would remain bound up with the monarchical ideal and express the crown's effort to promote a more progressive self-image. By encouraging pictures of Brutus or Socrates, the crown could communicate the image of a government whose authority rested not only on divine right, but also on secular ideas of justice and a rational system of values. It could also condemn and dissociate itself from tyranny. Socrates and Belisarius stood opposed to the unjust use of authority and for the principle of toleration. By celebrating them as heroic, exemplary citizens, the royal government could claim to be on the right side of virtue and also advertise the promise that in *this* state, patriotic duty and individual virtue were not in conflict.[26]

Yet, behind the analogies with ancient Rome and Greece stood the French king, calling for loyalty to the state as it

was then constituted. The monarch, however enlightened, was still in theory a kind of father, and the substance of patriotism remained filial piety. Thus official art was as crowded with images of noble patriarchs as the paintings of Greuze. But these old men are not merely fathers and certainly not the peasant and petty bourgeois patriarchs of Greuze's cluttered, Dutch-flavored households. They are fathers or fatherly figures who are also kings or noble Roman generals: Priam, Oedipus, Belisarius. Their will and virtues embody the higher justice and wisdom of the state. Nevertheless, their sufferings and sacrifices stir up the same ambivalence, the same conflicting desires as the fathers of Greuze. And they, too, bring these feelings to life in order to resolve them within a coherent set of values and beliefs. Like Greuze, official painters depended on the thrill of sublimated guilt in order to convert the abstractions of monarchical ideology into living, subjective experience.

Vincent was one of several artists who treated the subject of Belisarius—Marmontel's book had made it popular. According to a literary tradition, Belisarius, a general under the emperor Justinian, was unjustly banished and became a blind and wandering beggar. Vincent's painting (Fig. 2.5), exhibited in the Salon of 1777, reaches for the drama and immediacy of the baroque. Its surface is an array of color, light and contrasting textures—golden flashes of metal, rich red draperies, aged and youthful flesh. The scene is set outside the gates of Rome where Belisarius is begging alms. Like Greuze's narrative of the ungrateful son, Vincent's work struggles to organize within a moral framework conflicting feelings of guilt, fear and respect. Although he is blind, presumably helpless and dependent on his youthful guide, Vincent's Belisarius is far from pathetic. He is a powerful, scowling, threatening figure whose massive red-robed body dominates the space and those around him. He leans forward aggressively, almost accusingly, toward a soldier who is placing a coin in the tell-tale helmet. The soldier has just recognized Belisarius, and the moment is painfully uncomfortable. The younger man bites his lip and lowers his head in guilty silence. At the peak of his manhood and strength, he visibly cringes before the blind old victim. The same guilt casts its shadow on the faces of his companions. The confrontation fills the entire width of the canvas, and Vincent, allowing no distractions or resolution, pulls the viewer into its midst.

A number of critics noticed the work and, while they

recognized Vincent as a talented young history painter, they were also ill-at-ease before his painting. Wrote one:

> The story of the general . . . losing his sight and being reduced to begging for his life after a long prison term is so extraordinary, so moving, that I am surprised that it failed so completely to warm the spirit of the young artist.[27]

Others also expressed the opinion that Belisarius ought to be more noble, and his benefactor warmer and more sympathetic to him.[28] Evidently the moment Vincent chose left these observers with too much they could not resolve. Unable to identify comfortably with either of the major figures, they found the work wanting.

David treated the same confrontation in a painting of 1781 (Fig. 2.6). But David seems bent on distracting the viewer from its difficult aspects and stresses instead the pathos of the fallen patriarch. His Belisarius is emphatically and unequivocally weak, helpless and pathetic. The single soldier is kept at a distance, and David allows him little more than a broad stage gesture of surprise. In any case,

2.5 François-André Vincent, *Belisarius*. Salon of 1777. Montpellier, Musée Fabre (photo: Claude O'Sughrue).

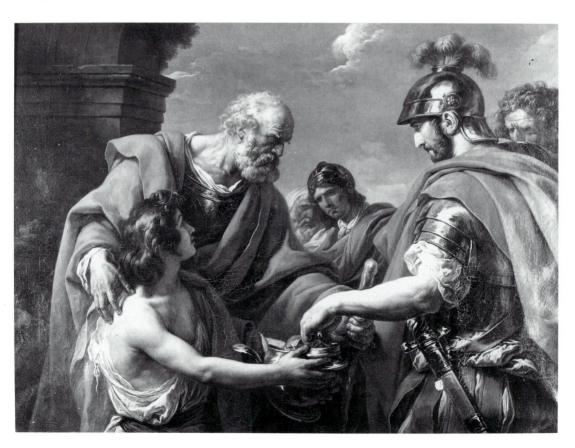

42

Belisarius, lost in his blindness, is oblivious to his presence. Moreover, the comforting figure of a Roman matron stands between the two men and mediates the confrontation. Wiping away a tear, she drops a coin into the general's helmet, repeating the act of the soldier in Vincent's work, but without his discomfort. Her woman's pity is untainted by filial guilt.

Jean F.-P. Peyron, another history painter, also exhibited a *Belisarius,* but another moment in the story (Fig. 2.7). Peyron both amends the sufferings of the old man and morally resolves the narrative. In his painting, the general has been rescued by a peasant who was once a soldier under his command—a son-like figure. In the peasant's house he is ceremonially enthroned as *père de famille.* Peyron's image compresses into one several moments of the ceremony. The strong, noble-looking peasant, at Belisarius' right, is introducing him to the family with a speech that Peyron had printed in one of the Salon *livrets*[29]: 'It is he who saved you from the ravages of the Huns; without him the roof over our heads would have been reduced to ashes . . . ' (whereupon the women, continues the *livret,* declare Belisarius 'the second father' of their children). Still feeble, blind and dependent,

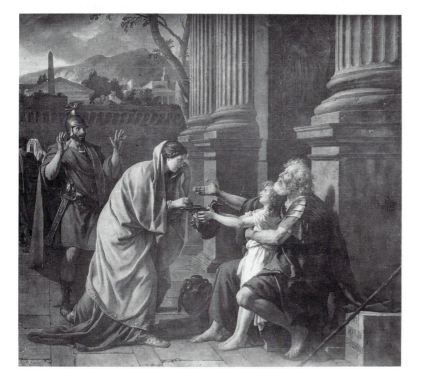

2.6 Jacques-Louis David, *Belisarius.* Salon of 1781. Lille, Musée des Beaux-arts (photo: museum).

43

he sits in the seat of patriarchal power, an image of the weak made strong and the strong made weak. The desire for resolution is present in the form of the work as much as in the subject. The many figures are carefully arranged to form a simple, frieze-like composition. Like the story's happy ending, the composition achieves an overall tranquility and order.

Although Peyron's resolution appears to affirm the old morality, some of its ingredients suggest new or emergent attitudes. The old man sits on the throne, but he has no real legal rights or obligations in this family. Indeed, the family, uniting behind its vigorous peasant leader, freely chooses to enthrone and protect him, clearly demonstrating that the apparent sovereign is without sovereign power. The narrative solution thus hints at the possibility of separating patriarchal power from the living body of the patriarch, even while the old ceremonial trappings of authority are preserved. Like some of Greuze's old fathers, Belisarius 'falls' as a figure of real power: he outlives his social role. But as a powerless old man he survives and is cared for in his old age. In *The Coming of Age,* Simone de Beauvoir argues that the late eighteenth

2.7 Jean-François-Pierre Peyron, *Belisarius.* Salon of 1779. Toulouse, Musée des Augustins (photo: Jean Dieuzaide).

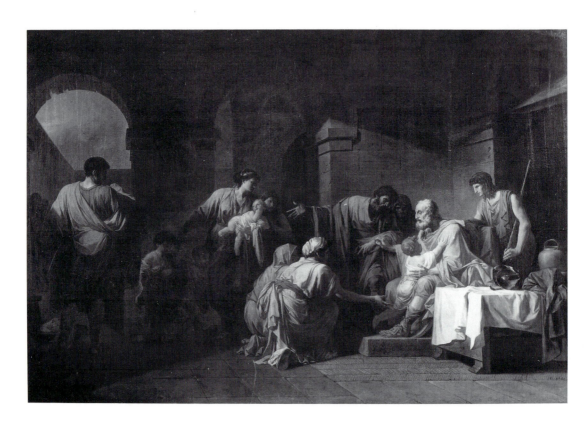

44

century developed a new tolerance and sympathy for old age itself.[30] Changing attitudes toward authority and old age indeed appear to intersect in works such as this. It may be that, with the erosion of patriarchal authority in the late eighteenth century, old men, less able to control their sons' lives, could appear as more sympathetic beings. Yet, whatever these new feelings, Peyron still insists on expressing them in traditional symbols. The old man, actually a retired patriarch, must still appear as *père de famille*.

I began by suggesting that French Salon painting can show us a certain kind of discourse about authority. The works I have discussed so far document latent feelings of aggression. I want to turn now to a painting in which this latent content begins to work its way to the surface. *The Deluge* by J.-B. Regnault (Fig. 2.8) was finished and put on exhibition in the

2.8 Jean-Baptiste Regnault, *The Deluge*. Salon of 1789. Paris, Louvre (photo: Les Musées Nationaux, Paris).

45

Salon just before the Revolution. Regnault has invented an unbearably conflicted situation. A young man is rescuing his father in a flood when he sees his exhausted wife and infant child in obvious peril. The horrified son must decide between saving his father or throwing him off in order to rescue his wife and child. To fulfill his duty as a son he must sacrifice his manhood as a husband and father. On another level, the choice is between the future and the past, which Regnault characterizes as a deadening weight. This old man is obviously decrepit. He gestures in uncontrolled panic, mindful only of his own safety and unaware of the painful choice his existence poses for his son. Regnault has stripped him of nobility, leaving only an object of burdensome, oppressive duty.

The image was no doubt inspired by Virgil's *Aeneid*. In Book II, Aeneas carries his father from a burning Troy. But in the *Aeneid* the past and the future are not in conflict. Aeneas, the future founder of Rome, not only rescues his father but also leads his small son to safety. There is never a question of sacrificing father for son or son for father. Aeneas' wife, who follows behind, will be lost. But, having produced Aeneas' son, she is (as her ghost declares) no longer needed. The same is not true of Anchises, the father, who represents the cultural patrimony. Indeed, Virgil's imagery makes clear that the future depends on the preservation of the past. Anchises, riding the shoulders of his son, his grandson at their side, carries ritual objects held sacred by Trojan patriarchs of the past. The continuity between the past and the future is assured by the continuity between male generations. If Regnault evokes Virgil's message, he appears to do so in order to throw its wisdom into doubt. In his treatment of the theme, the duty of the son is no longer self-evident, and the past now jeopardizes the future.

The figure of the father in Regnault's work comes as close as possible to the type of ridiculous old man familiar in farce and satire. This type of old man, the antithesis of the venerable father, flourished as a mockery of patriarchal power in the seventeenth and eighteenth centuries.[31] The old man in Le Prince's *Rendez-vous* (1774) is typical. Like scores of other old fools in eighteenth-century art, he is cuckolded by his wife and her young lover. Boilly treated the same theme in *The Jealous Old Man* (1791) (Fig. 2.9). The father in Regnault's *Deluge* is as doddering and as impotent as these old men and just as much an obstacle to the desires of youth. But in these comic pictures, the conflict

never comes to a crisis and direct confrontation is avoided. The young lovers who trespass on the old man's rights hide behind screens and bushes. Intrigue and deceit within the established order are their politics. In contrast, Regnault forces the viewer to imagine overthrowing the old man and provides the circumstances to justify such action. Thus on the eve of the Revolution, this ingenious and very popular picture raised an unusually high degree of conscious and carefully justified hostility toward the traditional demands of patriarchal authority.

The differences in content between this and the farcical pictures becomes even more meaningful in relation to the different social purpose each type of work served and its intended context. A 'cabinet' picture like Boilly's belonged to a marginal realm of culture. Like a joke told in private, the rebellious impulse it touched off could be safely discharged and enjoyed as an inconsequential moment. Even when seen in the Salons, such paintings and prints were hung in peripheral sections and treated as commodities to be sold and used in private.

Regnault's work, on the other hand, claimed a different quality of attention. Its serious tone and literary allusions—it can suggest not only the *Aeneid* but also the Biblical flood—give it the status of a history painting, officially validated as

2.9 Boilly, *The Jealous Old Man* (*Le Vieillard jaloux*), 1791. Saint-Omer, Musée de Beaux-arts (photo: Giraudon/Art Resource).

47

the highest genre. According to the Count D'Angiviller, who directed the academy under Louis XVI, history painting was 'the voice of the sovereign' and a means of shaping public opinion. It was under D'Angiviller that the academy encouraged its production more vigorously than ever and also took more control over its exhibition. The official Salon became the only place in which new history paintings could be publicly exhibited. Erotic, 'indecent' art was prohibited there, and other, non-official exhibitions were suppressed or denied the right to show history painting.[32] At the same time, the exhibition room, the Salon Carré, was made a more dignified space. A serious new staircase was built next to it in 1780 and, just before the Revolution, the room was given top-lighting.[33] Obviously, the crown did not finance history painting merely to provide aesthetic entertainment to art lovers. Nor was the Salon to be merely a showcase for artists' wares, although it was that, too. The Salon was an official ceremonial space whose main ideological purpose was to validate certain values and beliefs as collective ideals. History painting made the central meaning of the Salon most visible and was therefore its most charged ideological focal point. Conversely, in the context of the Salon, history painting found its fullest ideological use.

It is in this context that we should consider Regnault's *Deluge* and its implicit hostility toward patriarchal rights. Certainly, one could be more critical of the old order. Political and philosophical tracts had long criticized French society more sharply and pointedly than this painting, and the libellous pamphlets studied by Robert Darnton attacked authority more directly and with more violent hostility.[34] By comparison, the critical content of the *Deluge* is mild. But it is one thing to read of such matters in private and quite another to encounter them, even partially expressed, in a public space officially consecrated to the celebration of collective ideals. Thus, despite official intentions, the ceremony of the Salon and its displays of history painting could help shape a new consciousness and new attitudes toward authority. Through paintings such as this, dangerous feelings, traditionally suppressed, could gradually know themselves and begin to claim the legitimacy of commonly shared knowledge. That such content should appear in the inhibiting space of the Salon and in the dignified language of history painting signals an extreme build-up of tension and frustration with the old order.

Nevertheless, for all its hostility, Regnault's image does

not look beyond the traditional family. The parricide that Regnault comes near to proposing, is justified by an emergency, not rationalized ideologically. As in Greuze's narrative of filial rebellion, authority continues to be localized in the paternal body. The son may replace the father, but the old family model will be left intact. Regnault knows what he does not want, but cannot yet see beyond that.[35]

The task at hand was to imagine in concrete terms a new set of social relations. For the men of the Revolution, there was no doubt that the task was accomplished by one artist: Jacques-Louis David. By 1789, David was the acknowledged leader of French painting and the dominant figure in its most difficult genre. David's great history paintings of the 1780s— *The Oath of the Horatii* (Fig. 2.10), *The Death of Socrates* and the *Brutus* (Fig. 2.11)—are more typical of history painting as it was taught in the academy than Regnault's *Deluge*. David's works illustrate not the fictions of poetry but the historical deeds of Greeks and Romans. Salon critics, both the authorized and the

2.10 David, *The Oath of the Horatii*. Salon of 1785. Paris, Louvre (photo: Les Musées Nationaux, Paris).

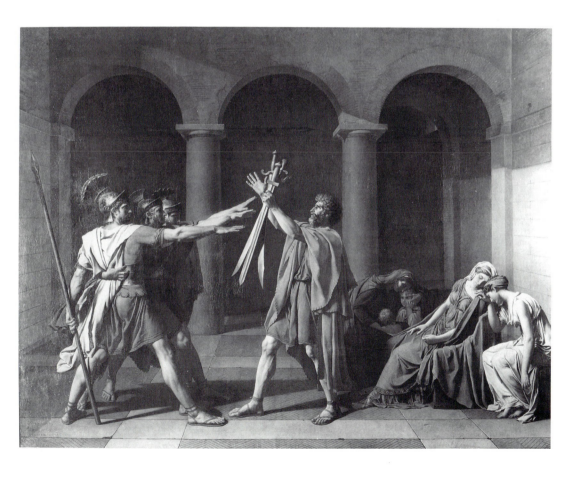

unauthorized, repeatedly praised these paintings as perfect fulfillments of the genre's demands. Yet, in the light of the Revolution, it became apparent that these monumental works celebrated not simply the noble virtue of patriotism but the ideals of the Revolution—the inherent right of individuals to shape freely their own destinies. Working within the rules of the academy and its artistic code, David had seized upon and developed liberal implications in the crown's position, appropriating one of the crown's favorite ideological vehicles for the Revolution—or so it would appear later, when the Revolution arrived to claim the appropriation. *Then* it was clear that, through the 1780s, he had been rehearsing his public—and himself—in a new set of emotions and ideas.[36] It is with David that the contradiction between the Republican ideal of patriotism and the monarchical ideal of patriarchal authority works its way into visibility. But it was only when that Republican ideal triumphed historically that men saw unequivocally David's art as prophecy.

2.11 David, *The Lictors Returning the Bodies of His Sons to Brutus*. Salon of 1789. Paris, Louvre (photo: Les Musées Nationaux, Paris).

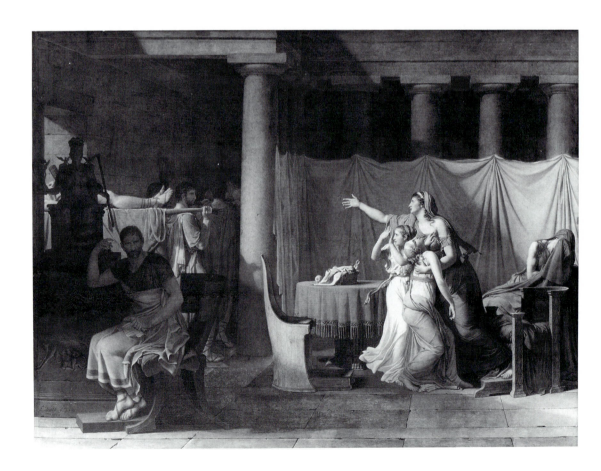

The most monumental of David's pre-Revolutionary works are the *Oath of the Horatii,* finished in 1784, and the *Brutus,* finished in 1789 at the outbreak of the Revolution. In the *Oath,* the sons of the Horace family swear allegiance to their father, promising to defend the family compound against an imminent attack. In the *Brutus,* the founder of the Roman Republic has ordered the death of his sons for having conspired with the deposed Tarquinius (an off-stage fallen father). It is the moment when the bodies are brought back to Brutus' house.

In both of these works, authority is no longer simply the will of the father. And these fathers, far from being weak or old, are vigorous men of action still in their prime. They are all bone and muscle, and they move in a world of sharply rendered, ungiving surfaces, a world of fixed definitions and universal truths. The *Oath* especially breathes liberal optimism and faith in the efficacy of individual action. David imagines an ideal social space. In its cool, clear light men meet and act together as individual citizens. The sons do not merely swear loyalty to a father. They assert their wills as free individuals, enter into a political contract and choose their obligations. Here, as in the *Brutus,* this new public realm is exclusively male. It is defined in sharp opposition to the domestic realm to which the women are confined. The division is clearly articulated by the spatial composition of each work. In the female realm, the old relations of domination and subjugation still prevail. The new principle of authority demands the exercise of reason, a faculty David's women lack. Bound only by blood ties, the women cannot know the higher moral life of their male kin.

The *Brutus,* conceived in 1788,[37] states the new political relations more explicitly than the *Oath.* It also states the terrible cost of bringing those relations to light and is therefore darker, its two sides more disjointed. Brutus has caught his sons in treason against the Roman Republic. The conflict is not so much between father and sons as between the traditional demands of the family and the new demands of the state. Brutus, both father of the traitors and founder of the Republic, is torn between his old patriarchal duty to protect his sons and his new Republican duty to the state. The sons are sacrificed to the higher authority. With this act, authority is definitively separated from the patriarchal body, rationalized as an abstract principle and identified as the state.

David shows Brutus after the moment of decision, but still

visibly tormented by his ordeal. He sits tensely, still clutching the damning evidence, isolated from and in opposition to the grieving women. The shadow in which he sits is cast by a cult statue of Rome—the Rome in whose name the sons were sacrificed. Brutus leans nearer to it as the decapitated bodies of his sons, the terrible result of his decision, are brought home to him.

The *Brutus* was finished even as the Revolution began. It became, almost immediately, a symbol of that Revolution. David himself became a deputy to the Convention and would eventually become a regicide. Meanwhile, the Convention moved to abolish the old laws governing social and political life. These laws would be remade more than once but, in all of their variations, the power of fathers and—in theory—of rulers was legally limited and made subject to the higher authority of the state.[38] A new set of relations, those between the individual and the state, definitively replaced the old relations of dependency and obligation, even though, at the moment, not everyone could claim membership in the new relations. David foretold the outcome. More than anyone else, he made visible the ideals of those who, like himself, would lead the Revolution.

In principle, the new state was an abstract and genderless entity that brought patriarchy to an end. In practice, the new state ended *absolute* patriarchy in order to replace it with a more democratized, less acknowledged form. The king was overthrown and his realm dissolved, but the king's authority would live on. Now separated from the patriarchal body, it was shared out among the minority of privileged males who would collectively man and control the new offices of the state. As Blake understood, in the modern world, authority could rule more effectively from within—lodged in the psyches of the old man's sons. It is relevant to note that the psychic task Freud called the Oedipus complex became a significant and universal experience only at this historical moment.[39] The Oedipus complex becomes *socially* necessary to the reproduction of the bourgeois world precisely because it is the process whereby the old man's authority—and hence the state—is internalized.

Around 1800, the image of the embattled and victimized old man faded from the center of high art. Appropriately so, since the social pressures and conflicts that had first called him into being were now essentially resolved. The old man was finally free to retire from active life in art as in reality.

1. Paul Orliac and J. de Malafosse, *Histoire du droit privé, III: Le Droit familial* (Paris, 1968), 35 and 80.

2. James R. Rubin, 'Oedipus, Antigone and Exiles in Post-Revolutionary French Painting,' *Art Quarterly* (Autumn 1973), 141–71.

3. For example, Forty's *Jacob Recognizing the Bloody Robes of His Son Joseph* (1791) suggests such an interpretation as does Garnier's *Daedalus and Icarus on the Walls of the Cretan Labyrinth* (1795) (the father is warning the son not to fly too high). More explicit are: Lajeune's *A Father Arming His Son to Defend La Patrie, Liberté, Egalité* (1793); Caroffe's *Agis Re-establishing in Sparta the Laws of Lycurgus* (1793) (he is burning the acts that destroyed equality while an old soldier, carried by his children, thanks the gods for the regeneration of his country). Most vehement is A.E. Fragonard's *The First Athenian Parricide* (1796), in which a parricide is condemned to die of starvation in a cell that also contains the corpse of his father. A guard is posted to keep him from sleeping.

4. Orliac and Malafosse, *Le Droit familial,* 30–5 and 72–80; Michael Walzer, *Regicide and Revolution* (London and New York, 1974), 8f; and Fred Weinstein and Gerald M. Platt, *The Wish to Be Free* (Berkeley, Los Angeles and London, 1969), 1–136.

5. Ibid., 33f; Erich Fromm, 'The Theory of Mother Right and Its Relevance for Social Psychology' (1934), in *The Crisis of Psychoanalysis* (Greenwich, Conn., 1970), 124–30.

6. Robert Darnton, 'The High Enlightenment and the Low-Life of Literature in Prerevolutionary France,' *Past and Present,* no. 51 (May 1971), 81–115; and 'Reading, Writing and Publishing in Eighteenth-Century France: A Case Study in the Sociology of Literature,' *Daedalus,* C, no. 1 (Winter 1971), 214–56; John R. Gillis, *Youth and History: Tradition and Change in European Age Relations, 1770–Present* (New York and London, 1974), 1–21 and 83–4; Colin Lucas, 'Nobles, Bourgeois and the Origins of the French Revolution,' *Past and Present,* no. 60 (August 1973), 84–126; Mary K. Matossian and William D. Schafer, 'Family, Fertility and Political Violence, 1700–1900,' *Journal of Social History,* XI, no. 2 (Winter 1977), 137–78; Michel Vovelle, 'Le Tournant des mentalités en France, 1750–1789: la sensibilité pré-révolutionaire,' *Social History,* no. 5 (May 1977), 605–29; and Weinstein and Platt, *The Wish to Be Free,* 1–136.

7. Ibid., 51f; and Elizabeth Fox-Genovese, *The Origins of Physiocracy, Economic Revolution and Social Order in Eighteenth-Century France* (Ithaca and London, 1976); and John Renwick, *Marmontel, Voltaire and the Bélisaire Affair,* vol. CXXI of *Studies on Voltaire and the Eighteenth Century,* ed. Theodore Besterman (Banbury, Oxfordshire, 1974), 61–81.

8. David V. Erdman, *Blake: Prophet Against Empire* (Princeton, NJ, 1954), *passim;* and J. Bronowski, *William Blake, 1757–1827: A Man Without a Mask* (Baltimore, Md., 1954), *passim.*

9. Edwin G. Burrows and Michael Wallace, 'The American Revolution: The Ideology and Psychology of National Liberation,' *Perspectives in American History,* 6 (1972), 167–89.

10. Orliac and Malafosse, *Le Droit familial,* 72–8.

11. Carol Duncan, 'Happy Mothers and Other New Ideas in Eighteenth-Century Art,' *Art Bulletin,* LX (Dec. 1973), reprinted in this volume.

12. Ibid.

13. Many of Greuze's fathers are bedridden, dead, or near death, e.g., *Le Paralytique, La Dame Bienfaisante,* and the two sketches: *La Mort d'un père regretté par ses enfants* and *La Mort d'un père abandonné de ses enfants.*

14. Diderot, *Salons,* ed. Jean Seznec and Jean Adhémar (Oxford, 1957), II, 156–60.

15. Arthur M. Wilson, *Diderot* (New York, 1972), *passim.* See also Edgar Munhall, *Jean-Baptiste Greuze, 1725–1805* (exhibition catalogue) (Hartford, Conn.: Wadsworth Atheneum), 170 and 178, for the theme of the father's curse in literature; and Anita Brookner, *Greuze, The Rise and Fall of an Eighteenth-Century Phenomenon* (Greenwich, Conn., 1972), 32–3.

16. Samuel Monk, *The Sublime* (1935) (Ann Arbor, 1960).

17. For examples of the use of the term and the expectation to be stirred and disturbed, see De la Font de Saint Yenne, *Reflexions sur quelques causes de l'état présent de la peinture en France* (Paris, 1747) [Deloynes Coll., BN, Paris, II, 46–7]; Abbé Le Blanc, *Lettre sur l'exposition des ouvrages de peinture, sculpture, etc., de l'année 1747* [Deloynes Coll., II, 482]; 'Exposition des peintures, sculptures et gravures en 1775,' *Mercure de France* [Deloynes Coll., X, 165]; *Nouvelle critique impartiale des tableaux de salon, par un société d'artistes.* no. 1 (Paris, 1791) [Deloynes Coll., XVII, 469].

18. Mathon de la Cour, *Lettres à Monsieur ***sur les peintures, les sculptures et les graveurs exposés au Salon de Louvre en 1765* (Paris 1765) [Deloyne Coll., VIII, 487]. See Diderot, *Salons,* IV, 41 and Brookner, *Greuze,* 66–7, for other critical reactions to Greuze's images of dead fathers.

19. *Coupe de patte sur le Salon de 1779, Dialogue* [Deloyne Coll., XI, 141–2].

20. Jean Locquin, *La Peinture d'histoire en France de 1747 à 1785* (Paris, 1912); and Orest Ranum, *Paris in the Age of Absolutism: An Essay* (New York, London, Toronto, 1968), 193–4.

21. James A. Leith, *The Idea of Art as Propaganda in France, 1750–1799* (Toronto, 1965).

22. Loquin, *La Peinture d'histoire, passim.*

23. Carol Duncan, 'Neutralizing the Age of Revolution,' *Artforum* (Dec. 1975), 46–54, reprinted in this volume.

24. Alfred Cobban, *A History of Modern France, I: 1715–1799* (Baltimore, Md., 1963), 90–9 and 111–12; Diderot, *Salons,* II, 9; Jean Egret, *The French Prerevolution,* trans. Wesley D. Camp (Chicago, 1977); and Norman Hampson, *The First European Revolution, 1776–1815* (New York, 1969), 65–72.

25. Loquin, *La Peinture d'histoire,* 54–5; and Ranum, *Paris in the Age of Absolutism,* 132–65, 193–4, 262–7 and 288.

26. The Belisarius of late eighteenth-century French painting comes from a book by Marmontel (1767) in which Belisarius is portrayed as an ideal patriot who argues for enlightened monarchy and tax reform. After the Sorbonne's unsuccessful attempt to suppress it (for religious reasons), Marmontel emerged as a favorite of the crown and his book

a symbol of royal liberalism. See John Renwick, *Marmontel,* and Jeanne R. Monty, 'The Myth of Belisarius in Eighteenth-Century France,' *Romance Notes,* IV, no. 2 (Spring 1963), 127–31. An excellent article by Albert Boime on the theme of Belisarius appeared just as this article was completed. My own work completely supports Boime's portrayal of the crown's effort to promote an enlightened self-image and its use to that end of the Belisarius theme ('Marmontel's *Bélisaire* and the Pre-Revolutionary progressivism of David,' *Art History,* III, no. 1 [March 1980], 81–101).

27. *L'Année littéraire* [Deloyne Coll., XLIX, 795–6].

28. 'La Prêtresse, ou nouvelle manière de prédire qui est arrivé' (1777) [Deloyne Coll., X, 970], and *French Painting 1774–1830: The Age of Revolution* (exhibition catalogue: The Detroit Institute of Arts and The Metropolitan Museum of Art, 1975), 670–2.

29. *Explication des ouvrages . . . Salon de 1796,* no. 370 [Deloynes Coll., XVIII].

30. Simone de Beauvoir, *The Coming of Age,* trans. Patrick O'Brian (New York, 1972), 272.

31. Philippe Ariès, *Centuries of Childhood* (New York, 1962), 30–1.

32. Locquin, *La Peinture d'histoire,* 60–3; and Diderot, *Salons,* I, 1–8.

33. Christiane Aulanier, *Histoire du Palais et du Musée du Louvre, Vol. II: Le Salon Carré* (Paris, n.d.), 35–8.

34. Robert Darnton, 'The High Enlightenment,' op. cit.

35. In 1800, the painter Girodet treated the same theme with even greater pessimism in a monumental work that hangs in the Louvre. In this painting, the son also carries his father on his back, but at the same time strains to pull his wife to safety atop a steep precipice whose only tree he grasps with his other hand. His two sons, in turn, cling to their mother's body. The old father, depicted as a bony, limp burden, thinks only of the little sack of gold he clutches. But all are doomed: the tree on which the whole group depends is withered and already breaking. In a moment, they will all plunge to their death. The horror of the situation is that there are no longer any choices.

36. The best studies of this question of the conscious political content in David's pre-Revolutionary history paintings are Tomas Crow, '*The Oath of the Horatii* in 1785: Painting and Pre-Revolutionary Radicalism in France,' *Art History,* I (Dec. 1978), 424–71; and Robert Herbert, *David, Voltaire, Brutus and the French Revolution: An Essay in Art and Politics* (New York, 1973). Crow, arguing from a close reading of David's style and the critical responses to it, concludes that David's work expressed and successfully communicated a radical pre-Revolutionary sensibility. Herbert, arguing from the iconography and looking for an articulated ideology, concludes that the paintings are only 'potentially' political.

37. The choice of Brutus as a subject in this historical moment is significant. David had been commissioned to treat another subject but on his own switched to the theme of Brutus (see Herbert, ibid.).

38. Louis Delzons, *La Famille française et son évolution* (Paris, 1913), 15–25; Orliac and Malafosse, *Le Droit familial,* 35 and 40. Mona Ozouf, in 'Symboles et fonction des âges dans les fêtes de l'époque révolutionnaire,' *Annales historiques de la Révolution française,* XLII, no. 202

(Dec. 1970), 569–93, discusses the way in which festivals for youth and old age during the Revolution stressed the supremacy of the civic realm over all age groups. See also Walzer, *Regicide and Revolution,* 35–89.

39. Weinstein and Platt, *The Wish to Be Free,* 198–9.

INGRES'S *VOW OF LOUIS XIII* AND THE POLITICS OF THE RESTORATION

In November, 1826, Ingres's *Vow of Louis XIII* (Fig. 3.1) was installed in the Cathedral of Montauban with great pomp.[1] The event, more a political than a religious affair, was in keeping with the spirit and meaning of the new altarpiece. The elaborate installation ceremonies not only recalled but in many ways recreated the coronation of Charles X at Rheims Cathedral in 1824. The crowning of Charles, the last Bourbon king, was controversial. In the judgment of many of his contemporaries and of most modern historians, this coronation was a farcical attempt to revive the trappings of a pre-Revolutionary France, a France irretrievably lost to the vicissitudes of history. Then, two years later, the king's men staged a reenactment of that event. The *Mass* that Cherubini composed for the ceremony at Rheims was once again performed and Ingres's image of Louis XIII was substituted for the anachronistic figure of his descendant.

The modern literature on the *Vow of Louis XIII* has focused almost exclusively on whether Ingres solved the artistic problems the work posed—how he treated the double subject of the King and the Virgin, how he utilized the art of Raphael, and so forth.[2] And, although modern scholars are aware that the painting pleased official government circles and gave ideological support to the Bourbon dynasty, the painting has nevertheless been discussed as if it were purely a product of Ingres's artistic judgment. The modern reader is left to conclude that men and women of the 1820s experienced it with only such artistic and stylistic questions in mind.

The *Vow of Louis XIII,* however, attests to far more than Ingres's imaginative activity. Indeed, to understand fully even

This essay was first published in *Art and Architecture in the Service of Politics,* ed. Linda Nochlin and Henry Millon (Cambridge, Mass., 1978), 80–91. It is reprinted here by permission of MIT Press.

the artistic problems Ingres resolved, it is necessary to consider the work within the broader political and ideological context of the times. In imagery flattering to the Bourbon house, the *Vow of Louis XIII* affirmed a definite ideology and reinforced one of the most contested doctrines of the Right: the alliance between the throne and the altar. Generated in a particularly reactionary moment of a generally reactionary period, the *Vow of Louis XIII* was both a specific response to events of 1820 and a reflection of an outlook that thrived during the Restoration as a whole.

In 1814, after the fall of Napoleon, the Bourbon house returned to a France exhausted by war.[3] Long years of absence combined with the presence of a new generation had both mellowed and dimmed the memory of the Bourbons in the minds of the French. Their return was the work of Talleyrand and the Allies, who were anxious for a peaceful and unified France. To them, the Bourbons were the only house with luster enough to fill the vacuum left by Napoleon, the only name with sufficient past glory to rally French national pride and identity. The Bourbons were recalled not because the French people wanted to reject the past twenty-five years and return to pre-Revolutionary days, but because no one could think of anyone better to unify the nation.

Of the returning emigrés, few besides Louis XVIII seemed to understand the conditions of their return. Even before he reached Paris, he issued a charter calculated to appease the fears and to win the cooperation of those who had served France during the past quarter century. After a conciliatory preamble, it granted basic civil liberties, established a representative government with two houses, promised taxation with consent, and guaranteed existing property rights and new titles. Louis XVIII understood the necessity of compromise.

Surrounding Louis, however, was a crowd of emigrés who regarded constitutional government with horror and fear. Led by the King's younger brother, the arrogant Comte d'Artois—the future Charles X—they were known as the Ultra-Royalist or Clerical Party. These old aristocrats and high church officials had never wavered in their loyalty to the Bourbons, and now they were rewarded with key government posts. The Charter—a document venerated by Liberals—infuriated them, and throughout the Restoration, they dedicated themselves to preventing the fulfillment of its promises. More Royalist than the king, they were aptly de-

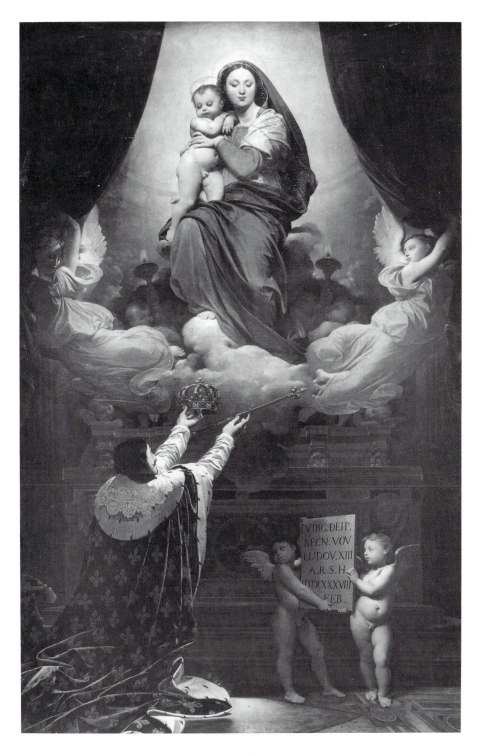

3.1 Jean-Auguste-Dominique Ingres, *The Vow of Louis XIII*, 1824. Cathedral of Montauban (photo: Les Musées Nationaux, Paris).

scribed by their contemporaries as having forgotten nothing and learnt nothing during their years of exile. In their eyes, the Restoration was a mandate to return France to the way it had been in 1789. They were especially determined to see all confiscated properties returned to the church and the aristocracy, the revival of all privileges abolished since 1789, and the return of education to the hands of the church. Although denied their full will by Louis XVIII's more realistic policies (between 1816 and 1820, the Ultras were the opposition party), they were an active and influential force, enjoying special relationships to the king. At bottom, Louis XVIII and his supporters shared many of their views, and their Ultra prejudices often set the tone of the official Restoration.

To the Ultras, the past twenty-five years were a scorge, a punishment sent by God to an aristocracy that had allowed itself to be led astray by the teachings of Voltaire, Rousseau, Diderot, and the like. In the view of Ultras, the poisonous ideals of the Enlightenment philosophers had eroded and undermined the institutions and beliefs without which no ordered society could exist: the authority of the church and the doctrine of the divine right of kings. To them, the Revolution was the design of Providence—like the Biblical flood, it swept away the evil excesses of the eighteenth century so that France might begin anew. They even believed that they had been called back by a repentant people to reestablish absolute monarchy. The task now was to put France back on her pre-Revolutionary course, avenge the crimes of the past, and purge the nation of all Revolutionary elements.

The Right—the King's Party—while not sharing the wilder fantasies of its Ultra faction, was nevertheless bent on significantly undoing many of the changes brought about in the previous twenty-five years. Above all, it was determined to secure the sovereignty of the throne, and, like its Ultra faction, it was convinced that religion was monarchy's best ally. The Revolution had proven that when the authority of the church crumbled, all other institutions would topple with it. Therefore, as Bonald, De Maistre, and other theorists of the Right argued, the authority of the church must be strengthened. The Right urged the restoration of the church to its ancient position and power not because Catholicism was the true faith, but because Catholicism provided the most effective ideological sanction for monarchy. Religion, as Georges Brandes wrote, "was employed as the police, the army, the prisons were employed, to keep everything quiet

and support the principle of authority."[4] Or, to quote Chateaubriand, "To *the most Christian King* religion was no more than a medicinal liquor, well adapted to form one of the ingredients of the brew called monarchy."[5]

The alliance between the throne and the altar, then, was a cornerstone of Bourbon policy. Insensitive to the widespread anticlericism of the populace, especially where it concerned the education of their children, a zealous church, under the protection of the government, set out to reeducate Frenchmen in matters of religion. None of the hundreds of outrages perpetrated by the Revolution—the desecration and confiscation of church property, the destruction of relics, the suppression of orders, the massacres of priests who refused to accept the authority of the state over that of Rome, the blasphemous attempts to replace Christianity with the worship of secular ideals—none of these crimes had been forgotten, and the church was determined to impress the people with the sinfulness of their recent ways.

Missions—bands of fanatical priests—swept into every district, holding revival meetings and preaching loyalty to the throne. Their visit to a town usually culminated in a large, outdoor assembly, attended by the mayor and other officials. There, around a great bonfire, public penance would be made for the crimes of the Revolution, and copies of Voltaire and the *Encyclopedia* were thrown into the flames. The church also turned to more conventional methods to reeducate the people. State-supported convents and government-financed seminaries were established. Officially, the latter were meant for prospective priests only, but they also served—illegally—as an alternative to the secular educational system established after the Revolution; parents wishing to stay on the good side of local officials and hoping for the future advancement of their sons' careers found it expedient to send them there. The Jesuits, although still outlawed in France (they had been expelled in 1757), were secretly encouraged to teach in schools and even opened schools of their own—without, however, acknowledging their identity. The government also commissioned scores of religious monuments and church decorations. In return for all of this, the clergy were relentless and fervent campaigners for the Right, preaching its doctrines from every pulpit in the land. These activities, often exaggerated by rumor and the Liberal press, aroused real anxiety in the middle classes, which feared a return to the *Ancien Régime* and the loss of their newly acquired property and privileges.

A rigid and reactionary Catholicism became the official ideology of the Restoration. An ambiguity in the Charter justified this, for while guaranteeing religious freedom, it also declared Catholicism the religion of the state. Throughout the Restoration, loyalty to the government was expressed as support for the church, and at all levels of society, individuals found it useful to visibly support the church. Indeed, such activities were secretly noted and often recorded by members of the clergy, lay religious societies, government men and the police—Stendhal's *The Red and the Black* hardly exaggerates the conspiratorial climate of the times. Prefects and the police kept copious files on individuals (among other things, they were useful in rigging the lists of voters at election time), noting what cafés they frequented, who their friends were, and what newspapers they read.[6] In the drawing rooms of the illustrious, those unofficial centers of power where men advanced their political and artistic careers, one took care to hold the "Right opinions." Here it was mandatory to express horror at the Revolution, Napoleon and all Liberal ideas and to show ardent support for religious education, the king's legislation, Sunday laws, the poetry of Lamartine and De Maistre's *Du Pape,* an ultramontaine tract beloved by the Right. Above all, one's relationship to the church was regarded as the key to one's political sympathies. As Stendhal wrote, religion was "a powerful corporation with which it is most advantageous to be affiliated."[7]

What one said about the past was as politically charged as one's attitude toward religion. As the historian Stanley Mellon has shown, political controversy in the Restoration frequently raged around conflicting claims regarding the history of France—both ancient and recent.[8] The Right wanted the past twenty-five years striken from the official record of French history, seeing in them only a period of regicide and national crime. They adamantly refused to acknowledge in the acts of the Revolution or the Empire any precedents for the present. Conservative historians contrasted those years to idealized accounts of Old France, and with many artists and writers, portrayed bygone monarchies as golden ages, the old aristocracy as inherently noble, and past kings as wise and good. For Liberals, on the other hand, as for most middle-class Frenchmen whose lives, feelings, and fortunes had been shaped by them, the past twenty-five years were a source of deep pride, a dazzling era of military glory and enlightened social progress. Unable to attack the monarchy directly—such attacks would constitute treason—Liberal

historians such as Thierry and Guizot exposed the corruptions of past monarchies and the class conflicts of pre-Revolutionary France, representing the Revolution as an inevitable outcome of earlier French history. During the Restoration, history was the most popular, the most controversial, and the most ideologically charged literary pursuit. In this context, every image and utterance of and about the national past could be ammunition in an ideological battle.

The literary men of the Restoration gave poetic substance to Rightist views of the past. Chateaubriand, De Maistre, Lamartine, and Hugo expounded the beauty and wisdom of societies founded on the authority of the church and governed by divinely appointed monarchs. In their poems and novels, the past is envisioned as a socially harmonious world in which rulers and the ruled accept without question the given political and religious order. Their writings, along with the "troubadour" subjects fashionable in Romantic art, evoke shimmering images of medieval life in which Christianity invests even simple relationships and everyday experience with grandeur and significance. Yet these post-Enlightenment intellectuals, while disaffected with the Enlightenment ideals of their fathers, were nevertheless heirs of the Age of Reason. The innocent, unquestioned faith for which they envied the past—that faith that assured men of the purposefulness of existence—eluded them. Their writings express more the desire to believe in some absolute authority than authentic faith in Christianity.[9] Chateaubriand, whose *Génie du Christianisme* was the inspiration of this generation and whose rhapsodic eulogies of the church and the king made him the most effective propagandist for the Restoration, made no pretense to faith in his memoirs: "A Republican, I serve the Monarchy; a philosopher, I honour religion. These are not contradictions: they are forced consequences of the uncertainty of theory and the certainty of practice among men."[10]

In the place of faith, Restoration literature substituted self-conscious sentimentality and a reverence for the symbols and trappings of tradition. The dogmas, rituals, and artifacts of the church and the throne were researched, revived, and made the objects of enthusiastic aesthetic transport. "The kind of piety was coming into vogue which consisted in looking at religion pathetically, gazing at it from the outside, as one looks at an object in a museum, and saying: How poetic! how touching! how beautiful!"[11]

Ingres's *Vow of Louis XIII* faithfully reflects the religious sentimentality of the Restoration and the counterfeit piety of official state religion. The insistent presence of past art,[12] the airlessness of the spaces, the sharp-edged and atrophied Raphaelesque forms—these and the strict hierarchical relationship between King and Virgin suggest the rigid dogmas and calculated faith of official Catholicism. At the same time, the lurid colors, the rouged mouths and the too-explicit textures make exaggerated appeal to the emotions and the senses.[13] Ingres speaks of the beyond, but unconvincingly, and only on the authority of past art. He is distanced from the transcendental reality he portrays: between it and himself he has placed both older art and a mass of concrete, meticulously observed objects. The king's act of faith goes almost unnoticed in the assemblage of researched visual facts. Yet the visual facts suggest contradictory realities. The illusionism is unstable: the king's vision, rendered in a broader style than the foreground, flattens out into a pastiche of Raphael, an art object before which Louis XIII absurdly kneels; or, more disturbingly, it threatens to materialize as a concrete, voluptuous woman, who, with her cupidlike son, is displayed before him. The flaming torches and the sultry climate suggested by the blushing light emanating from the holy realm contradict the spiritual effect they were meant to enhance.

Beyond its affirmation of the general tone and spirit of the official Restoration, Ingres's *Vow of Louis XIII* fulfilled more specific political and ideological functions. As a state-financed commission destined for the Cathedral of Montauban, it benefited a particular group of politicians. The officials who commissioned it were the Mayor of Montauban, the local prefect, deputies from Tarne-et-Garonne (one of whom was a former mayor of Montauban), and the Baron Portal, one of Louis XVIII's ministers. During the Restoration, politicians frequently commissioned religious art for local churches as a means of influencing their conservative constituencies or reassuring church and higher state officials of their ideological colors.[14] The combination of officials involved in the commission of Ingres's *Vow of Louis XIII* can leave little doubt that the work was meant to serve such purposes. They not only represent the alliance between the church and the government, they also exemplify the chains of authority that linked local town halls to the king's cabinet.

The commission stipulated that the subject had to be approved by the prefect, but was to be chosen by the mayor

in consultation with the Bishop of Montauban.[15] The subject
they agreed upon clearly reveals their political intent, and
although altered by Ingres, the finished work was well suited
to affirm their allegiance to the Bourbon house and its pol-
icies. The subject—the vow of Louis XIII—is not a traditional
Christian subject, nor is it even a very religious one.[16] De-
signed to glorify the Bourbons and to sanctify the present
throne and altar alliance, it honors an earlier Bourbon king
as he prayed for divine aid in the midst of political and re-
ligious strife. Louis XIII's vow was taken in 1636,[17] at a
moment when his throne was threatened and heresy divided
the land. As Ingres's painting illustrates, the king, who offers
his crown and scepter to the Virgin, placed France under her
protection in return for her help. Two years later, the king,
now victorious, published and made good his promises to
her. He decreed that every year, on the Day of the Assump-
tion, in every church of the realm, a procession to the Virgin
was to take place along with the celebration of High Mass.
The Revolution put an end to this tradition, but Louis XVIII,
on his return to France, immediately revived it.[18] The
seventeenth-century Louis had also donated a painting to the
main altar of Notre-Dame of Paris representing himself
kneeling before the Virgin and the dead Christ. Several of
these were executed in the seventeenth century,[19] and it was
this subject that the mayor, the prefect and the Bishop of
Montauban had in mind when they commissioned Ingres to
execute a painting for the altar of the cathedral.

Besides glorifying the Bourbon line in general, the choice
of subject alludes more specifically to Louis XVIII. Historians
of the Right had already pointed out analogies between the
reigns of Louis XIII and Louis XVIII, both of which followed
a period of religious and civil conflict. As one Restoration
historian, Anaïs de Raucou Bazin, wrote in the preface to his
Histoire de France sous Louis XIII, "The reign of Louis XIII
emerged, after the great commotion of the religious wars,
almost into the same conditions where we ourselves are, in
the wake of the double upheaval caused by the Revolution
and the Empire."[20] Ingres's altarpiece not only evokes the
same comparison, it suggests that the Virgin takes a special
interest in the Bourbons and that as long as they occupy the
throne, France will enjoy her personal protection.

Such flattery was not unusual in the Restoration, but in
1820, when the work was commissioned, government of-
ficials had a particularly strong motive to laud the Bourbon
line and the alliance between the throne and the altar. Be-

tween 1816 and 1820, Louis XVIII had opposed the more reactionary ideas of the Comte d'Artois and his friends. Events of 1820, however, initiated a dramatic shift to the Right. In February, the young Duc de Berry, the only male member of the Bourbon family capable of producing an heir to the throne, was fatally stabbed by an obscure stablehand named Louvel, a fanatical Republican. The assassination produced a great wave of fear and reaction throughout France, and the Comte d'Artois and his clique were quick to exploit it to their advantage. With no supporting evidence, they insisted that the assassination was the result of a conspiracy and that the really guilty parties were the moderate Royalists, for under their Liberal-leaning policies, subversive and revolutionary elements of society had been able to grow and organize. The assassination of the Duc, they pointed out, proved the wisdom of the hard line that they had been advocating all along. In the climate of shock and fear generated by the Duc's death, they successfully pressed their demand that the king dissolve his moderate Royalist cabinet. After this, the Comte d'Artois and his party took increasing control of the government, and the sick old king increasingly became their willing tool.

As the Comtesse de Boigne remarked, "The death of the Duc de Berry was more useful to his family than his life."[21] People in all levels of public life hastened to affirm their faith in Christianity and to assure the Bourbons of their loyalty. Funeral orations by clerics, memorial speeches by politicians, and poems and odes by Chateaubriand and his followers lamented the murdered Duc, emphasized the national tragedy of his death and recounted the nobility of his line.[22] It was a time to remember all of the Louis's and the Bourbons of the past, and to glorify one was to glorify all. When it was learned that the Duchesse de Berry was pregnant, there was more public proclaiming.

The *Vow of Louis XIII* was conceived, then, at a moment when everyone connected with the government was making a point of displaying their allegiance to the Bourbon house and to the policies of the Right. It is conceivable that the subject of the painting was even meant to allude to the pregnancy of the Duchesse de Berry. Louis XIII, at the time he made the vow, had prayed for an heir, and in January 1638, it became known that the queen was pregnant.[23] Since the family history of the Bourbons was being told and retold with such frequency and ardor in 1820, it is not unlikely that the Montauban group thought to draw this analogy, too, and

thus underline the idea that the Virgin habitually intervenes in the affairs of the Bourbons. Lamartine's *Ode* on the birth of the new heir, the Duc de Bordeau, developed this idea at length, calling the new heir "the miracle child," his birth a "divine marvel," and his cradle "sacred."[24]

When Ingres received news of the commission in Florence, he immediately pronounced the subject ill-conceived. There followed a complex correspondence between Florence and Montauban, with letters to and from the town officials and the lawyer Gilibert, Ingres's boyhood friend who had been instrumental in securing him the commission and who now acted as his intermediary.[25] From his side, Ingres objected to the double subject of the king's vow and the Pietà. First of all, it broke the classical law of unity; its two subjects would divide the viewers's attention and produce a disturbing effect. Second, lacking the necessary documents in Florence, he would be unable to portray Louis XIII with satisfactory accuracy. The Virgin alone would be a better subject. From Montauban came the reply that the painting not only must commemorate the Assumption of the Virgin, but must also allude to the special celebrations and meanings that the Day of the Assumption held for the Bourbons. Then, in 1821, both sides changed their minds. Evidently, Ingres's arguments had gotten to the mayor and the prefect. Not wishing to violate this law of unity about which the artist spoke, they approved the Virgin of the Assumption as the subject of their painting. In response, however, Ingres abruptly withdrew his aesthetic objections and proposed an altered version of the double subject: the vow of Louis XIII before the Virgin and Child.

Ingres scholars—that is, Ingres scholars who admire the finished work—have attributed the artist's change of mind to purely artistic motives.[26] According to this explanation, Ingres accepted the double subject in place of the Virgin alone only when—and because—he resolved the compositional problems it posed. The imagination and originality of the work are taken to be sufficient proof of the artist's motives. To argue the purely artistic merits or faults of the work, however, demonstrates nothing about Ingres's motives—assuming that one can isolate and weigh such ingredients. Anyone familiar with Ingres and his obsessive ideal of beauty must grant that he would not have undertaken a task that seriously violated his artistic credo. However, it is more difficult to agree that Ingres accepted a

67

commission that so obviously praised the Bourbons only as an opportunity to meet its pictorial challenges. To assume such an idealistic, politically disinterested motive is to accept an ideological rationalization of the political content of the work. That Ingres—doctrinaire idealist that he was—eventually took this very position is understandable; but, Ingres's letters and the contingencies of his career suggest a more complex explanation.

In 1820, when Ingres received the commission for the *Vow of Louis XIII,* he was forty-three years old, had lived outside of France for years, and, except for a few artist-friends and patrons, was little known or appreciated. His exhibits to the Paris Salons were never well received, and disheartened, he had been sending fewer paintings there as the years went by. As he himself so often lamented, his career seemed to be under the influence of an unlucky star. Ingres's career options had always been more limited than those of Delacroix, Eugène Devéria, and other luminaries of the art world. Without inherited means, he also lacked the charm and easy manners necessary for acceptance into the drawing rooms of the fashionable. Then as now, wealthy patrons of art decorated their social gatherings with artists as well as art. Always a stiff and sober petit bourgeois, awkward in his speech, and ill at ease in educated society, Ingres was never able to advance his career by this route—as he himself knew.[27] Moreover, he simply did not *look* like an artist—or what people expected artists to look like.

If he passed you in the street, you would take him for a Spanish priest dressed up as a bourgeois: a swarthy, bilious complexion; a dark, alert, suspicious, ill-humoured eye; a brow narrow and receding; short, thick hair, jet-black once and always greasy, divided by a parting down the centre of a pointed skull; large ears; veins beating vigorously at the temples; a prominent nose, inclined to be hooked and made to appear short on account of the vast space separating it from the mouth; cheeks coarse and baggy; chin and cheekbones very pronounced; jaw like a rock, and lips thin and sullen.[28]

Genius was expected to have more fiery, nervous looks—the unruly hair, sensitive brow, and smoldering gaze of a Delacroix, for example.

By 1821, after much correspondence with Montauban, Ingres hardly could have remained innocent of the propagandistic nature of the commission—if, in fact, he ever was innocent of it. Indeed, his letters after 1821 reveal a very

shrewd understanding of the opportunity the commission provided for a virtually assured success in Paris.[29] He frequently refers to the painting as a decisive change in his fortunes, "the most important moment in my life." From the moment he dedicated himself to the double subject, he resolved to accompany the finished work to the Salon, and he wrote Gilibert that he intended "to strike while the iron is hot." As he repeatedly told his friend, he was putting into it three times the work he normally would, but as he was doing it for "ma gloire," it was worth it.

Thus, if the government would use his artistic skills to further its ends, Ingres would use the government to further his own. In any case, glorifying the Bourbons probably did not violate any of his personal convictions. Politically, he appears to have resembled many of his compatriots in the nineteenth century: of Royalist sentiments and, in principle, inclined toward constitutional monarchy, he was fearful of revolution; and, needing to earn a living, he was adaptable to and willing to serve a succession of authoritarian régimes.[30] Like many petits bourgeoises, he was in awe of established authority, impressed with the official honors it bestowed, and flattered to be recognized and patronized by men of rank and title.

Moreover, this was neither the first nor the last time that Ingres lent his talents to political interests. Among the few patrons he had attracted since the fall of the Empire were several Ultra-Royalists who had already given him commissions of this kind.[31] The Duc de Blacas, a violent reactionary, a crony of the Comte d'Artois and one of the most notorious and unpopular Ultras of the Restoration, had commissioned from him *Henry IV Playing with His Children,* 1817—one of those themes illustrating the charm and humaneness of pre-Revolutionary monarchs that pleased the Right. In 1819, Blacas also bought Ingres's *Roger and Angelica* for the king's collection. Between 1815 and 1819, Ingres undertook two commissions glorifying the Berwick-Alba family, and although he found one of them too repugnant to complete (*The Duc of Alba at Saint-Gudule, Brussels*—an event commemorating the Duc's bloody massacres of the Dutch in the sixteenth century), he did finish the second, *Philip V Investing the Marechal of Berwick with the Golden Fleece.* Finally, in 1821, the Comte Amidée de Pastoret, a fervent convert to the Bourbon cause, commissioned *The Dauphin Entering Paris,* showing a supposed fourteenth-

century ancestor of the Pastoret family demonstrating his loyalty to the future Charles V, who had recently vanquished a challenger to the throne.

Having divined the kind of opportunity that the Montauban commission presented, it is little wonder that Ingres's artistic imagination came up with a pictorial solution that fulfilled its original purpose. By accepting the Bourbon subject matter, he preserved the overt ideological intent of his patrons, thus increasing by several times the probability of a favorable reception for the work in Paris. And by substituting the Madonna for the Pietà (and also by facing Louis XIII away from the viewer and showing only a small part of his face), he mitigated the causes of his original "aesthetic" objections. Those aesthetic objections, however, especially his complaint that the subject as first proposed was not a unified one, hardly make sense without considering the ideological import of the work. The image of a king before the Pietà is no more disunified than the one Ingres finally chose. As realized by Philippe de Champaigne and other seventeenth-century artists, it emphasizes the idea of the king's Christian piety by showing him before the dead Christ—that is, as a penitent. It is understandable that now, in 1820, the subject should strike Ingres as lacking in a compelling central idea. Its strong appeal to traditional religious feeling and its prominent display of royal religious affect must have seemed not to the point—judging from the finished work. His resolution of the problem was not a matter of bringing unity out of something disunified, but of changing the emphasis of the iconography in order to render it more relevant to the ideological needs of his patrons and to the sensibilities of his nineteenth-century audience.

Ingres's substitution of the Adoration theme for the Pietà enabled him to focus upon and stress the Bourbon claim to legitimacy. The central issue of the King-Virgin relationship as it is presented here is not the king's piety as a good Christian ruler but the king's right to rule. The figure of Louis is conceived largely as a reigning Bourbon monarch. Ingres dwells upon his Bourbon costume and the symbols of his power but skirts the matter of his subjective religious experience. The transaction in which the king is engaged is to the point: he offers to the Virgin the symbols of his power, and, in return, will receive from her (in the form of a military victory) the confirmation that they are his to hold. Truer to his times than he might have been able to admit consciously, Ingres created an altarpiece in which the alliance between

throne and altar is starkly portrayed as political in nature. Of course, seventeenth-century images of the *Vow of Louis XIII* also promulgate the legitimacy of the Bourbon house; but in Ingres's altarpiece, the emphasis of the doctrine of divine right so overwhelms the issue of the king's Christian virtue that the latter is suppressed as a distracting countertheme. The very insistency with which the doctrine is argued testifies to its shakiness in the minds of Ingres's countrymen. Following his artistic intuition, he shrewdly took their measure when he decided to base his appeal not on their religious faith but on their respect for authority, divinely or otherwise sanctioned.

The opening of the Salon on September 24, 1824, came two weeks after the death of Louis XVIII. On September 27, the Comte d'Artois entered Paris as King Charles X. Two weeks later, the *Vow of Louis XIII* was put on display at the Salon. Ingres, after eighteen years of absence, now enjoyed the triumph he had anticipated for the last three years. To his friend Gilibert, he stressed the purely artistic nature of his triumph, repeating the flattering comments made to him—how the painting came just in time to stop bad taste and how it was inspired by Raphael without being a copy of him—and assuring his friend that the most respected artists—Gérard, Girodet, Gros, and Dupaty—had personally lauded his work to him.[32] Most twentieth-century scholars have followed Ingres in choosing to believe that the *Vow of Louis XIII* was judged strictly on the basis of its artistic qualities and that Ingres's triumph was purely a matter of aesthetics. In fact, published opinion of the time was divided about the artistic merits of the work;[33] Stendhal, for example, while admiring Ingres's drawing, found the work lacking expression.[34] Yet, many voices did declare the painting an artistic triumph and Ingres the champion of tradition. These accolades, however, must be taken at least in part as a way of flattering the new Bourbon king. In any case, the critical response cannot be understood only in the light of academic disputes over style and certainly not as a reflection of disinterested aesthetic taste. Critics commonly registered their support of a work's ideological content by praising its artistic qualities. Of course, Ingres's painting had to fulfill some notion of artistic quality. To function ideologically, the work had to be measurable and justifiable on separate, aesthetic grounds—good drawing, a proper understanding of tradition, and so forth. But without

its ideological import, it is unlikely that it would have been thus extolled.

That the Liberal press remained silent about the political meanings of the altarpiece is not surprising. The conventions of art criticism did not lend themselves to such analysis easily. Moreover, angering the king by attacking the ideology of a monumental artistic effort undertaken on his behalf would have been unwise. The Bourbons were extremely sensitive to the least criticism and did not hesitate to prosecute even innuendos they thought mocking or disrespectful to the king, the church, and their symbols of authority. As Stanley Mellon has shown, it was official dogma that the king was loved by the people, and anyone contesting this in print was liable to legal prosecution.[35] The elaborate censorship and press laws habitually legislated by the Bourbon government could bring severe damages to periodicals or to individual journalists.[36] The art press was as closely scrutinized as the political press, and publications could be suspended for what they published about paintings.[37] Stendhal probably went as far as one dared when he wryly commented that Ingres's figures lacked a feeling for the divine, that they were without celestial "onction," and that, despite the attention the work was receiving in the press, it was not popular among visitors to the Salon.[38] Finally, at that moment, there was a temporary truce between the king and the press—Louis XVIII had just been interred and Charles X had just arrived on the throne. The storm would break over issues much bigger than a painting that glorified the Bourbon monarchy.

Much has been written about the role of Ingres and the *Vow of Louis XIII* in the art politics of 1824. Ingres is often represented as the upholder of classical tradition in the face of a Romantic opposition led by Delacroix, whose *Massacre of Chios* was also exhibited in the Salon. The implication is that classicism was becoming identified with reaction while the Romantic school, with its love of color and open brushwork and its disdain for rules, was the artistic corollary of forces demanding social and political change. It is true that after 1824 leading Romantic writers like Chateaubriand and Hugo became disenchanted with the Bourbon monarchy and that the growing Liberal opposition was attracting talented young painters like Géricault and Delacroix. However, at this time, there were no ideological claims being made about styles themselves, and in painting especially neither Romanticism nor Neoclassicism can be firmly identified with the Right or the Left, either in the Restoration

or in the decades following. Open techniques, vibrant colors, and emotionally appealing subjects appeared in works both pleasing and displeasing to the Right. Moreover, paintings were not judged merely on their formal and stylistic characteristics.

Delacroix's *Massacre of Chios* was no more unconventional in its form than paintings exhibited by Eugène Devéria and other young colorists who were doted on by the Right. It was its subject that was more controversial. The Greeks' struggle to liberate themselves from the Turks was a great Liberal rallying cause in the '20s, and the spectacle of Greek victims could easily be taken as an indirect criticism of French foreign policy, which—while it did not hesitate to crush constitutional government in Spain—had so far refused to extend aid to the Greeks. To espouse liberty for the Greeks was also a way to espouse liberty at home without directly attacking the monarchy. "At a time when it was impossible to cry 'Long Live Liberty,' those who were disaffected were quick to see the advantage of shouting 'Long Live the Greeks.' "[39] In 1826, from the floor of the Chamber of Deputies, Benjamin Constant invoked the Greek cause in an indictment of Charles X's ministry. His words seem to articulate the political message of Delacroix's painting: " . . . The inhumanity of your diplomacy is witnessed in the ruins of Greece, the corpses of martyrs, old men, women, and children."[40]

Ingres's *Vow of Louis XIII,* on the other hand, affirmed all the ideals Ultras invoked to justify their policies—the alliance of the throne and the altar and the doctrine of the divine right of kings. Charles X was notoriously indifferent to art, good or bad, and it was surely for political and not aesthetic reasons that his first minister, Villèle, offered to buy the painting so that it might be kept permanently in Paris. His bid of 80,000 francs—Montauban was getting it for 5,000—was turned down, but the work was detained in Paris for two years (even while Montauban clamored for it), and a large, official engraving of it was made widely available.[41] Nor is it surprising that Ingres's name was advanced for the Legion of Honor by two of Charles X's most fervent and important supporters— the Vicomte de La Rochefoucauld, a fanatical Ultra, and the Minister of the Interior, Corbière.[42]

To the extent that it pleased the Right, the *Vow of Louis XIII* must have annoyed Liberals. For during the two years that the work remained in Paris as an officially revered object, the concepts it glorified were increasingly attacked by a growing opposition and defended by an ever more vociferous

Right. Popular prints of the time attest to the anger and distrust with which the urban crowd regarded the king, the church, and the aristocracy.[43] Even as Ingres was receiving his Cross at the closing ceremonies of the Salon, the king's new legislative program was beginning to stir hot debate.[44] It included two bills that especially signaled his intentions to annul everything accomplished by the Revolution. The first, the Law of Sacrilege, would make it a crime to profane the sacred vessels and wafers used in the mass. The prescribed punishment was as bizarre as it was drastic: the criminal, in black hood and barefooted, was to be decapitated—after having had his hand cut off. The bill, which made Catholic religious dogma civil law, was passed, but at a price to the king. It stirred deep-seated anticlerical feelings among the people, and seemed to confirm the popular fear that the Jesuits and the Clerical party were dictating state policy. Indeed, the bill inspired a wave of clerical fanaticism, with priests refusing burial and marriage to suspected Liberals.[45] The second bill, which would have reinstituted the ancient laws of primogeniture, was defeated, but not before it, too, convinced the people of the king's intention to turn back the clock and revive the privileges and inequalities of feudalism. Its defeat was celebrated in Paris for days, and the city rang with the cry, "Down with the Jesuits."[46]

Other events of 1825 and 1826 exacerbated these fears. But nothing raised anticlerical feeling more than the king's coronation in Rheims Cathedral, in May 1825. This controversial event also seems a kind of dramatization of Ingres's altarpiece, and it was fitting that Ingres was chosen as its official artist. The coronation manifested in reality the same desire to reconstruct a dead past through archaeological detail. "The present coronation," wrote Chateaubriand, "will be not a coronation, but the representation of a coronation."[47] All of the ancient coronation rituals and dressings were adhered to as if there had never been a Revolution. The king was even annointed with what was purported to be some of the original holy oil miraculously given to Clovis by a heaven-sent dove in the fifth century. Pieces of the ancient vial, smashed during the Revolution, were conveniently produced and authenticated by a clerical commission, and traces of the original oil were used as a base for a new supply. Besides striking people as absurd—Béranger's poem mocking the pompous ceremonies was immensely popular[48]—the business of the holy oil raised important issues. The revival of this and the other rituals was interpreted as a reassertion of ancient absolutism.

74

To Liberals, the Charter was the ultimate authority upon which the monarchy rested, and through it, the king was responsible to the people. The Bourbons, however, had always insisted that ultimate authority resided in the King by divine right and that the Charter was a grant from the king to the people.[49] The coronation ritual seems to sanctify a return to absolute monarchy, to the days when the king's will was law.

Worst of all, the ceremony of annointment required the king to lie on the floor while a high church official applied the oil. That is, the ceremony would have the king do precisely what Napoleon had refused to do in his coronation of 1804—grovel before priests. The image of the pious king prostrating himself before the powers of the church—Louis XIII comes close to this in Ingres's painting—was extremely disturbing to this generation of French, who nurtured strong Gallican sentiments and vivid memories of 1804, when Napoleon had seized the crown from the hands of the pope and placed it on his head himself. People were now convinced that Charles X was the tool of the Jesuits. So went Béranger's poem, *The Coronation of Charles the Simple:*

> Charles in the dust now prostrate lies;
> "Rise up, Sir King," a soldier cries.
> "No," quoth the Bishop, "and by Saint Peter,
> The Church crowns you; with bounty treat her!
> Heaven *sends* but 'tis priests who *give;*
> Long may legitimacy live!"[50]

Two years later, when the *Vow of Louis XIII* was installed in the Cathedral of Montauban and the *Coronation Mass* by Ingres's friend Cherubini was heard again, both Liberals and Ultras must have remembered afresh the ritual enacted at Rheims. That same year, in the church Jubilee celebrations, Charles X could be seen again submitting to priests, meekly trailing them in the public processions. Rumor had it that he had been secretly ordained as a priest and was now the complete captive of the Jesuits.

Ingres's *Vow of Louis XIII* was unveiled at a moment when the church, the king, and the symbols of their allied authority were targets of mounting popular hatred and ridicule. By creating a lucid symbol of that alliance—a reminder of everything that was to bring down Charles X—Ingres might well have claimed a modest contribution to the deepening tensions of the time: he helped furnish the trappings of the despised monarchy whose pompous rituals increasingly aroused the conscious hostility of the people.

That hostility would continue to grow as Charles X blindly pursued his Ultra policies and as the nation, increasingly polarized by the politico-theological issue, moved closer to revolution.

NOTES

1. *Ingres d'après une correspondance inédite,* ed. Boyer d'Agen (Paris, 1909), p. 175; and Paris: Petit Palais, *Ingres* (exhibition catalog), October 27, 1967, to January 29, 1968, p. 190.

2. For examples, see P.-M. Auzas, "Observations iconographiques sur le *'Voeu de Louis XIII,'* " in *Colloques Ingres,* a special number of the *Bulletin du Musée Ingres* (Montauban, October 15, 1969), pp. 1–11; J. Alazard, *Ingres et l'ingrisme* (Paris, 1950), pp. 68–70; F. Elgar, *Ingres* (Paris, 1951), p. 7; Petit Palais, *Ingres,* p. 190 (catalog entry by Daniel Ternois); and N. Schlenoff, *Ingres, ses sources littéraires* (Paris, 1956), pp. 140–147.

 Not all Ingres scholars see the painting as an artistic success. See R. Rosenblum, *Ingres* (New York, 1967), p. 126, for a most perceptive visual analysis of the work; and W. Friedlaender, *David to Delacroix* (New York, 1968), pp. 80–81. Friedlaender found the work so derivative that he could "not quite understand why just this particular picture should have had such a tremendous success." The explanation he offered is the one accepted by most scholars: established academic taste needed a champion of classical traditions to oppose Delacroix and the young Romantic painters who were out in force at the Salon of 1824.

3. For the political history of the Restoration, I have relied mainly on the following: F. B. Artz, *France Under the Bourbon Restoration, 1814–1830* (New York, 1963) and *Reaction and Revolution, 1814–1832* (New York, 1963); V. N. Beach, *Charles X of France, His Life and Times* (Boulder, Colorado, 1971); G. de Bertier de Sauvigny, *The Bourbon Restoration,* trans. L. M. Case (Philadelphia, 1966); G. Brandes, *Main Currents in Nineteenth Century Literature* (New York, 1901–1906), Vols. I and III; J.-P. Garnier, *Charles X, le roi, le proscrit* (Paris, 1967); M. D. R. Leys, *Between Two Empires* (London/New York/Toronto, 1955); S. Mellon, *"The Politics of History: A Study of the Historical Writing of the French Restoration"* (Doctoral dissertation, Princeton University, 1954, also available as a book); R. Rémond, *The Right Wing in France, From 1815 to de Gaulle,* trans. J. M. Laux (Philadelphia, 1969); J. H. Stewart, *The Restoration in France, 1814–1830* (a collection of documentary texts) (Princeton, New Jersey, 1968).

4. *Main Currents,* III: 197.

5. In ibid., III: 164. Napoleon had similarly used religion as a prop to his authority. Following the Terror and its devastating attacks on the church, France experienced a wave of proclerical sentiment. Rather than risk opposing it, Napoleon sought to use it as a support to his throne. The Concordat of 1802 and the Coronation of 1804 were in part designed to disassociate Catholicism from the Bourbon house and to identify it with his own (ibid., III; 35–37 and 52–56).

6. Artz, *France,* pp. 49, 75–79.

7. Stendhal, *The Life of Henri Brulard,* trans. C. A. Phillips (New York, 1955), p. 292.
8. Mellon's *The Politics of History* is devoted entirely to this subject.
9. Artz, *Reaction,* Chap. 3; and Brandes, *Main Currents,* Vol. III.
10. *The Memoirs of Francois René Vicomte de Chateaubriand,* trans. A. Teixeira de Mattos (New York, 1902), III: 37.
11. Brandes, *Main Currents,* III: 85.
12. For the artistic sources of the *Vow of Louis XIII,* see Auzas, "Observations," pp. 3 ff.
13. See also the visual analysis by Robert Rosenblum in *Ingres,* p. 126; and W. Hofmann, *Art in the Nineteenth Century,* trans. B. Battershaw (London, 1961), p. 152.
14. S. Kent, *Electoral Procedure Under Louis Philippe* (Yale Historical Publications, No. 10) (New Haven, 1937), pp. 125–127.
15. Petit Palais, *Ingres,* p. 190; and Schlenoff, *Ingres,* pp. 141–142.
16. P. Angrand, *Monsieur Ingres et son époque* (Paris, 1968), pp. 34–36. Angrand is an exception among Ingres scholars for the attention he gives to the relationship between politics and the artist's work.
17. For the text of the vow, see Auzas, "Observations," p. 1.
18. Ibid., p. 7.
19. Ibid., pp. 3 ff. The best known is the one by Philippe de Champaigne, formerly in Notre-Dame, Paris, now in the Musée de Caen.
20. Paris, 1840, I: iii–vi. Although published in 1840, Bazin's sentiments belong to the Restoration.
21. In Stewart, *Restoration,* p. 139.
22. Mellon, *Politics,* p. 100.
23. Bazin, *Histoire,* pp. 13 ff.
24. Lamartine, *Oeuvres* (Paris, 1826), I: 96–97.
25. *Ingres . . . correspondance,* pp. 55–82; and Schlenoff, *Ingres,* pp. 142–146.
26. Alazard, *Ingres,* pp. 68–70; Petit Palais, *Ingres,* p. 190; J. Pope-Hennessy, *Raphael* (New York, 1970), pp. 254–255; and Schlenoff, *Ingres,* pp. 145–147.
27. Amaury-Duval, *L'Atelier d'Ingres* (1878) (Paris, 1924), pp. 215, 219. Ingres was fully aware that the social skills he lacked could make a difference in his career (*Ingres . . . correspondance,* p. 85).
28. Th. Silvestre, quoted in M. Easton, *Artists and Writers in Paris* (London, 1964), p. 168.
29. *Ingres . . . correspondance,* pp. 60–71; 114–116; 119; and Angrand, *Ingres,* pp. 44–45.
30. Angrand, *Ingres,* passim. Ingres glorified every French régime from the Consulate to the Second Empire—with the exception of the Second Republic.
31. Ibid., pp. 36–43; Petit Palais, *Ingres,* pp. 112, 142, 174.
32. *Ingres . . . correspondance,* pp. 120–125.
33. Dorathea K. Beard, "Ingres and Quatremère de Quincy: Some Insights into Academic Maneuvers" (Paper delivered at the Annual Meeting of the College Art Association of America, January 23–26, 1974). According to Beard, many newspapers simply ignored the work.
34. Stendhal, "Salon de 1824," in *Mélanges d'art* (Paris, 1932), pp. 116–119.
35. Mellon, *Politics,* pp. 101–102.

36. Artz, *France*, pp. 82–83 and *Reaction*, pp. 224–25; Beach *Charles X*, pp. 236–238; I. Collins, *The Government and the Newspaper Press in France, 1814–1881* (London, 1959); C. Ledré, *La Presse à l'assaut de la monarchie, 1815–1848* (Paris, 1960); and Stewart, *Restoration*, pp. 131–137.
37. Collins, *The Government*, p. 17; and Ledré, *La Presse*, p. 18.
38. Stendhal, "Salon de 1824," pp. 116–119.
39. Beach, *Charles X*, pp. 231–235; and Artz, *Reaction*, p. 207
40. Beach, *Charles X*, p. 231.
41. Petit Palais, *Ingres*, p. 190.
42. Angrand, *Ingres*, p. 48.
43. Artz, in *France*, reproduces a lithograph of 1824, "The Past and the Present," which is especially interesting for the way it reverses the throne-altar relationship as depicted by Ingres. While the left side of the print remembers the Empire as a time of enlightenment and justice, the right side depicts the Restoration as a modern dark age: figures representing the monarch and his aristocratic supporters are shown to be *above* and resting upon a fanatical, fire-and-brimstone-preaching clergyman.
44. Beach, *Charles X*, pp. 182–197, 224–225; and Stewart, *Restoration*, pp. 154–155.
45. Artz, *France*, p. 159.
46. Beach, *Charles X*, pp. 224–226.
47. *Memoirs*, IV: 109.
48. *The Coronation of Charles the Simple*, in Stewart, *Restoration*, pp. 150–152. The poem earned him nine months in jail.
49. Artz, *France*, pp. 37–38; Beach, *Charles X*, pp. 198–199; and Mellon, *Politics*, p. 82.
50. Stewart, *Restoration*, p. 151.

MODERN ART AND THE SOCIAL RELATIONS BETWEEN THE SEXES

Part Two

VIRILITY AND DOMINATION IN EARLY TWENTIETH-CENTURY VANGUARD PAINTING

In the decade before World War I, a number of European artists began painting pictures with a similar and distinctive content. In both imagery and style, these paintings forcefully assert the virile, vigorous and uninhibited sexual appetite of the artist. I am referring to the hundreds of pictures of nudes and women produced by the Fauves, Cubists, German Expressionists and other vanguard artists. As we shall see, these paintings often portray women as powerless, sexually subjugated beings. By portraying them thus, the artist makes visible his own claim as a sexually dominating presence, even if he himself does not appear in the picture.

This concern with virility—the need to assert it in one's art—is hardly unique to artists of this period. Much of what I am going to say here is equally relevant to later twentieth-century as well as some nineteenth-century art.[1] But the assertion of virility and sexual domination appears with such force and frequency in the decade before World War I, and colors the work of so many different artists, that we must look there first to understand it. It is also relevant to ask whether these artists sought or achieved such relationships in reality, whether their lives contradict or accord with the claims of their art. But that is not the question I am asking here. My concern is with the nature and implications of those claims as they appear in the art and as they entered the mythology of vanguard culture. In this I am treating the artists in question not as unique individuals, but as men whose inner needs and desires were rooted in a shared historical experience—even if the language in which they expressed

This essay was first published in *Artforum* (December 1973), 30–39. Revised and reprinted in *Feminism and Art History: Questioning the Litany*, ed. Norma Broude and Mary Garrard (New York, Harper and Row, 1982), 292–313. It is reprinted here by permission of *Artforum* Magazine, Inc.

themselves was understood by only a handful of their contemporaries.

The material I explore inevitably touches on a larger issue—the role of avant-garde culture in our society. Avant-garde art has become the official art of our time. It occupies this place because, like any official art, it is ideologically useful. But to be so used, its meaning must be constantly and carefully mediated. That task is the specialty of art historians, who explain, defend and promote its value. The exhibitions, courses, articles, films and books produced by art historians not only keep vanguard art in view, they also limit and construct our experience of it.

In ever new ways, art history consistently stresses certain of its qualities. One idea in particular is always emphasized: that avant-garde art consists of so many moments of individual artistic freedom, a freedom evidenced in the artist's capacity for innovation. Accounts of modern art history are often exclusively, even obsessively, concerned with documenting and explicating evidence of innovation—the formal inventiveness of this or that work, the uniqueness of its iconography, its distinctive use of symbols or unconventional materials. The presence of innovation makes a work ideologically useful because it demonstrates the artist's individual freedom as an artist; and *that* freedom implies and comes to stand for human freedom in general. By celebrating artistic freedom, our cultural institutions "prove" that ours is a society in which all freedom is cherished and protected, since, in our society, all freedom is conceived as individual freedom. Thus vanguard paintings, as celebrated instances of freedom, function as icons of individualism, objects that silently turn the abstractions of liberal ideology into visible and concrete experience.

Early vanguard paintings, including many of the works I shall discuss, are especially revered as icons of this kind. According to all accounts, the decade before World War I was the heroic age of avant-garde art. In that period, the "old masters" of modernism—Picasso, Matisse, the Expressionists—created a new language and a new set of possibilities that became the foundation for all that is vital in later twentieth-century art. Accordingly, art history regards these first examples of vanguardism as preeminent emblems of freedom.

The essay that follows looks critically at this myth of the avant garde. In examining early vanguard painting, I shall be looking not for evidence of innovation (although there is

plenty of that), but rather for what these works say about the social relations between the sexes. Once we raise this question—and it is a question that takes us outside the constructs of official art history—a most striking aspect of the avant garde immediately becomes visible: however innovative, the art produced by many of its early heroes hardly preaches freedom, at least not the universal human freedom it has come to symbolize. Nor are the values projected there necessarily "ours," let alone our highest. The paintings I shall look at speak not of universal aspirations but of the fantasies and fears of middle-class men living in a changing world. Because we are heirs to that world, because we still live its troubled social relations, the task of looking critically, not only at vanguard art but also at the mechanisms that mystify it, remains urgent.

I

Already in the late nineteenth century, European high culture was disposed to regard the male-female relationship as the central problem of human existence. The art and literature of the time is marked by an extraordinary preoccupation with the character of love and the nature of sexual desire. But while a progressive literature and theater gave expression to feminist voices, vanguard painting continued to be largely a male preserve. In Symbolist art, men alone proclaimed their deepest desires, thoughts and fears about the opposite sex. In the painting of Moreau, Gauguin, Munch and other end-of-the-century artists, the human predicament—what for Ibsen was a man-woman problem—was defined exclusively as a male predicament, the woman problem. As such, it was for men alone to resolve, transcend or cope with. Already there was an understanding that serious and profound art—and not simply erotic art—is likely to be about what men think of women.

Symbolist artists usually portrayed not women but one or two universal types of woman.[2] These types are often lethal to man. They are always more driven by instincts and closer to nature than man, more subject to its mysterious forces. They are often possessed by dark or enigmatic souls. They usually act out one or another archetypal myth—Eve, Salomé, the Sphinx, the Madonna (Fig. 4.1).

Young artists in the next avant-garde generation—those maturing around 1905—began rejecting these archetypes just

83

as they dropped the muted colors, the langorous rhythms and the self-searching artist-types that Symbolism implied. The Symbolist artist, as he appears through his art, was a creature of dreams and barely perceptible intuitions, a refined, hypersensitive receiver of tiny sensations and cosmic vibrations. The new vanguardists, especially the Fauves and the Brücke, were youth and health cultists who liked noisy colors and wanted to paint their direct experience of mountains, flags, sunshine and naked girls. Above all, they wanted their art to communicate the immediacy of their own vivid feelings and sensations before the things of this world. In almost every detail, their images of nudes sharply contrast to the virgins and vampires of the 1890s. Yet these younger artists shared certain assumptions with the previous generation. They, too, believed that authentic art speaks of the central problems of existence, and they, too, defined Life in terms of a male situation—specifically the situation of the middle-class male struggling against the strictures of modern, bourgeois society.

Kirchner was the leader and most renowned member of the original Brücke, the group of young German artists who worked and exhibited together in Dresden and then Berlin between 1905 and 1913. His *Girl Under a Japanese Umbrella*

4.1 Edvard Munch, *Salomé*. Lithograph, 1903. Private collection.

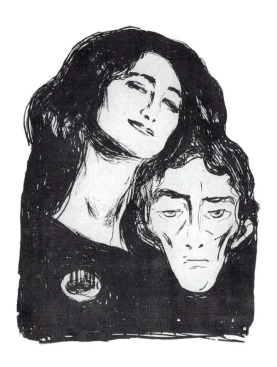

(ca. 1909) asserts the artistic and sexual ideals of this gener-
ation with characteristic boldness (Fig. 4.2). The artist seems
to attack his subject, a naked woman, with barely controlled
energy. His painterly gestures are large, spontaneous, some-
times vehement, and his colors intense, raw and strident.
These features proclaim his unhesitant and uninhibited re-
sponse to sexual and sensual experience. Leaning directly over
his model, the artist fastens his attention mainly to her head,
breasts and buttocks, the latter violently twisted toward him.
The garish tints of the face, suggesting both primitive body
paint and modern cosmetics, are repeated and magnified in
the colorful burst of the exotic Japanese umbrella. Above the
model is another Brücke painting, or perhaps a primitive or
Oriental work, in which crude shapes dance on a jungle-
green ground.

Van Dongen's *Reclining Nude* (1905–06), a Fauve work, is
similar in content (Fig. 4.3). Here, too, the artist reduces a
woman to so much animal flesh, a headless body whose ex-
tremities trail off into ill-defined hands and feet. And here,
too, the image reflects the no-nonsense sexuality of the artist.
The artist's eye is a hyper-male lens that ruthlessly filters out
everything irrelevant to the most basic genital urge. A lustful
brush swiftly shapes the volume of a thigh, the mass of the
belly, the fall of a breast.

Such images are almost exact inversions of the *femmes fatales*

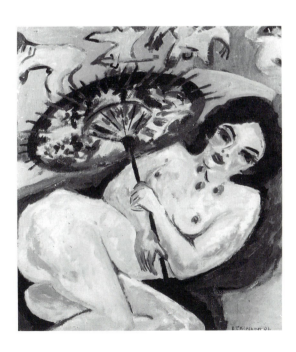

4.2 Ernst Ludwig Kirch-
ner, *Girl Under a Japanese
Umbrella*, c. 1909. Düssel-
dorf, Kunstsammlung
Nordrhein-Westfallen
(photo: Kunstsammlung).
Copyright Dr. W. and
I. Henze, Campione
d'Italia.

of the previous generation. Those vampires of the 1890s loom up over their male victims or viewers, fixing them with hypnotic stares. In Munch's paintings and prints, females engulf males with their steaming robes and hair. The male, whether depicted or simply understood as the viewer-artist, is passive, helpless or fearful before this irresistibly seductive force which threatens to absorb his very will. Now, in these nudes by Kirchner and Van Dongen, the artist reverses the relationship and stands above the supine woman. Reduced to flesh, she is sprawled powerlessly before him, her body contorted according to the dictates of his erotic will. Instead of the consuming *femme fatale,* one sees an obedient animal. The artist, in asserting his own sexual will, has annihilated all that is human in his opponent. In doing so, he also limits his own possibilities. Like conquered animals, these women seem incapable of recognizing in him anything beyond a sexually demanding and controlling presence. The assertion of that presence—the assertion of the artist's sexual domination—is in large part what these paintings are about.

In the new century, even Munch felt the need to see himself thus reflected. His *Reclining Nude,* a watercolor of 1905, is a remarkable reversal of his earlier *femmes fatales.* Both literally and symbolically, Munch has laid low those powerful spirits

4.3 Kees Van Dongen, *Reclining Nude,* 1906. Whereabouts unknown.

along with the anxieties they created in him. This nude, her head buried in her arms, lies at his disposal, while he explores and translates into free, unrestrained touches the impact of thighs, belly and breasts on his senses and feelings.

Most images of female nudity imply the presence (in the artist and/or the viewer) of a male sexual appetite. What distinguishes these pictures and others in this period from most previous nudes is the compulsion with which women are reduced to objects of pure flesh, and the lengths to which the artist goes in denying their humanity. Not all nudes from this decade are as brutal as Van Dongen's, but the same de-humanizing approach is affirmed again and again. Nudes by Braque, Manguin, Puy and other Fauves are among scores of such images. They also occur in the work of such artists as Jules Pascin, the Belgian Realist Rik Wouters and the Swiss Félix Vallotton (*The Sleep*, 1908). *Nude in a Hammock* (1912), by Othon Friesz, is a Cubistic version of this same basic type of sleeping or faceless nude. So is Picasso's more formalist-ically radical *Woman in an Armchair* (1913), where all the wit and virtuoso manipulation of form are lavished only upon the body, its literally hanging breasts, the suggestive folds of its underwear, etc. Indeed, Picasso's Cubist paintings main-tain the same distinction between men and women as other artists of this decade did—only more relentlessly; many of these other artists painted portraits of women as authentic people in addition to nudes. Max Kozloff observed the strik-ing difference between Picasso's depictions of men and women in the Cubist period:

The import of *Girl With a Mandolin* perhaps becomes clearer if it is compared with such contemporary male subjects as Picasso's *Portrait of Ambroise Vollard*. The artist hardly ever creates the image of a woman as portrait during this period. He reserved the mode almost entirely for men. . . . In other words, a woman can be typed, shown as a nude body or abstracted almost out of recognition, as in *Ma Jolie,* where the gender of the subject plays hardly any role, but she is not accorded the particularity and, it should be added, the dignity of one-to-one, formalized contact furnished by a por-trait. More significant is the fact that Vollard is presented as an individual of phenomenal power and massive, ennobled presence, while the female type often gangles like a simian, is cantilevered uncomfortably in space, or is given bowed appendages.[3]

The artistic output of the Brücke abounded in images of powerless women. In Heckel's *Nude on a Sofa* (1909) and his *Crystal Day* (1913) (Fig. 4.4), women exist only in reference to—or rather, as witnesses to—the artist's frank sexual in-

terests. In one, the woman is sprawled in a disheveled setting; in the other, she is knee-deep in water—in the passive, arms-up, exhibitionist pose that occurs so frequently in the art of this period. The nude in *Crystal Day* is literally without features (although her nipples are meticulously detailed), while the figure in the other work covers her face, a combination of bodily self-offering and spiritual self-defacement that characterizes these male assertions of sexual power. In Kirchner's *Tower Room, Self-Portrait with Erna* (1913) (Fig. 4.5), another faceless nude stands obediently before the artist, whose intense desire may be read in the erect and flaming object before him. In a less strident voice, Manguin's *Nude* (1905) makes the same point. In the mirror behind the bed, the nude is visible a second time, and now one sees the tall, commanding figure of the artist standing above her.

The artists of this decade were obsessed with such confrontations. In a curious woodcut, published as *The Brothel* (ca. 1906) (Fig. 4.6), the French Fauve Vlaminck played with the tension inherent in that confrontation. What activates the three women in this print is not clear, but the central nude raises her arms in ambiguous gesture, suggesting both protest and self-defense. In either case, the movement is well contained in the upper portion of the print and does not prevent the artist from freely seizing the proffered, voluptuous body.

4.4 Erich Heckel, *Crystal Day*, 1913. Munich, Staatsgalerie Moderner Kunst (photo: Staatsgalerie).

Evidently, he has enjoyed the struggle and purposely leaves traces of it in the final image.

Matisse's painting of these years revolves around this kind of contest almost exclusively, exploring its tensions and seeking its resolution. Rarely does he indulge in the open, sexual boasting of these other artists. Matisse is more *galant,* more bourgeois. A look, an expression, a hint of personality often mitigate the insistent fact of passive, available flesh. In the nice, funny face of *The Gypsy* (1905–06), one senses some human involvement on the part of the artist, even as he bent the lines of the model's face to rhyme with the shape of her breasts. Matisse is also more willing to admit his own intimidation before the nude. In *Carmelina* (1903) (Fig. 4.7), a powerfully built model coolly stares him down—or, rather, into—a small corner of the mirror behind her. The image in that mirror, the little Matisse beneath the awesome Carmelina, makes none of the overt sexual claims of Manguin's *Nude* or Kirchner's *Tower Room* (Fig. 4.5). But the artful Matisse has more subtle weapons. From his corner of the mirror, he blazes forth in brilliant red—the only red in this somber composition—fully alert and at the controls. The artist, if not the man, masters the situation—and also Carmelina, whose dominant role as a *femme fatale* is reversed by the mirror image. Nor is the assertion of virility direct and

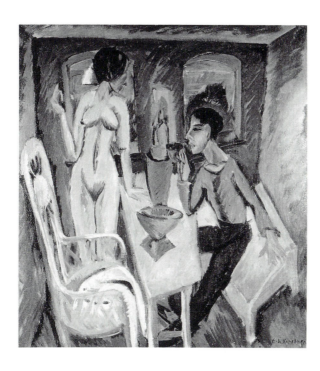

4.5 Kirchner, *Tower Room, Self-Portrait with Erna,* 1913. U.S.A., private collection. Copyright Dr. W. and I. Henze, Campione d'Italia.

open in other paintings by Matisse, where the models sleep or lack faces. Extreme reductions and distortions of form and color, all highly deliberated, self-evident "aesthetic" choices, transpose the sexual conflict onto the "higher" plane of art. Again, the assertion of virility becomes sublimated, meta-morphosed into a demonstration of artistic control, and all evidence of aggression is obliterated. As he wrote in "Notes of a Painter" (1908), "I try to put serenity into my pictures. . . ."[4]

The vogue for virility in early twentieth-century art is but one aspect of a total social, cultural and economic situation that women artists had to overcome. It was, however, a particularly pernicious aspect. As an ethos communicated in a hundred insidious ways, but never overtly, it effectively alienated women from the collective, mutually supportive endeavor that was the avant garde. (Gertrude Stein, inde-pendently wealthy and, as a lesbian, sexually unavailable to men, is the grand exception.) Like most of their male coun-terparts, women artists came primarily from the middle classes. It is hardly conceivable that they would flaunt a desire for purely physical sex, even in private and even if they were capable of thinking it. To do so would result in social suicide and would require breaking deeply internalized taboos. In any case, it was not sexuality per se that was valued, but male sexuality. The problem for women—and the main

4.6 Maurice Vlaminck, *The Brothel*, c. 1906. Woodcut. Paris, private collection.

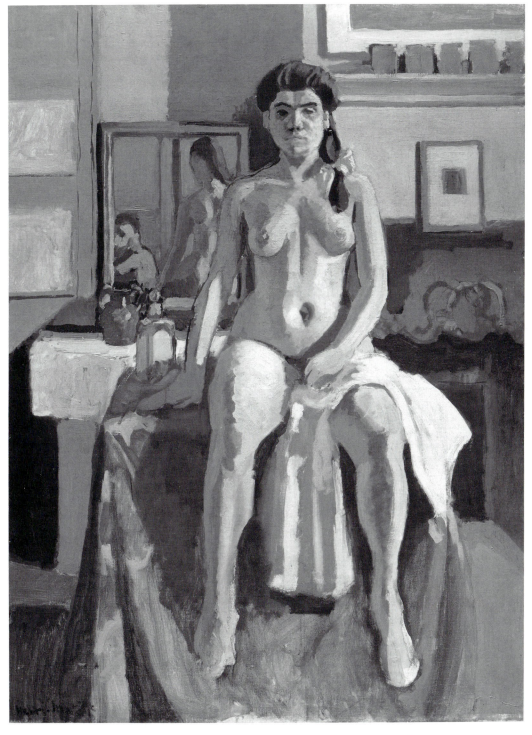

4.7 Henri Matisse, *Carmelina*, 1903, oil on canvas, 32 × 32¼″. Courtesy, Museum of Fine Arts, Boston, Tompkins Collection (photo: museum).

thrust of women's emancipation—was not to invert the existing social-sexual order, not to replace it with the domination of women; the new woman was struggling for her own autonomy as a psychological, social and political being. Her problem was also the woman problem. Her task was also to master her own image.

Accordingly, the German artist Paula Modersohn-Becker confronted female nudity—her own—in a *Self-Portrait* of 1906 (Fig. 4.8). Fashioned out of the same Post-Impressionist heritage as Brücke art and Fauvism, this picture is startling to see next to the defaced beings her fellow artists so often devised. Above the naked female flesh are the detailed features of a powerful and determined human being. Rare is the image of a naked woman whose head so outweighs her body. Rare, that is, in male art. Suzanne Valadon, Sonia Delaunay-Terk and other women of this period often painted fully human female beings, young and old, naked and clothed. Among

4.8 Paula Modersohn-Becker, *Self-Portrait*, 1906. Basel, Oeffentliche Kunstsammlung (photo: museum).

male artists, only Manet in the *Olympia* comes close. But there the image-viewer relationship is socially specified. Olympia is literally flesh for sale, and in that context, her self-assertiveness appears willful and brash—a contradiction to the usual modesty of the nude. As a comment on bourgeois male-female relationships, the *Olympia* is both subversive and antisexist; it is, however, consciously posed as male experience and aimed, with deadly accuracy, at the smug and sexist male bourgeoisie. Modersohn-Becker, on the other hand, is addressing herself, not as commodity and not even as an artist but as a woman. Her effort is to resolve the contradiction Manet so brilliantly posed, to put herself back together as a fully conscious and fully sexual human being. To attempt this, with grace and strength to boot, speaks of profound humanism and conviction, even while the generalized treatment of the body and its constrained, hesitant gestures admit the difficulty.

II

Earlier, I suggested that the powerless, defaced nude of the twentieth century is an inversion of the Symbolist *femme fatale*. Beneath this apparent opposition, however, is the same supporting structure of thought.[5] In the new imagery, woman is still treated as a universal type, and this type, like the Sphinxes and Eves of the previous generation, is depicted as a being essentially different from man. In the eyes of both generations of artists, woman's mode of existence—her relationship to nature and to culture—is categorically different from man's. More dominated by the processes of human reproduction than men, and, by situation, more involved in nurturing tasks, she appears to be more *of nature* than man, less in opposition to it both physically and mentally. As the anthropologist Sherry Ortner has argued, men see themselves more closely identified with culture, "the means by which humanity transcends the givens of natural existence, bends them to its purposes, controls them in its interests." Man/culture tends to be one term in a dichotomy of which woman/nature is the other: "Even if woman is not equated with nature, she is still seen as representing a lower order of being, less transcendental of nature than men."[6]

However different from the Symbolists, these younger artists continued to regard confrontations with women as real or symbolic confrontations with nature. Not surprisingly,

the nude-in-nature theme, so important to nineteenth-century artists, continued to haunt them. And like the older artists, they, too, imagined women as more at home there than men. Placid, naked women appear as natural features of the landscape in such works as Heckel's *Crystal Day* (Fig. 4.4), Friesz's *Nude in a Hammock* and numerous bathers by Vlaminck, Derain, Mueller, Pechstein and other artists. The bacchante or the possessed, frenzied dancer is the active variant of the bather and frequently appears in the art of this period. Nolde's *Dancers with Candles* (1912) and Derain's *The Dance* (ca. 1905) equally represent women as a race apart from men, controlled by nature rather than in control of it.

Myths cultivated by artists would seem to contradict this dichotomy. Since the nineteenth century, it was fashionable for male artists to claim a unique capacity to respond to the realm of nature. But while they claimed for themselves a special intuition or imagination, a "feminine principle," as they often called it, they could not recognize in women a "masculine principle." The pictures of women produced in this epoch affirm this difference as much as Symbolist art. Women are depicted with none of the sense of self, none of the transcendent, spiritual autonomy that the men themselves experienced (and that Modersohn-Becker so insisted upon). The headless, faceless nudes, the dreamy looks of Gauguin's girls, the glaring mask of Kirchner's *Girl Under a Japanese Umbrella* (Fig. 4.2), the somnambulism of the *femmes fatales*— all of these equally deny the presence of a human consciousness that knows itself as separate from and opposed to the natural and biological world.

The dichotomy that identifies women with nature and men with culture is one of the most ancient ideas ever devised by men and appears with greater or lesser strength in virtually all cultures. However, beginning in the eighteenth century, Western bourgeois culture increasingly recognized the real and important role of women in domestic, economic and social life. While the basic sexual dichotomy was maintained and people still insisted on the difference between male and female spheres, women's greater participation in culture was acknowledged. In the nineteenth century the bourgeoisie educated their daughters more than ever before, depended on their social and economic cooperation and valued their human companionship.

What is striking—and for modern Western culture unusual—about so many nineteenth- and twentieth-century vanguard nudes is the absoluteness with which women were

pushed back to the extremity of the nature side of the di-
chotomy, and the insistence with which they were ranked in
total opposition to all that is civilized and human. In this
light, the attachment of vanguard artists to classical and bib-
lical themes and their quest for folk and ethnographic material
takes on special meaning. These ancient and primitive cultural
materials enabled them to reassert the woman/nature-man/
culture dichotomy in its harshest forms. In Eve, Salomé, the
Orpheus myth and the primitive dancer, they found Woman
as they wanted to see her—an alien, amoral creature of pas-
sion and instinct, an antagonist to rather than a builder of
human culture. The vanguard protested modern bourgeois
male-female relationships; but that protest, as it was ex-
pressed in these themes, must be recognized as culturally
regressive and historically reactionary. The point needs to be
emphasized only because we are told so often that vanguard
tradition embodies our most progressive, liberal ideals.

The two generations of artists also shared a deep ambiv-
alence toward the realm of woman/nature. The Symbolists
were at once attracted to and repelled by its claims on them.
Munch's art of the nineties is in large part a protest against
this male predicament. From his island of consciousness, he
surveys the surrounding world of woman/nature with both
dread and desire. In paintings by Gauguin, Hodler and Klimt
(especially his "Life and Death" series), woman's closeness
to nature, her effortless biological cooperation with it, is en-
viable and inviting. She beckons one to enter a poetic, non-
rational mode of experience—that side of life that advanced
bourgeois civilization suppresses. Yet, while the realm of
woman is valued, it is valued *as* an alien experience. The artist
contemplates it, but prefers to remain outside, with all the
consciousness of the outside world. For to enter it fully means
not only loss of social identity, but also loss of autonomy
and of the power to control one's world.

The same ambivalence marks the twentieth-century work
I have been discussing, especially the many paintings of nudes
in nature. In these images, too, the realm of woman/nature
invites the male to escape rationalized experience and to know
the world through his senses, instincts or imagination. Yet
here, too, while the painter contemplates his own excited
feelings, he hesitates to enter that woman/nature realm of
unconscious flesh, to imagine himself *there*. He prefers to
know his instincts through the objects of his desire. Rarely
do these artists depict naked men in nature. When they do,
they are almost never inactive. To be sure, there are some

naked, idle males in Kirchner's bathing scenes, but they are clearly uncomfortable and self-conscious-looking. More commonly, figures of men in nature are clothed, both literally and metaphorically, with social identities and cultural projects. They are shepherds, hunters, artists. Even in Fauve or Brücke bathing scenes where naked males appear, they are modern men going swimming. Unlike the female bather, they actively engage in culturally defined recreation, located in historical time and space. Nowhere do these men enter nature—and leave culture—on the same terms as women. Now as in the 1890s, to enter that world naked and inactive is to sink into a state of female powerlessness and anonymity.

Matisse's *Joy of Life* (*Bonheur de vivre*) of 1905–06 seems to be an exception. In this sun-drenched fantasy, all the figures relate to nature, to each other and to their own bodies in harmony and freedom. No one bends to a force outside oneself. Yet, even in this Arcadia, Matisse hesitates to admit men. Except for the shepherd, all the figures with visible sexual characteristics are women. Maleness is suggested rather than explicitly stated. Nor is the woman/nature-man/culture dichotomy absent: culturally defined activities (music-making and animal husbandry) are male endeavors, while women simply exist as sensual beings or abandon themselves to spontaneous and artless self-expression.

No painting of this decade better articulates the male-female dichotomy and the ambivalence men experience before it than Picasso's *Demoiselles d'Avignon* of 1906–07 (Fig. 4.9). What is so remarkable about this work is the way it manifests the structural foundation underlying both the *femme fatale* and the new, primitive woman. Picasso did not merely combine these into one horrible image; he dredged up from his psyche the terrifying and fascinating beast that gave birth to both of them. The *Demoiselles* prismatically mirrors her many opposing faces: whore and deity, decadent and savage, tempting and repelling, awesome and obscene, looming and crouching, masked and naked, threatening and powerless. In that jungle-brothel is womankind in all her past and present metamorphoses, concealing and revealing herself before the male. With sham and real reverence, Picasso presents her in the form of a desecrated icon already slashed and torn to bits.

If the *Demoiselles* is haunted by the nudes of Ingres, Delacroix, Cézanne and others,[7] it is because they, too, proceed from this Goddess-beast and because Picasso used them as beacons by which to excavate its root form. The quotations from ancient and non-Western art serve the same purpose.

The *Demoiselles* pursues and recapitulates the Western European history of the woman/nature phantom back to her historical and primal sisters in Egypt, ancient Europe and Africa in order to reveal their oneness. Only in primitive art is woman as sub- and superhuman as this.[8] Many later works by Picasso, Miró or de Kooning would recall this primal mother-whore. But no other modern work reveals more of the rock foundation of sexist antihumanism or goes further and deeper to justify and celebrate the domination of woman by man.

4.9 Pablo Picasso, *Les Demoiselles d'Avignon*, 1906–07, oil on canvas, 96⅜ × 92½". New York, The Museum of Modern Art, Lillie P. Bliss Bequest (photo: museum).

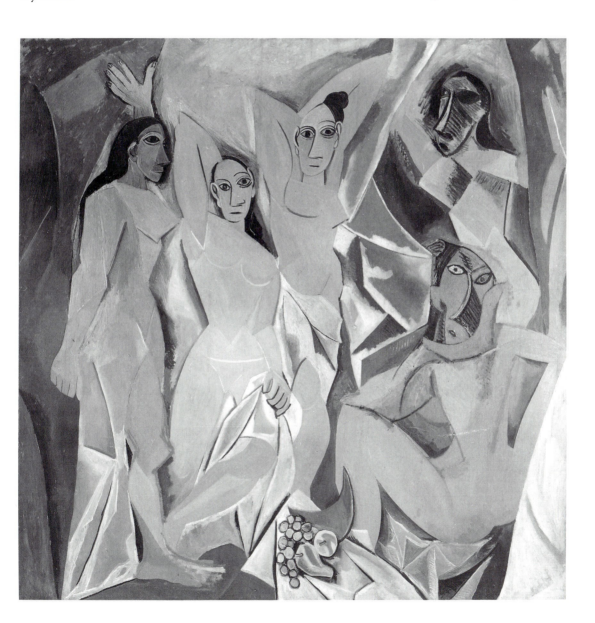

Although few of Picasso's vanguard contemporaries could bear the full impact of the *Demoiselles* (Picasso himself would never again go quite as far), they upheld its essential meaning. They, too, advocated the otherness of woman, and asserted with all their artistic might the old idea that culture in its highest sense is an inherently male endeavor. Moreover, with Picasso, they perpetuated it in a distinctly modern form, refining and distilling it to a pure essence: from this decade dates the notion that the wellsprings of authentic art are fed by the streams of male libidinous energy. Certainly artists and critics did not consciously expound this idea. But there was no need to argue an assumption so deeply felt, so little questioned and so frequently demonstrated in art. I refer not merely to the assumption that erotic art is oriented to the male sexual appetite, but to the expectation that significant and vital content in *all* art presupposes the presence of male erotic energy.

The nudes of the period announce it with the most directness; but landscapes and other subjects might confirm it as well, especially when the artist invokes aggressive and bold feeling, when he "seizes" his subject with decisiveness, or demonstrates other supposedly masculine qualities. Vlaminck, although primarily a landscape painter, could still identify his paintbrush with his penis: "I try to paint with my heart and my loins, not bothering with style."[9] But the celebration of male sexual drives was more forcefully expressed in images of women. More than any other theme, the nude could demonstrate that art originates in and is sustained by male erotic energy. This is why so many "seminal" works of the period are nudes. When an artist had some new or major artistic statement to make, when he wanted to authenticate to himself or others his identity as an artist, or when he wanted to get back to "basics," he turned to the nude. The presence of small nude figures in so many landscapes and studio interiors—settings that might seem sufficient in themselves for a painting—also attests to the primal erotic motive of the artist's creative urge.

Kirchner's *Naked Girl Behind a Curtain* (dated 1907) makes just this connection with its juxtaposition of a nude, a work of primitive art and what appears to be a modern Brücke painting. The *Demoiselles,* with its many references to art of varied cultures, states the thesis with even more documentation. And, from the civilized walls of Matisse's *Red Studio* (1911) (Fig. 4.10) comes the same idea, now softly whispered. There, eight of the eleven recognizable art objects represent

female nudes. These literally surround another canvas, *The Young Sailor* (1906), as tough and "male" a character as Matisse ever painted. Next to the *Sailor* and forming the vertical axis of the painting is a tall, phallic grandfather clock. The same configuration—a macho male surrounded by a group of nude women—also appears in the preparatory drawings for the *Demoiselles,* where a fully clothed sailor is encircled by a group of posing and posturing nudes. Picasso eventually deleted him but retained his red drinking vessel (on the foreground table) and made its erect spout a pivotal point in the composition.[10] Another phallocentric composition is Kirchner's much-reproduced *Self-Portrait with Model* (1910) (Fig. 4.11). In the center, Kirchner himself brandishes a large, thick, red-tipped paintbrush at groin level, while behind him cringes a girl wearing only lingerie.

That such content—the linking of art and male sexuality—should appear in painting at precisely the moment when Freud was developing its theoretical and scientific base indicates not the source of these ideas but the common ground from which both artist and scientist sprang. By justifying

4.10 Matisse, *The Red Studio*, 1911, oil on canvas, 71¼ × 72¼″. New York, The Museum of Modern Art, Mrs. Simon Guggenheim Fund (photo: museum).

scientifically the source of creativity in male sexuality,[11] Freud acted in concert with young, avant-garde artists, giving new ideological shape and force to traditional sexist biases. The reason for this cross-cultural cooperation is not difficult to find. The same era that produced Freud, Picasso and D. H. Lawrence—the era that took Nietzsche's superman to heart—was also defending itself from the first significant feminist challenge in history (the suffragist movement was then at its height). Never before had technological and social conditions been so favorable to the idea of extending democratic and liberal-humanistic ideals to women. Never before were so many women and men declaring the female sex to be the human equals of men, culturally, politically and individually. The intensified and often desperate reassertions of male cultural supremacy that permeate so much early twentieth-century culture, as illustrated in the vanguard's cult of the penis, are both responses to and attempts to deny the new possibilities history was unfolding. They were born in the midst of this critical moment of male-female history, and as such, gave voice to one of the most reactionary phases in the history of modern sexism.

4.11 Kirchner, *Self-Portrait with Model*, 1910. Hamburg, Kunsthalle (photo: Elke Walford). Copyright Dr. W. and I. Henze, Campione d'Italia.

Certainly the sexist reaction was not the only force shaping art in the early twentieth century. But without acknowledging its presence and the still uncharted shock waves that feminism sent through the feelings and imaginations of men and women, these paintings lose much of their urgency and meaning. Moreover, those other historical and cultural forces affecting art, the ones we already know something about—industrialization, anarchism, the legacy of past art, the quest for freer and more self-expressive forms, primitivism, the dynamics of avant-garde art-politics itself, and so on—our understanding of these must inevitably be qualified as we learn more about their relationship to feminism and the sexist reaction.

Indeed, these more familiar issues often become rationalizations for the presence of sexism in art. In the literature of twentieth-century art, the sexist bias, itself unmentionable, is covered up and silently approved by the insistence on these other meanings. Our view of it is blocked by innocent-sounding generalizations about an artist's formal courageousness, his creative prowess or his progressive, humanistic values. But while we are told about the universal, genderless aspirations of art, a deeper level of consciousness, fed directly by the powerful images themselves, comprehends that this "general" truth arises from male experience alone. We are also taught to keep such suspicions suppressed, thus preserving the illusion that the "real" meanings of art are universal, beyond the interests of any one class or sex. In this way we have been schooled to cherish vanguardism as the embodiment of "our" most progressive values.

III

Our understanding of the social meanings of the art I have been considering—what these artists imply about society and their relationship to it—especially needs reevaluation. Much avant-garde painting of the early twentieth century is seen as a continuation of the nineteenth-century traditions of Romantic and Realist protest. Most of the artists whose names appear here were indeed heirs to this tradition and its central theme of liberation. Like others before them, they wished for a world in which man might live, think and feel, not according to the dictates of rationalized, capitalist society, but according to his own needs as an emotionally and sensually free human being.

The Fauves and the Brücke artists especially associated themselves with the cause of liberation, although in different national contexts. The French artistic bohemia in which the Fauves matured enjoyed a long tradition of sympathy and identification with vanguard politics.[12] In the first decade of the century, the anarchist ideas that so many Neo-Impressionists had rallied to in the previous generation were still nurtured. (Picasso, too, moved in anarchist circles in Barcelona before he settled in Paris.) The heyday of the artist bomb-thrower was over, but the art-ideology of the avant garde still interpreted flamboyant, unconventional styles of art and behavior as expressions of anarchist sentiments. The young Fauves understood this, and most of them enjoyed (at least for a time) being publicized as wild anarchists out to tear down the establishment. Germany, on the other hand, more recently organized as a modern, bourgeois state, had only begun to see artist-activists; traditionally, dissident German artists and intellectuals withdrew from society and sought solace in transcendental philosophies. In accord with this tradition, Brücke artists were programatically more hostile to cities than the Fauves, and more fervent nature-lovers.[13] They were also more organized and cohesive as a group. In a Dresden shop, they established a communal studio where they worked and lived together in what we would call today an alternative lifestyle. Yet, however distinct from the Fauves, they embraced many of the same ideals. At the outset, they announced their opposition to the rationalism and authoritarianism of modern industrial life. The banner they waved was for free, individual self-expression and the rehabilitation of the flesh.

The two groups shared both an optimism about the future of society and the conviction that art and artists had a role to play in the creation of a new and freer world. For them, as for so many of their vanguard contemporaries and successors, the mission of art was liberation—individual, not political. Liberal idealists at heart, they believed that artists could effect change simply by existing as individual authentic artists. In their eyes, to exercise and express one's unfettered instinctual powers was to strike a blow against, to subvert, the established order. The idea was to awaken, liberate and unleash in others creative-instinctual desires by holding up visions of reality born of liberated consciousness. That only an educated, leisured and relatively non-oppressed few were prepared to respond to their necessarily unconventional and avant-garde language was generally ignored.

The artist, then, exemplified the liberated individual *par excellence,* and the content of his art defined the nature of liberated experience itself. Such ideas were already present in the nineteenth century, but in that decade before World War I, young European painters took to them with new energy and excitement. More than anything else, the art of this decade depicts and glorifies what is unique in the life of the artist—his studio, his vanguard friends, his special perceptions of nature, the streets he walked, the cafés he frequented. Collectively, early vanguard art defines a new artist type: the earthy but poetic male, whose life is organized around his instinctual needs. Although he owes much to the nineteenth century, he is more consciously anti-intellectual—more hostile to reason and theory—and more aggressive than any of his predecessors. The new artist not only paints with heart and loins, he seizes the world with them and wrenches it out of shape. And he not only experiences his instinctual nature with more intensity than those trapped in the conventional guilt-ridden world; his bohemian life offers him more opportunities to gratify his purely physical needs.

According to the paintings of the period, sexually cooperative women are everywhere available in the artist's environment, especially in his studio. Although they were sometimes depicted as professional models posing for their hourly wage, they usually appear as personal possessions of the artist, part of his specific studio and objects of his particular gratification. Indeed, pictures of studios, the *inner sanctum* of the art world, reinforce more than any other genre the *social* expectation that "the artist" is categorically a male who is more consciously in touch with his libido than other men and satisfies its purely physical demands more frequently. The nudes of Van Dongen, Kirchner and Modigliani often read as blatant pre- or postcoital personal experiences, and, according to much Brücke art, that communal studio in Dresden was overrun by naked, idle girls.

However selective these views of bohemia are, some social reality filters in—enough to identify the nameless, faceless women who congregate there in such numbers and offer their bodies with such total submission. Their social identity is precisely their availability as sex objects. We see them through the eyes of the artist, and the artist, despite his unconventional means, looked at them with the same eyes and the same class prejudices as other bourgeois men. Whatever the class situation of the actual models, they appear in these pictures as lower-class women who live off their bodies. Unlike gen-

eralized, classical nudes, they recline in the specified studio of the artist and take off contemporary—and often shabby—clothes. The audience of that time would instantly recognize in them the whole population of tarty, interchangeable and *socially* faceless women who are produced in quantity in modern, industrialized societies: mistresses of poor artists drawn from the hand-to-mouth street world of bohemia, whores, models (usually semi-professional whores), and an assortment of low-life entertainers and bar-flies. Whatever their dubious callings, they are not presented as respectable middle-class women. Indeed, by emphasizing their lower-class identity, by celebrating them as mere sexual objects, these artists forcefully reject the modesty and sexual inhibitedness of middle-class women as well as the social demands their position entitles them to make. Thus the "liberated" artist defined his liberation by stressing the social plight of his models and his own willingness to exploit them sexually.

For, despite the antibourgeois stance of these artists and their quest for a liberated vision, they rarely saw the social oppression before them, particularly that yoke which the bourgeoisie imposed upon womankind at large and on poor women in particular. The women that Toulouse-Lautrec painted and sketched were surely no better off socially than the women in these pictures. But where he could look through class differences and sordid situations, and still see sympathetic human beings, these young men usually saw only sexually available objects. Usually but not always. Two paintings of the same cabaret dancer, painted by Derain and Vlaminck on the same day, make a significant contrast. The woman in Derain's work, *Woman in Chemise* (1906) (Fig. 4.12), looks uncomfortable and unsure of herself before the gaze of the artist. Her awkward, bony body is self-consciously drawn together, and a red, ungainly hand, exaggerated by the artist, hovers nervously at her side. The artist's social superiority and the model's shabbiness are acknowledged, but not enjoyed or celebrated. Despite her dyed hair and make-up, the woman is seen as an authentic subjective presence who commands serious attention, unbeautiful but human. In Vlaminck's *Dancer at the "Rat Mort"* (1906) (Fig. 4.13) the same woman in the same pose is a brassy, inviting tart, a mascara-eyed sexual challenge. Set against a pointillist burst of color—those dots that were so beloved by the previous generation of anarchists—she is all black stockings, red hair, white flesh and a cool, come-on look. Vla-

minck, the avowed anarchist, is as thrilled by her tawdry allure as any bourgeois out for an evening of low life.

The socially radical claims of a Vlaminck, a Van Dongen or a Kirchner are thus contradicted. According to their paintings, the liberation of the artist means the domination of others; his freedom requires their unfreedom. Far from contesting the established social order, the male-female relationship that these paintings imply—the drastic reduction of women to objects of specialized male interests—embodies on a sexual level the basic class relationships of capitalist society. In fact, such images are splendid metaphors for what the wealthy collectors who eventually acquired them did to those beneath them in the social as well as the sexual hierarchy.

However, if the artist is willing to regard women as merely a means to his own ends, if he exploits them to achieve his boast of virility, he in his turn must merchandise and sell himself, or an illusion of himself and his intimate life, on the open avant-garde market. He must promote (or get dealers and critic friends to promote) the value of his special credo, the authenticity of his special vision, and—most importantly—the genuineness of his antibourgeois antagonism. Ul-

4.12 (left) André Derain, *Woman in Chemise*, 1906. Copenhagen, Statens Museum for Kunst (photo: museum).

4.13 (right) Vlaminck, *Dancer at the "Rat Mort,"* 1906. Paris, private collection.

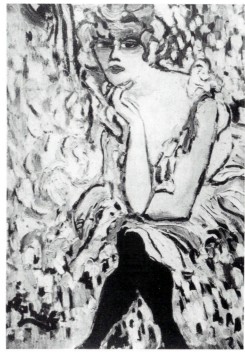

timately, he must be dependent on and serve the pleasure of the very bourgeois world (or enlightened segments of it) that his art and life appear to contest.[14] Here he lives a moral-social contradiction that is the corollary to his psychological dilemma before the sphere of woman/nature. The artist wants to but cannot escape the real world of rationalized bourgeois society. He is as tied to it economically as he is bound within its cultural and psychological constructs.

The enlightened art collector who purchased these works, then as now, entered a complex relationship with both the object he purchased and the artist who made it. On the most obvious level, he acquired ownership of a unique and—if he had taste—valuable and even beautiful object. He also probably enjoyed giving support and encouragement to the artist, whose idealism he might genuinely admire. At the same time, he purchased a special service from the artist, one that is peculiarly modern. In the sixteenth, seventeenth and eighteenth centuries, the wealthy patron often owned outright both the object he purchased and its erotic content. Frequently he specified its subject and even designated its model, whose services he might also own. The work bore witness not to the artist's sexual fantasies or libertine lifestyle (the artist could hardly afford such luxuries), but to the patron's. The erotic works commissioned by famous eighteenth-century courtesans were equally addressed to their male benefactors. In these twentieth-century images of nudes, however, the willfully assertive presence of the artist stands between the patron and the erotic situation represented. It is clearly the artist's life situation that is depicted; it is for him that these women disrobe and recline. And the image itself, rendered in a deliberately individual and spontaneous style, is saturated with the artist's unique personality. The collector, in fact, is acquiring or sharing another man's sexual-aesthetic experience. His relationship to the nude is mediated by another man's virility, much to the benefit of his own sense of sexual identity and superiority. For these nudes are not merely high-culture versions of pornography or popular erotica. Often distorted and bestial, they are not always very erotic, and they may appeal to homosexual males as much as to heterosexuals. They are more about power than pleasure.

The relationship between the collector and the artist may be read in the monographs that art historians and connoisseurs so often write about painters of nudes. These usually praise the artist's frank eroticism, his forthright honesty and his healthy, down-to-earth sensuality. Often there are al-

lusions to his correspondingly free sex life. The better writ-
ers give close and detailed analyses of individual works,
reliving the artist's experience before the nude. At some
point, higher, more significant meanings are invoked, things
about the human condition, freedom, art and creativity—
or, if the writer is a formalist, about the artist's coloristic
advances, his stylistic precocity or his technical innovations.
It is the moment of rationalization, the moment to back
away and put abstractions between oneself and the real
content of the paintings.

The collector could enjoy the same closeness to and the
same distance from that content. What ensues in that col-
lapsing and expanding space is a symbolic transference of
male sexual mana from bohemian to bourgeois and also
from lower to upper classes. The process began with the
artist, who adopted or cultivated the aggressive, presumably
unsocialized sexual stance of the sailor or laborer. The con-
tent of his art—his choice of nameless, lower-class women
and his purely physical approach to them—established the
illusion of his non-bourgeois sexual character. In acquiring
or admiring such images, the respectable bourgeois identifies
himself with this stance. Consciously or unconsciously, he
affirms to himself and others the naked fact of male dom-
ination and sees that fact sanctified in the ritual of high
culture. Without risking the dangers that such behavior on
his own part would bring, he can appropriate the artist's
experience and still live peacefully at home. For he cannot
afford, and probably does not want, to treat his wife as an
object. He needs and values her social cooperation and emo-
tional presence, and to have these, he must respect her body
and soul.

What the painting on the wall meant to that wife can only
be imagined. A Van Dongen or a Kirchner was scandalous
stuff, and few matrons were prepared to accept such works
on their aesthetic merits. But no doubt there were women
who, proud of their modernity, could value them as emblems
of their own progressive attitudes and daring lack of prudery.
Finally, we can speculate that some women, frightened by
suffragist and emancipation movements, needed to reaf-
firm—not contest—their situation. The nude on the wall,
however uncomfortable it may have been in some respects,
could be reassuring to the wife as well as the husband. Al-
though it condoned libertinism, it also drew a veil over the
deeper question of emancipation and the frightening thought
of freedom.

1. See my "Esthetics of Power," *Heresies,* 1 (1977), reprinted in this volume.

2. For the iconography of late nineteenth-century painting, I consulted A. Comini, "Vampires, Virgins and Voyeurs in Imperial Vienna," in *Woman as Sex Object,* ed. L. Nochlin, New York, 1972, pp. 206–21; M. Kingsbury, "The Femme Fatale and Her Sisters," in ibid., pp. 182–205; R. A. Heller, "The Iconography of Edvard Munch's *Sphinx,*" *Artforum,* January 1970, pp. 56–62; and W. Anderson, *Gauguin's Paradise Lost,* New York, 1971.

3. M. Kozloff, *Cubism and Futurism,* New York, 1973, p. 91.

4. Matisse, in H. Chipp, *Theories of Modern Art,* Berkeley, Los Angeles, London, 1970, pp. 132–33.

5. S. Ortner, "Is Female to Male as Nature Is to Culture?" *Feminist Studies,* Fall 1972, pp. 5–31.

6. Ibid., p. 10.

7. R. Rosenblum, "The 'Demoiselles d'Avignon' Revisited," *Art News,* April 1973, pp. 45–48.

8. The crouching woman at the lower right, especially as Picasso rendered her in preparatory studies, is a familiar figure in primitive and archaic art. See Douglas Fraser, "The Heraldic Woman: A Study in Diffusion," *The Many Faces of Primitive Art,* ed. D. Fraser, Englewood Cliffs, N.J., 1966, pp. 36–99. Anyone familiar with these symmetrical, knees-up, legs-spread figures can have little doubt that Picasso's woman was inspired by one of them. Grotesque deities with complex meanings, they are often in the act of childbirth, and in primitive villages they frequently occupied the place above the door to the men's lodge, the center of culture and power. Often, they were meant to frighten enemies and were considered dangerous to look at. They surely functioned ideologically, reinforcing views of women as the "other." Picasso intuitively grasped their meaning.

9. Vlaminck, in Chipp, *Theories,* p. 144.

10. Leo Steinberg discusses the phallic meaning of this object in "The Philosophical Brothel, Part I," *Art News,* September 1972, pp. 25–26. The juxtaposition of the phallus and the squatting nude especially recalls the self-displaying figures Fraser studies (see note 8), since they were sometimes flanked by phalli.

11. Philip Rieff, *Freud: The Mind of the Moralist,* New York, 1959, Ch. 5.

12. F. Nora, "The Neo-Impressionist Avant-garde," in *Avant-garde Art,* New York, 1968, pp. 53–63; and E. Oppler, *Fauvism Re-examined,* New York and London, 1976, pp. 183–95.

13. B. Myers, *The German Expressionists,* New York, 1957; and C. S. Kessler, "Sun Worship and Anxiety: Nature, Nakedness and Nihilism in German Expressionist Painting," *Magazine of Art,* November 1952, pp. 304–12.

14. R. Poggioli, "The Artist in the Modern World," in M. Albrecht, J. Barnett, and M. Griff, eds., *The Sociology of Art and Literature: A Reader,* New York, 1970, pp. 669–86.

THE ESTHETICS OF POWER IN MODERN EROTIC ART

In this essay, I am using the term erotic not as a self-evident, universal category, but as a culturally defined concept that is ideological in nature. More specifically, I am arguing that the modern art that we have learned to recognize and respond to as erotic is frequently about the power and supremacy of men over women. Indeed, once one begins to subject erotic art to critical analysis, to examine the male-female relationships it implies, one is struck with the repetitiousness with which the issue of power is treated. The erotic imaginations of modern male artists—the famous and the forgotten, the formal innovators and the followers—re-enact in hundreds of particular variations a remarkably limited set of fantasies. Time and again, the male confronts the female nude as an adversary whose independent existence as a physical or spiritual being must be assimilated to male needs, converted to abstractions, enfeebled or destroyed. So often do such works invite fantasies of male conquest (or fantasies that justify male domination) that the subjugation of the female will appear to be one of the primary motives of modern erotic art.

In Delacroix's *Woman in White Stockings* (1832) (Fig. 5.1), for example, an artist's model (i.e., a sexually available woman) reclines invitingly on a silken mattress. The deep red drapery behind her forms a shadowy and suggestive opening. The image evokes a basic male fantasy of sexual confrontation, but the model does not appear to anticipate pleasure. On the contrary, she appears to be in pain, and the signs of her distress are depicted as carefully as her alluring

A slightly longer version of this essay was first published in *Heresies* 1 (January 1977), 46–50. It was reprinted in *Feminist Art Criticism. An Anthology,* ed. Arlene Raven, Casandra Langer and Joanna Frueh (Ann Arbor/ London: UMI Research Press, 1988), 59–69. My gratitude to Flavia Alaya and Joan Kelly-Gadol, whose own work and conversation have enriched and clarified my thinking.

flesh. Her face, partly averted, appears disturbed, her torso is uncomfortably twisted, and the position of her arms suggests surrender and powerlessness. But this distress does not contradict the promise of male gratification. Rather, it is offered as an explicit *condition* of male pleasure—the artist's and the viewer's.

The equation of female sexual experience with surrender and victimization is so familiar in what our culture designates as erotic art and so sanctioned by both popular and high cultural traditions, that one hardly stops to think it odd. The Victorian myth that women experience sex as a violation of body or spirit or both, and that those who actively seek gratification are perverse (and hence deserving of degradation), is but one of many ideological justifications of the sexual victimization of women devised by the modern era. In the 20th century, the theory and practice of psychology has given new rationalizations to the same underlying thesis.

The visual arts are crowded with images of suffering, exposed heroines—slaves, murder victims, women in terror,

5.1 Eugène Delacroix, *Woman in White Stockings (La Femme aux bas blancs)*, c. 1832. Paris, Louvre (photo: Les Musées Nationaux, Paris).

under attack, betrayed, in chains, abandoned or abducted. Delacroix's *Death of Sardanapalus* (1827), inspired by a poem by Byron, is a *tour de force* of erotic cruelty. Ingres' *Roger and Angelica* (1867) also depicts woman as victim. Here, an endangered and helpless heroine—naked, hairless and swooning—is chained to a large, phallic-shaped rock, immediately below which appear the snake-like forms of a dragon. This fantastic but deadly serious statement documents a common case of male castration anxiety. But the artist-hero (he is Ingres-Roger) masters the situation: he conquers the dangerous female genitals. First he desexualizes Angelica—reduces her to an unconscious mass of closed and boneless flesh; then he thrusts his lance into the toothy opening of the serpent—Angelica's vagina transposed. Given the fears such an image reveals, it is no wonder that Ingres idealized helpless, passive women. The point here, however, is that neither Ingres' fears nor his ideal woman were unique to him.

Americans, too, thrilled to images of female victims. Hiram Power's *The Greek Slave* (1843) (Fig. 5.2) was probably the most famous and celebrated American sculpture in the mid-19th century. Overtly, the viewer could admire the

5.2 Hiram Powers, *The Greek Slave*, 1843, marble. In the Collection of The Corcoran Gallery of Art, Washington, D.C. Gift of William Wilson Corcoran (photo: gallery).

III

virtuous modesty with which Powers endowed the young slave girl, as did critics in the 19th century; but covertly, Powers invites the viewer to imagine himself as the potential oriental buyer of a beautiful, naked, humiliated girl who is literally for sale (he specified that she is on the auction block). The narrative content of this sculpture supports the same underlying thesis we saw in the Delacroix: for women, the sexual encounter must entail pain and subjugation, and that subjugation is a condition of male gratification. But even in paintings where nudes are not literally victims, female allure is treated in terms related to victimization. For Ingres, Courbet, Renoir, Matisse and scores of other modern artists, weakness, mindlessness and indolence are attributes of female sexiness. Germaine Greer's description of the female ideal that informs modern advertising could as well have been drawn from modern nudes:

Her essential quality is castratedness. She absolutely must be young, her body hairless, her flesh buoyant, and *she must not have a sexual organ*.[1]

That is, in the modern era, woman's desirability increases as her humanity and health (relative to male norms) are diminished.

The need to see women as weak, vapid, unhealthy objects—while not unique to the modern era—is evidently felt with unusual intensity and frequency in bourgeois civilization, whose technical advances so favor the idea of sexual equality. Indeed, as women's claims to full humanity grew, the more relentlessly would art rationalize their inferior status. For while literature and the theatre could give expression to feminist voices, the art world acknowledged only male views of human sexual experience. In that arena, men alone were free to grapple with their sexual aspirations, fantasies and fears. Increasingly in the modern era, artists and their audiences agreed that serious and profound art is likely to be about what men think of women. In fact, the defense of male supremacy must be recognized as a central theme in modern art. Gauguin, Munch, Rodin, Matisse, Picasso and scores of other artists, consciously or unconsciously, identified some aspect of the sexist cause with all or part of their own artistic missions. Art celebrating sexist experience was accorded the greatest prestige, given the most pretentious esthetic rationales, and identified with the highest and deepest of human aspirations.

Nudes and whores—women with no identity beyond their

existence as sex objects—were made to embody transcend-ent, "universally" significant statements. In literature as in art, the image of the whore even came to stand for woman in her purest, most concentrated form, just as the brothel became the ultimate classroom, the temple in which men only might glimpse life's deepest mysteries: "A Henry Miller, going to bed with a prostitute [in *Tropic of Cancer*], feels that he sounds the very depths of life, death and the cosmos."[2] Picasso's famous brothel scene, the *Demoiselles d'Avignon* (1907) (Fig. 4.9), where the viewer is cast as the male cus-tomer, makes similar claims—claims that art historians ad-vocate as "humanistic" and universal.[3] Art-making itself is analogous to the sexual domination of whores. The metaphor of the penis-as-paintbrush is a revered truth for many 20th-century artists and art historians. It also insists that to create is to possess, to dominate, and to be quintessentially male.

I try to paint with my heart and my loins, not bothering with style (Vlaminck).[4]

Thus I learned to battle the canvas, to come to know it as a being resisting my wish (dream), and to bend it forcibly to this wish. At first it stands there like a pure chaste virgin . . . and then comes the willful brush which first here, then there, gradually conquers it with all the energy peculiar to it, like a European colonist. . . . (Kandinsky).[5]

The kind of nudes that prevail in the modern era do not merely reflect a collective male psyche. They actively pro-mote the relationships they portray, not only expressing but also shaping sexual consciousness. For the nude, in her pas-sivity and impotence, is addressed to women as much as to men. Far from being merely an entertainment for males, the nude, as a genre, is one of many cultural phenomena that teaches women to see themselves through male eyes and in terms of dominating male interests. While it sanctions and reinforces in men the identification of virility with domina-tion, it holds up to women self-images in which even sexual self-expression is prohibited. As ideology, the nude shapes our awareness of our deepest human instincts in terms of domination and submission so that the supremacy of the male "I" prevails on that most fundamental level of experience.

Twentieth-century art has equally urged the victimization and spiritual diminution of women, shedding, however, the narrative trappings and much of the illusionism of the 19th century. The abandoned Ariadnes, endangered captives and cloistered harem women of 19th-century art become simply

naked models and mistresses in the studio or whores in the brothel. In nudes by Matisse, Vlaminck, Kirchner, Van Dongen and others, the demonstration of male control and the suppression of female subjectivity is more emphatic and more frequently asserted than in 19th-century ones. Their faces are more frequently concealed, blank or mask-like (that is, when they are not put to sleep), and the artist manipulates their passive bodies with more liberty and "artistic" bravado than ever.

The image of the femme fatale, especially popular at the turn of the century, would seem to contradict the image of woman as victim. Typically, she looms over the male viewer, fixing him with a mysterious gaze and rendering him willless. Yet she is born of the same set of underlying fears as her powerless, victimized sisters, as the depictions often reveal. Munch's *Madonna* (1893–94) (Fig. 5.3), a femme fatale *par excellence,* visually hints at the imagery of victimization. The familiar gestures of surrender (the arm behind the head) and captivity (the arm behind the back, as if bound) are clearly

5.3 Munch, *Madonna*, 1893–94. Oslo National Gallery (photo: Jacques Lathion).

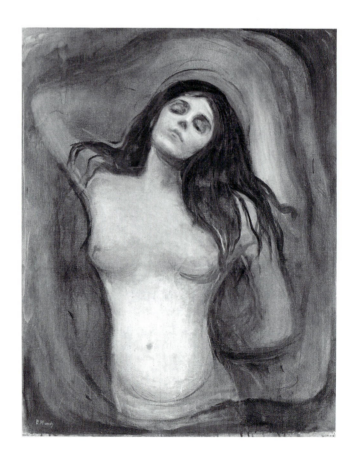

if softly stated. These gestures have a long history in Western art. The dying *Daughter of Niobe,* a well-known Greek sculpture of the 5th century B.C., exhibits exactly this pose. The raised arm is also seen in numerous 5th-century statues of dying Amazons and sleeping Ariadnes, where it conveys death, sleep or an overwhelming of the will. It may also convey the idea of lost struggle, as in the Amazon statues or in Michaelangelo's *Dying Captive* (The Louvre), themselves masterpieces of victim imagery with strong sexual overtones. But in the modern era, the raised arm (or arms) is emptied of its classical connotation of defeat with dignity and becomes almost exclusively a female gesture—a signal of sexual surrender and physical availability. Munch used it in his *Madonna* to mitigate his assertion of female power; the gesture of defeat subtly checks the dark, overpowering force of Woman. The same ambivalence can also be seen in the spatial relationship between the figure and the viewer: the woman can be read as rising upright before him or as lying beneath him.

However lethal to the male, the late 19th-century femme fatale of Munch, Klimt and Moreau ensnares by her physical beauty and sexual allure. In the 20th century, she becomes bestial, carnivorous and visibly grotesque. In images of monstrous females by Picasso, Rouault, the Surrealists and de Kooning, the dread of woman and male feelings of inferiority are projected, objectified and universalized. Yet here too the devouring woman implies her opposite, combining features of both the powerless and the threatening. The women in Picasso's *Demoiselles d'Avignon,* although physically mutilated and naked (vulnerable), aggressively stare down the viewer, are impenetrably masked, and display sharp-edged, dangerous-looking bodies. Picasso ambivalently presents them with sham and real reverence in the form of a desecrated, burlesque icon, already slashed to bits. De Kooning, in his continuing *Woman* series (Fig. 5.4), ritually invokes, objectifies and obliterates the same species of goddess-whore. Here too a similar ambivalence finds its voice in shifting, unstable forms whose emergence and destruction are accepted in the critical literature as the conscious "esthetic" pretext for his work. The pose his figures usually take—a frontal crouch with thighs open to expose the vulva—also appears in the *Demoiselles d'Avignon* (in the lower right figure), which, in turn, derives from primitive art. Like Picasso's figures, de Kooning's women are simultaneously inviting and repelling, above and below the viewer, obscene modern whores and terrifying primitive deities.

The pronounced teeth in de Kooning's *Woman and Bicycle* (1950)—the figure actually has a second set around her throat—also speak of primitive and modern neurotic fears of the female genitals. The *vagina dentata,* an ancient fantasy into which males project their terror of castration—of being swallowed up or devoured in their partner's sexual organs—is commonly represented as a toothed mouth. The image, which appears frequently in modern art, is a striking feature of Miró's *Woman's Head* (1938) (Fig. 5.5). The savage creature in this painting has open alligator jaws protruding from a large, black head. The red eye, bristling hairs and exaggerated palpable nipples, in combination with the thin weak arms, help give it that same mixture of comic improbability and terribleness that characterize Picasso's *Demoiselles* and de Kooning's *Women.* But in addition—and true to Miró's love of metamorphosing forms—the image can be read literally as the lower part of a woman's body, seen partly as if through an X ray. Inverted, the arms become open legs, the dark, massive head a uterus, and the long, dangerous jaws a toothed vaginal canal. The predatory creature in Picasso's *Seated*

5.4 Willem de Kooning, *The Visit*, 1966–67. London, The Tate Gallery (photo: author).

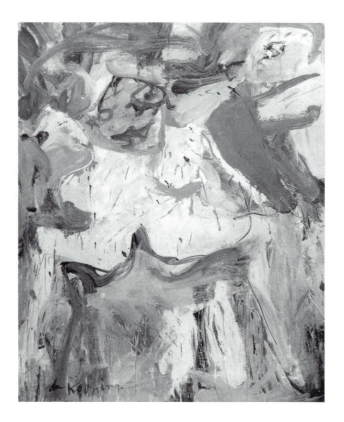

Bather (1929) not only has saw-toothed jaws, but several features of the praying mantis.

The praying mantis, who supposedly devours her mate, was a favorite theme in Surrealist art and literature. In paintings by Masson, Labisse, Ernst and others, the cannibalistic sexual rites of this insect become a metaphor for the human sexual relationship, and the female of the species becomes the Surrealistic version of the femme fatale. More subhuman and brutal than her 19th-century predecessors, she testifies to the higher level of sexual anxiety and hostility experienced by the 20th-century male. For as women increasingly demanded a share of the world, the defense of male authority became more desperate:

Now become a fellow being, woman seems as formidable as when she faced man as a part of alien Nature. In place of the myth of the laborious honeybee or the mother hen is substituted the myth of the devouring female insect: the praying mantis, the spider. No longer is the female she who nurses the little ones, but rather she who eats the male.[6]

Pictures of nudes in nature also affirm the supremacy of the male consciousness even while they ostensibly venerate or pay tribute to women as freer or more in harmony with nature than men. In 19th- as well as 20th-century paintings—Romantic, Symbolist or Expressionist—female nudes in out-

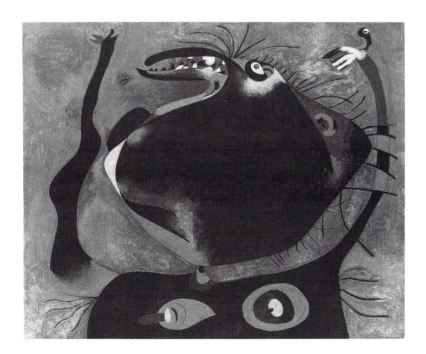

5.5 Joan Miró, *Woman's Head*, 1938. The Minneapolis Institute of Arts (photo: Institute).

door settings are treated as natural inhabitants of the landscape. In modern art, this woman-nature realm appears as an alluring invitation to sensual and imaginative experience. But for a middle-class male to enter that realm, even imaginatively, he must shed, along with his social identity and ego, a sense of his power to shape and control his world.[7] Significantly, men in nature almost always wear clothes and engage in cultural activity. And they live in real, historical time. Matisse's *Boy with Butterfly Net* (1907) is a magnificent image of a modern male in nature (or rather a male acting against nature), highly individualized and properly equipped for a specific purpose. Even when they are naked, like the men in Brücke and Fauve swimming scenes, they still act in a cultural, not a purely natural, context: going swimming is a modern recreation. The female bather, who has no male counterpart in modern art, lives outside of culture. Michelet, the 19th-century historian, poetically expressed the ideas implicit in the genre: man, he wrote, creates history, while woman:

follows the noble and serene epic that Nature chants in her harmonious cycles, repeating herself with a touching grace of constancy and fidelity. . . . Nature is a woman. History, which we very foolishly put in the feminine gender, is a rude, savage male, a sunburnt, dusty traveller. . . .[8]

Even in Matisse's *Joy of Living* (1906), where men and women share an Arcadian life, cultural activities (music-making, animal husbandry) are male endeavors while women exist merely as sensual beings or abandon themselves to emotionally expressive but artless and spontaneous dance.

How we relate to these works becomes a compelling issue once their sexual-political content is apparent. The issue, however, is difficult to grasp without first coming to terms with the ideological character of our received notions of art. For in our society, art—along with all high culture—has replaced religion (that is, among the educated) as the repository of what we are taught to regard as our highest, most enduring values. As sanctified a category as any our society offers, art silently but ritually validates and invests with mystifying authority the ideals that sustain existing social relations. In art, those ideals are given to us as general, universal values, collective cultural experience, "our" heritage, or as some other abstraction removed from concrete experience. Physically and ideologically, art is isolated from the rest of

life, surrounded with solemnity, protected from moral judgement. Our very encounters with it in museums, galleries and art books are structured to create the illusion that the significance of art has little or nothing to do with the conflicts and problems that touch common experience. Established art ideologies reinforce this illusion. According to both popular and scholarly literature, true artistic imaginations transcend the ordinary fantasies, the class and sex prejudices and the bad faith that beset other human minds. Indeed, most of us believe that art, by definition, is always good—because it is of purely esthetic significance (and the purely esthetic is thought to be good), or because it confirms the existence of the imagination and of individualism, or because it reveals other "timeless" values or truths. Most of us have been schooled to believe that art, *qua* art, if it is "good" art, is never bad *for* anyone, never has anything to do with the oppression of the powerless, and never imposes on us values that are not universally beneficial.

The modern masterpieces of erotic art that I have been discussing enjoy this ideological protection even while they affirm the ideals of male domination and female subjugation. Once admitted to that high category of Art, they acquire an invisible authority that silently acts upon the consciousness, confirming from on high what social customs and law enforce from below. In their invisible and hence unquestioned authority, they proclaim—without acknowledging it—what men and women can be to themselves and to each other. But once that authority is made visible, we can see what is before us: art and artists are made on earth, in history, in organized society. And in the modern era as in the past, what has been sanctified as high art and called True, Good and Beautiful is born of the aspirations of those who are empowered to shape culture.

NOTES

1. *The Female Eunuch* (New York, 1972), p. 57.
2. Simone de Beauvoir, *The Second Sex* (New York, 1961), p. 181.
3. Leo Steinberg, "The Philosophical Brothel, Part I," *Art News* (Sept., 1972), pp. 20–29; and Gert Schiff, "Picasso's Suite 347, or Painting as an Act of Love," in *Woman as Sex Object,* ed. Thomas B. Hess and Linda Nochlin (New York, 1972), pp. 238–253.
4. In Herschel B. Chipp, *Theories of Modern Art* (Berkeley, 1970), p. 144.
5. Quoted in Max Kozloff, "The Authoritarian Personality in Modern

Art," *Artforum* (May, 1974), p. 46. Schiff, op. cit., actually advocates the penis-as-paintbrush metaphor.

6. De Beauvoir, op. cit., p. 179.
7. Sherry Ortner, "Is Female to Male as Nature Is to Culture?" *Feminist Studies,* 1, No. 2 (Fall, 1972), p. 10.
8. Jules Michelet, *Woman (La Femme),* trans. J. W. Palmer (New York, 1860); pp. 104–105.

WHEN GREATNESS IS A
BOX OF WHEATIES

I used to say the thing in this country was to be like a box of Wheaties—to turn out a product so that everyone knew you by that product.

Alice Neel

The relationship between art criticism and feminism has still to be carefully considered. What does a feminist critic do? In what context should she seek to understand women's art? What is her relationship to women artists, old and young, feminist and not? Are the professional interests of criticism compatible with those of feminism? Critics have still to give these questions serious thought.

Nothing could reveal less thought of this kind than Cindy Nemser's *Art Talk: Conversations with Twelve Women Artists* (New York. 1975). And nothing better magnifies the need to sort out and examine critical and feminist values. That *Art Talk* exploits the women's movement is not the real issue. The social conditions that give rise to, and are perpetuated through, such books are. *Art Talk* teaches us that until we have figured out how these conditions affect people, we will not understand women artists as women or as professional artists.

Art Talk looks rather like other trade books about artists. Each of its 12 chapters is devoted to a single artist (Barbara Hepworth, Sonia Delaunay, Louise Nevelson, Lee Krasner, Alice Neel, Grace Hartigan, Marisol, Eva Hesse, Lila Katzen, Eleanor Antin, Audrey Flack and Nancy Grossman). The difference, aside from the fact that all the artists are women, is that each chapter is taken from tape-recorded conversations between Nemser and the artist. In these dialogues, the artists

This essay was first published in *Artforum* (October 1975), 60–64. It is reprinted here by permission of *Artforum* Magazine, Inc.

talk about their personal lives and their careers, the art world, feminism and other topics. As entertainment, the gossip and the life talk are far more vivid and moving than the art talk. Flashes of personalities caught by the tape recorder and pieces of lived experience that the women recount enliven many of its pages and give it what literary virtues it has. However, talk is often guarded—after all, it was being taped for a book—and conversations often become exchanges of empty generalizations and solemnly pronounced platitudes.

Art Talk, then, is an assemblage of diverse materials and voices. The one constant voice, however, is Nemser's. She sets the tone and purpose of the book and is very much a part of the dialogues. In the latter, she frames questions, offers opinions, changes the subject and frequently imposes her own interpretations on what the artists say about themselves and their work. Her views, which permeate *Art Talk,* do not proceed from any substantive or developed thesis about women artists or art. Rather, they arise from a set of values and concepts for which she seeks confirmation in her dialogues with artists.

Her introduction leads the reader through a series of contradictory and unsubstantiated statements. Her key term is "greatness." *Art Talk* is dedicated to the celebration of that quality in women artists. Nemser does not define it, but she tells us where to look for it: "I believe it will become clear that the highest accomplishment, greatness, in female artists is a rule rather than an exception." However, on the following page, we learn that "greatness is not found *en masse* either." We also read that great artists are, among other things, "awe inspiring," but "not always easy to deal with" and almost always "egocentric." Evidently, greatness is a marvelous but slightly unpleasant essence or property that adheres in people and things. Nemser emphasizes that greatness is not conditioned by historical or educational experience. Great women artists "achieve greatness no matter what the odds," and they "transcend it all in the service of their art." Greatness is not made; it just happens.

Nemser also tells us that women artists in all periods of history are as great as the greatest of their contemporary males, e.g. Michelangelo, Rembrandt and Cézanne, and that only bias and "art historical and critical brainwashing" have kept us ignorant of this fact.[1] The proof is before our eyes. "Without needing to delve into the past, we have before our eyes the awesome works of Louise Nevelson, Barbara Hepworth and Eva Hesse." Nemser is outraged that these and

other women artists have been denied "the power and prestige of their top male colleagues" and not allowed "to compete and take laurels among male peers." That is, simply being great is not sufficient to greatness; it demands rewards. *Art Talk* is meant to render women artists their due by changing things in the fields of criticism and art history. Nemser writes:

Well this feminist knew what she was fighting for. . . . I knew I would have to fight it [the status quo], to reverse it, to help win back for women artists their rightful place in the forefront of art history.

The mystery of greatness is immediately cleared up the moment one gets past the introduction. This greatness that resides in women artists, which bias has made invisible, turns out to be exactly the same greatness that is celebrated in men artists. Nemser does not question the authority of those notions of achievement against which women have been measured and found wanting; she affirms them and uses them to measure women. Specifically, she describes their achievements in the terms developed by established academic art history and orthodox criticism. Her aim is to represent women artists as the real innovators and leaders of "mainstream" vanguard art. She wants to establish that women did it, whatever it was, first. Why they did it is of secondary or no importance.

Accordingly, Hepworth created "vitalist" sculpture and was "the first to pierce the stone in 1931." The significance of piercing stone is not discussed. Sonia Delaunay was to be pushed into the role of *the* "moving force" behind another avant-garde movement (Orphism), but, as her interview makes clear, she protested so much that Nemser had to settle for giving her an "equal" role with her husband, Robert Delaunay. What Orphism was is not discussed, and apparently that question is not important to Nemser. Krasner is a co-inventor of the "over-all." She, "simultaneously with Pollock had taken the risk. . . ." Lila Katzen is credited with having influenced the stained paintings of Morris Louis, and so on. Each "first," or each portion of a "first," in being given to a woman, is taken away from a man. The reader must conclude that greatness is not self-evident in the *art* of great artists, for it waxes and wanes in relation to what other artists have done.

Nor is there allowance for the possibility that sometimes women artists, because they have been socially and psycho-

logically alienated from male–dominated vanguard groups, or disliked the role of women's auxiliary into which vanguard men have often pushed them, chose to go it alone. Georgia O'Keeffe, Louise Bourgeois, Alice Neel and Louise Nevelson are all women whose work was developed in relative social, psychological and artistic isolation, and I suspect that this is a common condition for much women's art in the 20th century. But the category of going it alone does not exist on Nemser's checklist of greatness. What happens to women and their art without the kind of group support that male vanguardists enjoy is consequently not asked, although Neel and Nevelson, who more or less take over their own interviews, make comments that may be relevant. Neel says, "It's sad to live on the shelf." Nevelson also talks about being, feeling alone (but Nemser tells her that "that seems to be the condition of the artist in our society"). In any case, Nemser explicitly denies that social or psychological isolation is a barrier to influencing avant-garde art, declaring this idea an "illogical rationale."

So the art talk in *Art Talk* is often taken up with who did what when and first. Nemser is so busy with her checklist, she does not do even the conventional job of the critic. She does not—nor does she let the reader—look closely at the art. The conversations, therefore, often read like short academic monographs. First there is the personal biography, then the art. (Neel insisted they were the same.) Chronological order is imposed as closely as possible (although Nevelson could not be controlled). Artistic influences and stylistic development are carefully noted, and any evidence to substantiate technical or formal innovation and influence is examined in detail. Artistic choices are given importance in relation to their subsequent popularity among other, preferably well-known, artists. Old masters are dragged in when Nemser thinks they are relevant for a contrast or a comparison (e.g. Nemser to Grossman: "These works don't resemble Picasso's collages of 'found objects' in that the things have not retained their original beauty").

The old art-historical lens, the one that rings a bell for new styles and art movements, is the one that relentlessly prevails in *Art Talk*. That lens, which dims or filters out lived experience, is well suited to measuring artists in relation to each other. It simplifies content by reducing it to general categories of style, subject matter, or materials. The kind of thinking it represents both fuels and justifies the particularly fierce spirit of competition and envy that eats into the souls of so

many artists. That spirit often hovers about the pages of *Art Talk*—in references to injuries that still fester, estranged friendships, comments about *other* artists' opportunism, and the willingness to hear one's work compared favorably to that of some close rival (I shall return to this subject of competition). Many of these artists decline to gossip, but enough of this comment remains in the edited text to reveal the not-very-astonishing truth that artists, whatever else they are, are as profoundly self-interested as the rest of us.

Nemser especially urges the older women to give evidence of their art-historical importance and also to testify against former male colleagues (and dead husbands) for having robbed them of the credit. Insofar as she has a thesis to prove, this is the crux of it. She is, moreover, convinced that the primary needs of all great artists are fame and prestige. What she appears not to understand is that great artists, particularly older, relatively neglected ones, can be fussy about who celebrates them and how and why they are celebrated. But Nemser, awestruck when near to greatness, does not notice such things as ordinary human pride.

Hence, her conversation with Sonia Delaunay, which revolves around Delaunay's *lack* of recognition, is a disaster. Nemser repeatedly tries to crown the eighty-nine-year-old artist with wreaths of achievement, but Delaunay keeps dodging her passes. Nemser tries a half-dozen ways to get her to say that she and not her husband Robert was "the moving force" behind Orphism. Delaunay does not cooperate. But Nemser won't take no for an answer. That is where feminism comes in. She tries to raise Delaunay's consciousness, i.e. to get her to admit how much she really wants a place in the forefront of art history for having innovated an important art movement.

Nemser: Isn't that one of the problems of being a woman artist? If you are married to a man who is an artist, you put his career first. You want him to prosper and then you have a tendency to efface yourself—to make yourself less important.

But Delaunay persists in claiming, even under extensive examination, that this kind of "importance" has nothing to do with making art. She alleges that she prefers "freedom of thinking and living" and making art "very much for myself" to "having a dealer" and making products that have to be exhibited and publicized, even though she engages in the latter. Nemser cannot believe this and is determined to *make* the old woman tell the truth: "You mean you really don't

care if your work is publicized or not?" "I don't care very much," answers Delaunay. But still Nemser presses her: "It seems extraordinary to me that you care so little about being recognized as a great artist." Delaunay does not think it is extraordinary and says things about how doing art is better than being recognized for doing it. Nemser knows that this is the subterfuge of an unraised consciousness and boldly continues her line of questioning. Finally, Delaunay, clearly repelled by Nemser's questions, erupts:

But I don't want it. It's a false idea you have—an American idea that artists must be famous. That's an idea of today.... Between me and painting there is nothing.

(Even then Nemser does not let up, but she never gets a confession.)

I do not want to leave the impression that specific works of art are never talked about in any depth or that they are discussed only in relation to other works of art. Some of the artists, as well as being gifted talkers, are intent on saying something about the ideas, feelings and experience they bring to their work. Neel, Antin and Grossman talk very much about their art in these terms. Flack and to some extent Marisol make interesting comments about their subject matter. Hartigan, on her *Grand Street Brides,* and Hesse, on the "absurdity" of her work, also provide moments in which artmaking is treated as something relevant to experience beyond the art world.

But talking about art is not the specialty of these professionals. Some of them get stuck with words so that meanings are left tentative, and they frequently indicate that interpreting art verbally does not interest them. Nemser often seems at a loss to bring them out, and sometimes, in seeming to agree with them, she contradicts them, a habit that is not conducive to conversation. Always her anxiousness to legitimize them as significant artists in established terms acts as a block to thinking, feeling and talking about their work in relation to the world beyond the art world. When Neel begins to talk about specific historical experience relative to a portrait of her son Hartly ("he was twenty-five and threatened with Viet Nam"), Nemser continues to declare the work "universal" in meaning, a portrait of "Everyman." Aside from whether or not a mother can see her son as Everyman, that is not what Neel was saying.

In the interview with Antin, the latter is pushed into an exchange that not only appears to silence her but also cuts

the center out of her work. Antin had been discussing *Carving: A Traditional Sculpture* (a series of unflattering photographs of herself nude, taken while dieting) and other works that grew out of her experience of herself as she is, in opposition to glamorous fantasy images that, as a woman, she has internalized. It is one of the few times in *Art Talk* that we hear someone with a highly raised consciousness whose work grows directly out of that consciousness. Nemser appears to be made uncomfortable by it and suggests that Antin's work is "universal." But Antin continues to talk about how *Carving* grew out of her experience of her body. Nemser puts an end to this by raising the question that everyone is asked:

But though your art is, of course, a woman's art because you did it, can it really be called *woman's art*—in the sense that *only* a woman could have done it? After all, couldn't some man have had the idea to do a piece of a woman dieting taking all the pictures and putting them up just as you did? If you didn't tell me, you, a woman, did it, how would I know the sex of the artist?

Antin appears surprised by the question, but then agrees that a man could have conceived it. The unlikeliness of that possibility is not discussed, and the subject is quickly changed.

Nemser's purpose is consistent with the logic of her main thesis: if women artists are as great as men artists, their art must not be different, *literally*. Greatness manifests itself in the same way all the time. It is a universal quality. Indeed, as Nemser must even sense herself, if its products are examined too closely in the context of specific human experience, e.g. being a woman in a woman's body, greatness as an essence begins to dissolve into the contingencies of life. In its preservation then, she must obliterate the idea that women's art can grow out of a consciousness and experience that is typically female. That idea threatens the acceptance of women's art as "normal" great art, indistinguishable from the "highest achievements" of patriarchal culture. Underneath it all, greatness is male.

Thus, while the question of female experience in relation to art often comes up, the way Nemser inevitably frames it (could not a man have made this work?) precludes any serious exploration of it. Nor does she express anything but contempt for organized women's art groups, characterizing them as competitive and without standards. Feminist art workshops and the problems that young women art students have in identifying with the role of the professional artist are never discussed. It is true that most of the women in the book

formed their identities as artists when the terms "artist" and "woman" were considered mutually exclusive. Indeed, theirs is the psychology of the exceptional woman, and despite the women's movement, most of them are still highly ambivalent about reconciling what for them is a contradiction: being a woman and an artist. Nevertheless, images of brides, mothers, babies, and cosmetics come up in their work as well as in the work of younger women. (Hepworth, Neel, Hartigan, Marisol, Antin, Flack and Grossman all treat one or another of these themes.) The pity is that the reader is never invited to consider in depth how each generation handled them and what kind of feelings they evoke in us.

Whatever Nemser thinks and feels about these works, she has not provided herself with a format in which she or others can give them serious attention. Certainly she appears to like art. But, with the exception of comments she makes to Krasner, she does not leave the impression that she is drawn to particular works *because they say something to her that she urgently feels should be said, because they give conscious shape to or illuminate some aspect of existence as she experiences it in a form that seems exactly right*. Instead, she identifies and catalogues. This cataloging, however, is consistent with her purpose. Nemser is not a critic, she is a publicizer. She publicizes things as art rather than explicating their qualities. The difference is not merely a literary one. In the art world, objects of art have double identities: they have interior meanings for their viewers, and value as commodities. Similarly, criticism advances the understanding of the values of the work as art, and by so doing augments its exchange value on the market. Since her ideology hobbles her insights into the work, her comment becomes blatant puffery.

Her failure to criticize, in combination with the artist-interview format, leaves these artists in a very ambiguous position, and a vulnerable one, too (but then, women often do end up in such positions). In our society, professional artists, even if they are more gifted as critics than most critics, cannot speak for the art value of their work in the same way that a critic does. Insofar as an artist seeks or even wants to maintain professional recognition—that is, if she wants to be an artist to someone other than herself and her friends—her work must have the value of art to others in her professional community. Someone other than the artist must buy it or exhibit it or treat it as art in some *demonstrable* way. Criticism is one of these demonstrations. But Nemser prizes the artists' statements only to confirm her propaganda about them as

individuals, not to illuminate her independent experience and judgment of their work. As a result, she not only imposes on us her own sycophantic and hence dehumanizing relationships to these women, but she also blocks our view of their work.

Because the artists in *Art Talk* get publicity and not criticism, they are left in the position of having to do their own mediating. As they have allowed themselves to be put in this position, they are all the more vulnerable. Talking about art with friends is one thing, but talking about it to a critic who does not criticize and who is holding a microphone and is going to make one's words the text of a book that claims things about one's contribution to mainstream vanguardism—that is something else. What can an artist say under such circumstances; or rather, what happens to her credibility under these circumstances?

Almost anything she says can appear to be self-promoting. The kind of artist-image she projects, how she talks about dealers and curators, whom she claims as artistic influences, what she says about her work and how it is distinguishable from the work of others—all this can be translated into plusses or minuses according to various critical value systems. (In fact, that is what Nemser's checklist is about.) Does she take care to name the year she became a friend of a now-famous and innovative artist because it is relevant to her work or because it credits her with having been among the *first* in some particular vanguard movement? Did she change her style for the esthetic reasons she gives? Was she as unaware of what others were doing as she says? It is no surprise that art-world people read interviews with artists with cynicism. The ambiguity of the situation calls for it. By failing to argue the value of the art as a genuine outsider, the critic provides a forum in which the artist can only appear as a publicity-seeker.

It is not cynicism that I propose as the attitude with which we approach *Art Talk*. On the contrary, Nemser inadvertently produces an opportunity to understand the conditions that create cynicism. If the words in this book are surrounded with ambiguity, and if it is uncomfortable to read, it is because the social discourse it records is uncomfortable and ambiguous. But the cause of this ambiguity, the failure of criticism, also opens a door. Because so many pieces of fact, fantasy and feeling float around unrelated or contradictory to the "thesis" they are supposed to demonstrate, the reader is allowed to glimpse what the "skilled" critic knows how to

conceal. Unwittingly, *Art Talk* reflects something of what happens throughout the art world—that complicated community that makes, exhibits, explains, promotes, buys and sells art. This world of social and economic relations, with all its clashing interests, creates a background racket throughout the book. The professional critic disguises or obliterates that sound by focusing the reader's attention only on the art in relation to other art, or immediate perception, or the artist's psychology and background, or cultural, social or historical experience. The socioeconomic relations of the art world itself, the social conditions in which works of art are produced, if they are pictured, appear idealized, sublimated as a process of cultural evolution, or as creative dialectics on the perimeters of the vanguard. But *Art Talk* is filled with contradictory pictures. No one of them firmly controls the book or gives it a unified ideology to which all the conflicting versions of reality can be assimilated.

In the gap between reality and ideology, the noise of the art world breaks through. In that world, hundreds of artists fight for the few critics, dealers, buyers and others who constitute a relevant audience for their work. There, every year, artists make thousands of works whose value as art is intelligible, accessible, and of interest to only a few people. Becoming visible, staying visible or becoming more visible to those few people consumes much of their time, energy and emotion. The artists in *Art Talk,* as experienced professionals, know that they must compete for attention and that their work will be judged in relation to the work of other artists. They know that they must compete with each other *through* their art even as they seek from each other the companionship of fellow professionals. They know what is selling and what is not, even if such considerations are unrelated to why they are artists. As artists they live capitalism and they live despite capitalism. Whether or not they like it and whether or not they are fully conscious of it, they must learn to think about their work in relation to the work of other artists if they want to survive.

There are few professions in which so much competition is covertly encouraged and overtly denied at the same time. Individual artists, however they try to make peace with this contradiction and whether or not they understand its causes, cannot transcend it. They live it—through the things they make or do, through what is said about those things, through what they say about themselves and look for in others, and above all, through their own ambitions, whose very shape

and substance reflect the relationships that constitute the art world. Committed to the values through which their art becomes intelligible—even while they anxiously calculate how to attract *away* from others and onto themselves the attention of those few available critics to whom their work is relevant—artists become cynical. As June Wayne has astutely observed, the cynicism of artists is founded on their sense of helplessness and finds expression in "hostile passivity."[2] Their situation, however, produces not only cynicism. It is not unusual to hear artists alternating rapidly between cynicism, artistic idealism and dreams of megalo-success.

Artists as professionals must compete, but they must not appear to compete. They need publicity, but must seek it in a form that is not publicity. They must not let their interests as professionals show.[3] At the same time, they are artists who seek social recognition as artists through their work. Publicity alone, or—as in *Art Talk*—barely disguised publicity, distorts their artistic seriousness and renders them as exploited objects.

Thus Nemser ends by reinforcing and capitalizing upon the very conditioning that oppresses artists in general and women artists in particular. Given the pressures that compel artists to seek critical attention, her offer to make a book of their words must have seemed attractive. But *Art Talk* perfectly exemplifies what happens to most women artists and their work, no matter how little they have embraced the standard, neutered categories that validate art for the market. They and their work are not well treated. Subjected to the competitive-comparative systems that rank and catalogue, the qualities of their work that speak of shared concrete experience—female as well as male—are diminished.

The galleries, museums, magazines, art schools, life-styles and talk-styles of the art world are geared to the cultivation and merchandizing of artists' ideals and sensibilities. In the dynamics of the art market, in which all efforts are inevitably weighed, personal and social idealism are used as ideological wrappings for the latest salable objects. Now as in the past, artists with causes become trademarks for their own commodities; feminists, too, run the danger of merchandizing their social aspirations. More and better criticism within established modes—old art history with women added—these are not real solutions. The value of established art thinking and how it functions as ideology must be critically analysed, not promoted anew. It may not be possible to resolve the contradictions within which artists work, but it is possible

to clarify them. Equity within present circumstances is better than nothing, but we do not have to accept those circumstances blindly and whole. Nemser's idea of greatness, like Alice Neel's box of Wheaties, is made to be consumed, not to nourish. Let us find out what it conceals, face the contradictions we have been taught not to see, and consciously choose what lines we are going to draw and where we can draw them.

NOTES

1. Nemser is trying to refute Linda Nochlin's "Why Are There No Great Women Artists?" *Art News,* January 1971, pp. 22–39.

2. See June Wayne, "The Male Artist as a Stereotypical Female," *Art Journal,* Summer 1973, pp. 414–416, for a lively description of artists' attitudes. Wayne goes on to suggest a number of ways artists can organize to solve their problems. In my view, these suggestions are unrealistic because they proceed from the false assumption that artists are a proletariat. Wayne also appears to assume that elitist culture can be democratized, an assumption with which I do not agree.

3. Ambiguous publicity, that is, publicity that is artful or art that publicizes, produces ambivalent feelings in the art community, e.g. the controversy surrounding the Linda Benglis ad in *Artforum* (November and December, 1974).

TEACHING, TALKING AND EXHIBITING ART: INSTITUTIONAL SETTINGS

Part Three

TEACHING THE RICH

The importance given to the arts in prestigious, liberal arts colleges—the expensive, "good" schools—has always aroused the envy of artists and humanists in the larger state schools. Indeed, small, elite colleges are often taken as models for special or experimental programs in state schools, and many public educators are committed to making such "quality" education accessible to everyone. A laudable goal, it would seem, but one that rests on a rather shaky assumption: that the democratization of elitist, liberal arts education is possible. Recent experiences that I had in a prestigious liberal arts college have led me to believe that the arts and the humanities as they are generally defined by colleges and other cultural institutions are largely resistant to democratization. For, the very concept of art that is fostered and preserved by the established art order is largely irrelevant to the life situations of all but a few. At the same time, culture-dispensing institutions have built-in ideological safeguards that effectively dissipate and discredit serious attempts even to question established conceptions. To illustrate:

In 1969, having just finished my doctorate in art history, I began teaching in a small, liberal arts college whose reputation for experimental education attracted the sons and daughters of the affluent and educated. Few and small classes, together with long office hours, promoted easy relations with students and an open course structure in which students increasingly determined the content of classroom discussions. These revolved around the meanings of specific works of art (from the eighteenth, nineteenth, and twentieth centuries) in relation to their changing societies, the situations of artists, the ideals of patrons, etc. Debate about the past frequently

This essay was first published in *New Ideas in Art Education,* ed. Gregory Battcock (New York, Dutton, 1973), 128–139.

led us to parallel issues in the present. A recurrent theme was the place of art in present culture—its confinement to the hushed and hallowed galleries of museums where, removed from all historical context, it virtually requires from the viewer passive, purely "aesthetic" contemplation. Students also explored the production and promotion of such objects of autonomous aesthetic experience for today's art market and museum world as well as the general tendency of modern society to consign creative activity to the ambiguous position of something both very important (more meaningful than common experience and highly status-conferring) and not important at all (totally useless and irrelevant to "real," material values). Many of my students, disenchanted with the present dichotomy between high and low culture, began to speculate about a world in which the aesthetic dimension would permeate common as well as special life activities. What is meant by "creative freedom," my creatively inclined art and literature majors began to ask, if to exist professionally as an artist one must produce the kind of commodities or performances that society certifies as Art?

The issues that I had been discussing with my students became concrete and real for me personally when the college committee that does the hiring and firing decided not to renew my contract and justified its decision on ideological grounds. Both verbally and in writing, I was charged with "overemphasizing the social aspects of art history" at the expense of "art appreciation." I was also taken to task for my (really quite timid) version of the open-structured course and for criticizing the cult of individualism that is especially rampant on this campus. Although the ideology that prompted these charges is based in idealist tradition, the particular form in which I met it deserves attention, for versions of it thrive in liberal arts colleges and humanities departments everywhere. To understand its special tone and emphases, it is helpful to recall the social and intellectual climate of America a generation ago. For, it is no accident that the individuals who found my approach to art history so objectionable were mostly humanists in their forties. They represent what younger people today are referring to as the humanism of the 1950s, since the kind of thinking this term conveys was at its height in the academic world during the postwar decades when that age group went through college and university. Now tenured professors, they have come into the power positions in their institutions, at precisely the moment when

their values are being vigorously challenged by a new generation that grew up in a different world.

In the 1950s, however, the élan of dissenting youth was all theirs. While most of their generation went to college for technical, commercial, or professional training, they read poetry, wrote novels, and cultivated a taste for art. What they sought, at their idealistic best, were alternatives to the single-minded materialism of America's booming, postwar business world. These were the holdouts, the people who chose elegant, semi-bohemian poverty over the 9-to-5 rat race. In their quest for intellectual scope, meaningful values, and the exercise of personal sensibilities, they were drawn into the humanities, that is, into college and university careers—almost the only careers in American society that could (and to some extent still do) offer a place for the kind of intellectual activity and cultured life-styles they sought. Especially in literature, art history, and musicology, they found realms rich in precisely those qualities of experience negated by the rest of culture, and it is not without reason that they defended the realm of art as something distinct from common experience. Common American experience meant "conformity," killing yourself with mindless work for bigger, tinnier cars, jerry-built tract houses, low TV culture, and tasteless Kool-Aid. In a postwar America whose unlimited appetite for material growth threatened everything not subject to unit-cost accounting, those committed to the cause of art could look at the big new science buildings on campus from their own cluttered little quarters with a certain sense of superiority.

In some ways, their thinking was the academic counterpart to that of the Abstract-Expressionist painters, who could find a place for personal expression only within the confines of those big canvases whose surfaces became arenas for inner experience, intuitive choice, and the "free," expressive gesture. So, many in this generation of academic humanists came to regard the freedom to exercise one's personal sensibilities and to choose artistic forms as the symbol and then the paradigm of all human liberty. For these refugees from a philistine society, art, literature, and the other humanities represented a sacred grove, a free zone whose boundaries had to be zealously defined and defended. Indeed, aggressive enemies lurked everywhere, not only in the hostile, materialist world without, but in the university itself—in sociology, for example, and in other so-called sciences that regarded man and his spiritual achievements as products of social forces.

To many humanists educated in those Cold War years, the issue of individual freedom as they knew it in their youth must seem to have come wholly alive again, with today's youthful left now acting the part of adversary. Thus put on the defensive, they often react as if the only alternative to their position is what they deem to be the Old Left's reduction of all cultural manifestation to a simple economic determinism. Even those who probably know better are apt to become uncomfortable when faced with any serious attempt to relate social contingencies to artistic choices. To draw again from my own experience: at lunch one day, I found myself next to a specialist in eighteenth-century English literature, and, with the intention of making conversation, began telling him about a book of essays by the British art historian Ellis K. Waterhouse. In this book (*Three Decades of British Art, 1740– 1770* [Philadelphia: American Philosophical Society, 1965]), Waterhouse places the art of Joshua Reynolds in its social-historical setting, relating it to both the desire for status among eighteenth-century English artists and the ideals of the aristocracy. In the course of his book, he not only describes Reynolds as a prig, but argues that the pompous portraits he painted for his Tory patrons reinforced their smugness and arrogance; that same Tory arrogance that hastened the American Colonies toward the Declaration of Independence. All this quite upset my colleague, who turned out to be a Reynolds lover. Reynolds, he gave me to understand, was a Great Artist, author of the *Discourses,* and should be treated as such—no more, no less. He insisted on knowing whether or not *I* thought Reynolds a Great Artist. My answer, that he did some good things, did not satisfy him. This same fellow turned up on the committee that was reviewing my contract, and in my interview with them opened the Reynolds question again. "Is it not true," he asked, "that you teach Reynolds as a social climber?" I tried to explain the issue, but my goose was already cooked. Having once declared social contingencies of the past or the present to be substantive issues in the history of art, I had committed the inadmissible transgression. For true establishment humanists, art must be treated ultimately and categorically as Art, to be revered for its own aesthetic sake *exclusive* of all other meanings. During the same interview, another committee member (this time a musicologist) kept asking me if I did or did not teach my students "art appreciation," making it evidently clear that my primary job was to teach students to value art

for its aesthetic pleasure alone and that to teach other meanings as well was to lessen the aesthetic value of an object.

From where they stood, I must have looked decidedly too "political" in a negative sense and was probably suspect of the most simplistic Old Leftism—judging art strictly on the basis of whether or not it directly addressed itself to the class struggle. From my point of view, however, *they* looked political in the broadest social sense: their demand that art be approached exclusively as an occasion for purified aesthetic experience not only wrenches from it a good part of its human import, but all the while it touts the spiritual sustenance of art, it insures its accessibility to only a small and privileged circle of consumers.

Indeed, the art historian's traditional role, in schools not only of this kind but less prestigious places as well, is precisely to transmit this ideology of aesthetic elitism. In the big state schools, humanities teachers may claim to be democratizing elitism for the masses by "civilizing" their students with exposure to high art—at least when they are not lamenting how few of their students are able to grasp the pearls cast before them. The failure of this endeavor, amply evidenced in those laments, in effect reinforces the gulf between the cultured and the uncultured. In contrast, the claim that art, literature, and music are civilizing or socially beneficial agents finds its greatest traction in expensive liberal arts colleges where one is privileged to be educating the children of professors, collectors, and museum trustees—the future guardians of established culture and its institutions. Here, if anywhere, are the students whose backgrounds and future lives make relevant a classroom experience in which all art, past and present, is approached as if it were explicitly made to be looked at in the vacuum of the museum or acquired for one's own pleasure. Here, traditional, undergraduate art history finds its best audience as it presents the history of art as so many objects, bracketing and magnifying stylistic qualities, extolling the innate genius with which each great master solved a formal or iconographic problem, drawing an occasional parallel from philosophy or some other humanistic discipline, and extracting the World Views and Ideas that furnish the realm of abstract, universal truths—all the while avoiding or playing down the social matrix of art and turning the anti-art intentions of much twentieth-century art to aesthetic profit by treating them as "formal advances" to be appreciated for their own sakes.

Again, in the setting of the prestigious liberal arts college, the mutually supportive relationship between establishment humanism and the larger social order finds especially favorable ground. At the one in which I taught, for example, although it is now going coeducational, the curricula (largely the liberal and creative arts) and the educational philosophy (the development of individual self-expression) are superbly cut for the social roles so many of its alumnae have played: affluent matrons who collect and patronize the arts. In a recent statement, the college's president described the school's educational aims exactly in accordance with their life situations:

In opposition to the idea that college experience must educate the student to be something, a something determined by the established order of the world, this college, in the spirit of the liberal arts, dedicates itself to educating the student simply to be.

This is accomplished, continued the president, when the student pursues such "enduring questions" as "What is man?" and "Who am I?" for, "only through the study of the great achievements of the human spirit—drama, poetry, philosophy—can these questions become part of a person's life." Now, the only people whom our social structure encourages "simply to be"—in a cultured, liberal arts way, that is—are wealthy, leisured women, probably America's major consumers (but not producers) of high culture. Establishment humanism and its related cult of individualism give both substance and ideological justification to this activity. While extolling the value of individual creativity, it certifies creative activity only in the form of objects or acts produced for the contained spheres of the art world, implicitly justifying the absence of aesthetic values in so-called common experience. And while proclaiming the meanings of these objects and acts to be universal and theoretically available to all men, it turns its back on the fact that the physical and mental lives of most people are *socially* organized so that no matter how many free days the museums offer, they have neither the interest and training nor the social and geographical proximity with which to benefit from these supremely humanizing products.[1] Thus establishment humanism protects and perpetuates the value of art in forms that insure its existence as a subculture, conserving both its authentic spiritual rewards and its real social prestige for the rich and those who serve them.

Since the late 1960s, challenges to the established art order and its ideology have been increasing, touching every sector

of the institutionalized art world. They have come from artists intent on changing their normal relationships to museums
and the art market and from scholars, critics, and teachers
who are no longer content to transmit established values and
modes of judgment unexamined. Other, more pervasive
forces are also at work in discrediting the prestige of the art
world. Most important perhaps is the increasing suspicion
with which young people regard all established institutions
and ideologies. The values of self-expression and self-
knowledge—the refusal to join the 9-to-5 crowd—still attract the young, and especially the affluent young. However,
the attraction is not the same as it was in the 1950s when
such values could provide sufficient life goals to a dissenting,
antimaterialist youth. In the 1970s the appeal of the academic
humanities must compete with the conviction that one has
as much or more to gain personally in a changed social order
and in the qualitatively different human relationships such
change would bring. Whatever real effects the various youth
movements might have on American society, they have at
least begun to shatter the illusion that the ivory tower exists
removed from the bad things in society, preserving and perpetuating only the good.

So far, however, challenges from artists, teachers, and students have had little effect on the real, ongoing operations of
cultural institutions, where establishment humanism remains
a viable ideology. Those protesting the irrelevance of high
culture constitute but a fraction—and a powerless one—of
an already small minority (the art world), and their voices
hardly carry beyond the select readership of art pages and
special magazines. At the same time, within institutions, issues are rarely discussed at their deepest levels; the concerned
professors, museum directors, and artists addressing themselves to the "crisis," i.e., the cultural blight in which most
people live, frequently end by perpetuating the very conceptions of art and artists they began by contesting. Such are the
arguments of those who urge that aesthetic experience should
leave the museums and become an integral part of life but
who offer as "alternatives" to present conceptions of art what
amount to old wine in new bottles: anti-object art that still
commands a mode of experience sealed off from other values
and life activities and that remains incomprehensible to those
whose life situations deny them the difficult intellectual preparation it demands. Such also are the arguments of educators
that we should democratize high culture by disseminating it
more vigorously to the "culturally deprived"—a Raphael in

every home as it were. But, no amount of art education will be effective so long as other aspects of existence remain untouched. Aesthetic consciousness cannot simply be sprinkled over a social reality that is virtually organized to repel it in the minds of all but a few. Until there are essential and substantive changes in that reality, aesthetic values will remain the monopoly of those initiated into the subculture of Art.

NOTE

1. Teachers in public colleges may protest that many of their students demonstrate high interest and capacity in art appreciation in spite of nonsupportive family backgrounds. I am sure they do. But what happens to them after they leave college and enter their working lives? Unless they join up with the intellectual establishment and thus escape the work world—and this requires exceptional skills and mobility— most of them will have neither the opportunities nor the interest to involve themselves with art on a continuing basis. It does not necessarily follow that they are any the poorer for being deprived of high culture *as our institutions define it.* (Conversely, I am not arguing that "low" or mass culture is therefore good art.) My point here is that institutions that claim to disseminate high culture to the masses do not fulfill their claims (see Linda Nochlin, "Museums and Radicals: A History of Emergencies," *Art in America* [July–August, 1971], pp. 26–39).

NEUTRALIZING THE AGE
OF REVOLUTION

The exhibition "French Painting 1774–1830: The Age of Revolution," like "The Impressionist Epoch" of last year, was
seen on both sides of the Atlantic. Starting at the Petit Palais
in Paris, it went to the Detroit Institute of Art, and then to
the Metropolitan Museum of Art in New York. Conceived
by Robert Rosenblum, whose work is well known to students
of the 19th century, and by Fred Cummings, Director of the
Detroit Institute of Art, it represents the collaborative efforts
of both French and American scholars. But unlike "The
Impressionist Epoch," which consisted largely of works that
hang permanently in the Metropolitan and a few other East-
Coast museums, this show brought together many paintings
from out-of-the-way collections in both Europe and America. Rarely seen canvases by David, Ingres, Géricault and
other luminaries of the late 18th and 19th centuries were
borrowed from provincial museums and private collections.
And numerous works, once famous but now forgotten, by
Vincent, Regnault, Boilly, Delaroche and a host of other late
18th- and 19th-century artists were dug out of museum storage rooms. Thus, even though Americans saw only three-
quarters of the 206 works listed in the catalogue,[1] what we
did view was a highly unusual and varied selection of Salon
painting that is unlikely to be shown again for a long time.

Aside from appreciating the superb curatorial effort behind
the show, one still has the problem of what to make of this
varied mass of material. For what gave these works an urgency in the 18th and 19th centuries is not always self-evident
to modern eyes. Many of these paintings, which assumed
high moral or intellectual import, lack an appropriate visual

A longer version of this essay was first published in *Artforum* (December
1975), 46–54. It is reprinted here by permission of *Artforum* Magazine, Inc.

strength. Though they strive for the grandeur of past art, they lack its conviction.

Yet, for all its seeming remoteness, the painting of this epoch constitutes a storehouse of suggestive thought and feeling, of fantasy and illusion. It is, in its way, a kind of history that can tell us much about the beginnings of our own times. For these are precisely the decades in which France (along with other Western nations) transformed itself from a monarchy into a modern bourgeois state. It is the adolescence, if not the infancy, of our age, and to a large extent the culture it forged still lives within us. The issues with which it struggled, and which were voiced in social and political ideals, also had their repercussions deep within the collective and individual consciousness of those who shaped culture. Those issues resounded from one end of this exhibition to the other.

Not least among them is the issue of art itself, its nature and purpose. The years the exhibition covers begin at a time when ambitious Salon painting was often a vehicle for the expression of moral and political optimism. Like the French stage, to which it habitually looked for inspiration, it stirred the emotions by magnifying the significance of moral choice. The dramatic scenes of heroism envisioned by David, Vincent, Peyron and Drouais between the 1770s and the 1790s were born of a rhetorical conception of art allied to a classical faith in the efficacy of individual action. Their harshly realistic heroes breathe the conviction that real social experience—history, not mythology—is the medium in which Man (but not Woman) realizes his fullest, noblest potential.[2] They wanted to recreate and imaginatively relive not the deeds of Christians but of Romans and Greeks, men who shaped their destinies in lucid, pre-Christian air. In the 1770s and '80s, such scenes could muster strong emotions in educated men. Stifled by a corrupt, inefficient governance structure that excluded them from meaningful decisions, they longed for such a stage in reality and for the political opportunities it would provide.

The rooms that were devoted to monumental, ambitious figure painting in the later 1790s and the early days of the 19th century document not merely a change in style, not merely an "artistic" trend to abstraction and fanciful subject matter, but the collapse of that optimism. There is also a different set of expectations about art and its purpose. By the late 1790s, strange, moody, cooly rendered fantasies and themes of amorous longing or ill-fated love largely replace moral and social feeling as the main artistic inspiration of

prestigious art. Girodet, Guérin, Charpentier, Broc and others create elegant but enervated, despairing or dying heroes. Even where subject matter refers to politics and the present—as in images of Napoleon or in the vast, spectacular battle scenes he commissioned—the appeal is to a passive observer who contemplates his own emotive state rather than his potential for moral passion and decision. What social idealism remains to inspire art has been metamorphosed into arcane allegories or obscure mysteries, as in the strange "Masonic" subject by the former radical, Regnault, *Physical Man, Moral Man. . . .*

Where ambitious figure painting once called upon the viewer to imagine himself in a rationally understood world, engaged in gripping and significant life decisions, it now invited him to dwell upon the emotional feelings attendant to his own state of powerlessness. Sublimely horrible situations that chill the blood and paralyze reason; themes of reverie and retrospection; images of otherworldly spirits glimpsed through luminous mists; lost loves and sleeping or dying lovers: these and other themes speak of yearnings unrealized and unrealizable, of hearts that must cool, and of loss.

The attitude toward immediate sense experience many of these works project is striking. Girodet, Gérard, Ingres (as well as lesser-known artists) display a certain fear of the flesh, an asceticism, a closing down of sensual consciousness. David had already chastened his vision, banishing from his painting those sensually appealing features that the 18th century had cultivated to such excess: the loaded brush, scintillating colors, luxurious textures—all that feasted the eyes and suggested the fragrance of nature and the pleasures of touch. In his painting of the '80s, the world is streamlined, filled with ungiving surfaces and sharply defined spaces. It is an all-business, man's world in the modern sense, accommodating only male action and passion and female emotional response. The bodies of men are bony, hard-muscled, their skin like tautly stretched leather; women's bodies, imagined with less specificity than the sturdy linen that drapes them, are conceived as smooth, generalized volumes.

David's students (and he himself at various times after 1800) recoil even further from sensory experience. Just as faith in individual action collapses, so the space in which figures exist contracts, and the figures themselves, often immobile, freeze into svelte, fastidiously rendered surface patterns. In paintings by Girodet, Gérard and others, a self-

oppressed sensibility finds comfort in the hairless, waxlike bodies of young men and women, or—as in Prud'hon's rendering of flesh—in soft, decomposing substances.

The same impulse that glorified individual action in the later 18th century was also extraordinarily fascinated with a specific character: the virtuous but victimized old man. This figure positively haunts late–18th-century painting. In this exhibition alone he appears three times as Belisarius, a wrongly dishonored Roman general who ended up a blind beggar (Vincent, Peyron and David painted him in 1776, 1779 and 1781 respectively) (Figs. 2.5–2.7). He also appears as Socrates, portrayed by David in 1787 choosing to die rather than betray his principles; as Suvée's Admiral de Coligny (1787), represented in confrontation with assassins; as a destitute, crazed Oedipus by Harriet (1796, not in the New York show); and as a Priam by Garnier (1792).

The noble old man, traditionally a symbol of revered authority, was not new to French art.[3] But so many noble but pitiful, endangered, dying and suffering old men were new, and they point to some deeply felt ambivalence about patriarchal authority.[4] In these same years, the radical William Blake deployed figures of old men to explore the links between political, social and sexual repression. In both his poetry and his art, which often treated the French and American Revolutions, Blake used bearded, white-haired patriarchs as images of repressive law and domination. They were often overthrown by strong, rebellious youths, representing a principle of both personal and political liberation.[5] These French Salon paintings rarely criticized patriarchal authority as deeply, directly or consciously as did Blake (or, for that matter, as did the kind of popular French prints that would never appear in the Salon). Even in Regnault's *Deluge* (1789) (Fig. 2.8), where the wish to overthrow the father-tyrant is almost stated, the decrepit old father, who literally weighs down his son, is still portrayed with passable sympathy. Such ambivalence is resolved in David's great paintings of the 1780s— *The Oath of the Horatii* and the *Brutus*—where moral authority is clearly on the side of the heroic older males who head both family and state.[6] The new ruling class that emerged at the end of the century—the class for which David already spoke in the 1780s—would also firmly reestablish paternalistic authority in the laws governing social and familial institutions.[7] Around 1800, having done its work, the theme of the old man faded from art. Significantly, with his disappearance, high art ceased to explore the possibilities of individual moral

action, and the excited passions such scenes expressed began to look staged and artificial.[8] Ambitious figure painting turned instead to the esthetic contemplation of impossible fantasies, remote myths (including the rapidly developing one of Napoleon), and—not surprisingly—of melancholy maidens and powerless, dying youths.

Years later, after the Revolution of 1830, Delacroix painted his *Liberty Leading the People,* the last work in this exhibition. It is a social fantasy very different from David's. The open, atmospheric space is largely structured around the strong, moving figure of the half-naked Liberty, whose glistening, womanly flesh, maternal breasts and serene features are spotlighted. In this figure, who is both allegorical and real, Delacroix projected longings that are at once social and psychological, public and personal. Liberty, in whose protective shadow a small boy finds courage, is both sexual and motherly, strong and gentle. Under her confident guidance, men of all classes, ages and races unite. She turns to beckon them on as she carries the tri-colored flag over the lifeless bodies that clutter the foreground—the corpses of men in torn military uniforms. The liberated state is feminine, nurturing and mothering. She will attend to the needs of her all-male citizens, who, in her care, will shed their separateness as they transcend the struggles that divide them. The substance of this liberty is individual gratification and social harmony, not individual power. The promise of gratification— of sensual gratification—comes through the rendering as well as the imagery, in the rich, thickly applied paint and the sonorous colors. In Delacroix's fantasy, men would be liberated from the bourgeois world that David's idealized heroes prophesy.

Obviously, the impact of an exhibition like this one depends almost totally on the historical consciousness—and not merely the stylistic consciousness—that the viewer brings to bear on the art. The issues that made these paintings seem compelling to those who commissioned or painted them are not always self-evident and not common knowledge for most American museum-goers. Yet, little in the design of the exhibition itself informed the viewer of the context that once made these works speak of vital feelings and interests. No historical thesis was presented, no suggestions about why this was an age of Revolution or what those revolutions were about. The small wall plaques next to each work, although occasionally supplying a piece of information about the subject matter or the patron, were mostly intent on identifying

the style to which art historians have assigned the work or the earlier style it emulated. One was left with the impression that artists were motivated primarily by the history of art and sought only to imitate older art. Politics and history were referred to only in blatantly propagandistic works that featured kings or the Emperor. The few columns of print supplied in a free brochure (the only alternative to the $15 catalogue) were too brief and too general to help the viewer make sense of specific works.

For example, the brochure treats the relationship between 18th-century Enlightenment philosophy and monarchical interests in art in a few lines that manage only to confuse the issue (the catalogue does no better). One reads that the *philosophes*—Enlightenment writers—believed in liberty and "criticized absolutism in France," but also that their writings inspired the crown to encourage art that would teach virtue to its subjects and "purify the taste of France." Certainly state-commissioned paintings reflected aspects of Enlightenment thinking; but toward 1780, *philosophes,* ever more radical, were expounding decidedly anticlerical and anti-aristocratic views that openly conflicted with the interests of the crown.[9] The images of virtuous nobles that the state commissioned, while they can be rationalized as appeals to nationalism, patriotism and morality (as both the brochure and the catalogue suggest), were meant to promote an established social order that was defending its image from aggressively critical segments of the bourgeoisie.

Such a scene is Durameau's *Continence of Bayard,* exhibited in the Salon of 1777. Contradicting the charges of corrupt morality leveled at the aristocracy by dissident writers, this painting depicts an aristocrat of yore bestowing a generous dowry upon a young woman who had been brought to him not for this purpose but for his own pleasure. (According to the Salon description, cited in the catalogue, the chevalier changed his intentions toward her only when he learned of her noble blood.) Nor does the catalogue entry, written by Anne Leclair, question the intent of the work. Leclair, enchanted by its authentic Gothic details, is puzzled by the hostile reactions it provoked in 18th-century critics, who liked neither the subject nor the image of Bayard "coldly holding up a purse." "It is paradoxical to see a work judged so harshly," writes Leclair, "when it would appear to correspond to the criteria of the new taste in its exaltation of national subject matter made fashionable by literature." In fact, the criteria Leclair invokes obscure rather than clarify

the critical response, and in the guise of art history offer the
20th century essentially the same rationalizations that the 18th
century advanced to explain a campaign launched by and for
the nobility. The same uncritical approach characterizes both
the catalogue essay covering this period and many of the
descriptions of specific works. It is as if the Louvre, the De-
troit Institute of Arts and the Metropolitan Museum of Art
have dressed up for the bicentennial by donning the robes of
the Royal Academy.

I will return later to the catalogue (not all of whose con-
tributors are as naïve about the ideological purposes of the
art they explicate). Here I want to characterize the immediate
experience of the exhibition itself, the paintings and the writ-
ten information provided in the galleries. For next to the
outstanding curatorial effort, the most striking thing about
the exhibition was its failure to provide relevant historical
information. For the most part, the exhibition simply pre-
sented these works as so many separate pieces of art history.
Invariably labeled according to style, their historical mean-
ings apparently derive from the fact that such was the "taste"
of the time—with the exception, of course, of blatantly "po-
litical art." The lack of explanation and analysis was so strik-
ing that, despite the protected ambience of the museum,
experiencing "The Age of Revolution" came very close to
watching television news.

There, too, one is confronted bluntly with a series of
events, facts and occurrences, presented briefly, uncritically
and without analysis: accidents, crimes, official government
pronouncements, cost-of-living data, strikes and the Dow
Jones. The very mode of presentation reinforces the illusion
that reality is fragmented, without history, unexplainable ex-
cept in terms of immediate causes, current "trends" and the
personalities of individuals. The news is always "objective"
events, never the on-going web of relationships from which
events arise. So, in this exhibition, each canvas was presented
as a discrete item, an objective occurrence. The list of his-
torical news events on the back of the brochure, all headline
stories in their day ("1793: Execution of Louis XVI") only
reinforced the impression of fragmentation and the irrelev-
ance of history-as-news to art.

In any case, Salon painting—and this is what the exhibition
consists of almost exclusively—was the medium least able to
respond to and express the living feelings and immediate
experience of the Revolution. As officials of the Revolution
complained, David included, Salon painting was a product

149

of the Academy, a privileged corporation controlled and financed by the crown and openly conceived as a servant of monarchical interests. From its beginning under Louis XIV, the esthetic standards it promulgated reinforced the prestige of painting that glorified the throne and the altar, e.g. pictures of virtuous kings and aristocrats, religious subjects and scenes of individual heroism drawn from the literature of elite culture (the classics). The 18th-century Academy had become lax in carrying out this mandate, but under Louis XVI, a reform campaign was launched to revive the "noble" ends of the old Academy. Working within official goals, David pushed them as far as possible into the service of his own progressive ideals. But during the Revolution (and notwithstanding the acclaim his earlier Salon paintings were now accorded), he and others in the Convention questioned the relevancy of Academic teaching. Above all, Revolutionary authorities sought to remove art from the control of an institution that, in their eyes, was organized to promote the image and the interests of despotism.

The problem, as they perceived it (but which they never solved to their satisfaction), was to convert high art—and ambitious artists—to the cause of the Revolution. At one point, in the conviction that patriotic citizens were better judges of art than Academy professors, the Convention set up a jury of citizens to judge an art competition. The actors, writers, journeymen, artists and other professionals who sat on this jury found the art submitted generally devoid of Revolutionary spirit, and they did not award first or second prizes.[10] During the Revolution, David himself virtually abandoned Salon painting, not only for politics, but in order to put his art into the streets—in the design of public pageants, festivals, mass demonstrations and political prints.[11] The pervasive institutional and ideological controls that governed the production of Salon painting in general (and not only images of rulers in particular) would seem a most relevant fact to include in an exhibition of Salon painting. But rather than look at past ideology critically the exhibition generally gives us past ideology as objective, neutral truth.

This brings me to the catalogue. This 712-page book was compiled by 22 scholars. Aside from the entries for each of the works exhibited, separate essays introduce the exhibition as a whole and each of its four periods (the reign of Louis XVI, 1774–1789; the Revolution, 1789–1799; the reign of Napoleon, 1800–1814; and the Bourbon Restoration, 1814–1830).

The first two of these essays present distorted pictures of the conditions under which art was produced. In this they tell more about established academic thinking in the 20th century than about 18th- or 19th-century art. The first essay, by Pierre Rosenberg, curator of painting at the Louvre, suggests that painting was somehow affected by the many political changes that mark this epoch, but he offers no thesis as to the nature of these changes or how painting registered them. Indeed, he states that the purpose of the exhibition is simply to trace "artistic tendencies" in themselves. Though history painting (pictures of noble rulers, religious subjects, etc.) is reported as "the most highly regarded category," it is not examined critically in relation to the interests of those who determined the hierarchy of genres. (Later in the catalogue, Antoine Schnapper points out that the higher genre was never popular beyond official and professional circles.) But what is more disturbing are the historically unwarranted claims Rosenberg makes for the freedom of the arts in these years and the disinterested motives of artists, officials, critics and patrons.

. . . Because of the unfamiliarity of the period, we thought it advisable where possible to follow the judgment of the artists themselves; consequently, we have attempted to exhibit works that were shown at the Salons.

Rosenberg goes on to characterize the Salon as an institution whose doors were generally "open" to all art. Evidently it existed only to encourage good art, for "the artists considered the works they sent to the Salon to be their very best." The reader is assured that the exhibition presents the best art of this era because it has selected paintings that were "celebrated" by contemporary critics. We further read that 18th- and 19th-century critics praised or condemned paintings only on the basis of their "objective" artistic merits.

Fortunately, other pages of the catalogue make it clear that politics and esthetics were not so separable in late 18th- and early 19th-century criticism. Jacques Vilain, for example, in his catalogue entry for Regnault's *Liberty or Death,* observes that the political radicalism of this work was surely the cause of the harsh criticism it received. Expressing "the pure and violent ideology of the Terror"—"Liberty or Death" was a motto of 1793—it was not exhibited until 1795, during the Thermidorian reaction, when such sentiments were decidedly unpolitic. In fact, throughout much of this epoch, the press was closely watched by the government, and under both

Napoleon and the Bourbons, fines and even imprisonment could befall the critic or editor who praised the esthetic quality of paintings that contradicted the official ideological view of things.[12]

The second essay, by Frederick Cummings, treating the fifteen years preceding the Revolution, continues in the same spirit. Not a single word is wasted on the historical conditions of the time. Whatever led to the Revolution apparently has absolutely nothing to do with art. The impression gained in this essay is that the art of the period changed because taste changed, both changes occurring in a perfectly sealed cultural vacuum. Evidently, new themes developed fortuitously, and all the crown wanted from artists was a new art style. Louis XVI and the Comte D'Angiviller, who directed the king's campaign to improve art (i.e., to reharness it to the interests of Royalty) simply had a taste different from Louis XV and his contemporaries. In fact, this Louis was apparently an extremely nice king who liked pictures of virtuous subjects. According to Cummings's essay, he wanted only to encourage art that would regenerate society and purify taste. The story has a happy ending, for the efforts of Louis XVI and D'Angiviller were crowned by success: artists gave them a "revolution"—in painting, a new style characterized by David's "new set of pictorial values arising from his study of the art of Caravaggio and Poussin." David was the most influential artist of the time because his art was the most individual; it displayed the strongest personality and passion. His "severe republicanism" is referred to once, in passing, but his art, like the art of others in the 1780s, essentially expresses only such general and abstract concerns as "the human condition" and "the regeneration of society."

With the third essay, the catalogue becomes serious. Antoine Schnapper, writing about painting during the Revolution, sharply contradicts many of the unfounded claims that precede his well-researched essay. And for the first time, the clamor of history is echoed in the pages of the catalogue. According to Schnapper, D'Angiviller's attempt to "reform" painting contributed to the violence of the crisis that split artistic circles and disrupted institutional life during the Revolution. The crisis revolved around the central issue of the Revolution: equality vs. privilege; and dissident artists, with David at their head, forcefully challenged the authority of the Academy. (In the midst of this, D'Angiviller, a hard-line Royalist, was hustled out of France by Louis XVI. Evidently

Louis believed that his presence would further incite the hostility of the rebelling artists.)[13]

While Schnapper draws a clear enough picture of these disputes, in his treatment of David's particular role, the issues once again become obscured. He attributes David's rancor against the Academy solely to feelings of personal injury saved up since student days, when the artist was repeatedly denied the Prix de Rome (according to Schnapper, justifiably)—this despite David's ongoing critical analysis of art patronage and privilege and the developed political ideals he often expressed in his active career in the Convention (over which, for a time, he presided). The last part of this essay gets completely bogged down in a futile attempt to demonstrate the purely esthetic merits of David's late work.

The final two periods, the Napoleonic era and the Bourbon Restoration, are treated by Robert Rosenblum in two separate essays. Only here is visual material sensitively examined. To my mind, the second of these essays goes deeper into the substance of the art than the first and also gives a more detailed picture of the ideological flavor of early 19th-century high culture. The first essay, while it stresses the propagandistic nature of images of Napoleon, tends to catalogue other, equally ideologically significant art according to various art categories. As a consequence, "political art" appears to be a category separate and distinct from other art. For example, paintings idealizing the medieval past are treated primarily as a new, entertaining vogue that the age explored for esthetic enjoyment alone, a "counterpart" to Greco-Roman subjects. While there is some truth in this, the vogue appears in a different light when it is seen in relation to the conflicting ideologies of the time, namely the Enlightenment's vehement rejection of "the Gothic" and the Royalists' and *emigrés'* defense of the Christian past. That is, the appearance and disappearance of medieval subjects relate to the issue of church authority, a central issue of the Revolution and one which would arouse violent emotions and bitter memories for decades to come.

Similarly, a painting by A. E. Fragonard (the son of the famous Honoré), *Vivant-Denon Returning the Bones of El Cid to His Tomb* (c. 1812), "ignores the grim military facts of the French invasion of Spain in favor of a mysterious meditation upon death, medieval heroes and gloomy Gothic vaults." But this work implicitly acknowledges those grim facts by countering them with a white-washed version. Rosenblum does

not spell out what he means by "grim facts." I assume he is referring to the cruel atrocities that French soldiers were inflicting upon an already brutalized peasantry—a counterrevolutionary peasantry, who, stirred up by a fanatical, ultraroyalist clergy, fought for a corrupt, oppressive monarchy. (Goya's *Disasters of War* characterizes those who fought this war and the atrocities that both sides committed.) Fragonard's painting not only is designed to ignore the real effects of French foreign policy, it presents for home consumption the picture of a high-ranking Napoleonic official bestowing great respect upon a relic venerated by the Spanish people. (Actually, according to the catalogue description, French troops had destroyed the original tomb of El Cid thinking that they would find treasure to loot.) In more ways than one, then, this work cynically contradicts the reality of the French invasion. To treat it primarily as an innocent Gothic entertainment is to rationalize and advocate, however unintentionally, the political interests that originally prompted it.

In general, the historical realities to which Napoleonic propaganda was addressed—realities which explain its specific impact—are barely mentioned. Rosenblum vividly describes the interesting shift in the way Napoleon was portrayed, from a heroic but still human figure, acting in a rationally understood world, to a remote, unreal deity (best seen in Ingres' painting *Napoleon Enthroned*). The effects of these works are sensitively evoked, but they are not related to the changing situation they addressed.[14] Rosenblum recognizes that images of Napoleon idealized what was, in fact, an authoritarian regime; and he has often explored the ways in which Napoleonic imagery utilizes older artistic traditions in order to manipulate the viewer and evoke in him feelings of awe and obeisance. But rather than develop the meanings of these works in relation to historical realities and to Napoleon's ideological needs, he invites the viewer to savor their esthetic qualities in isolation from their other meanings (see below, the passage on David's *Napoleon at Saint Bernard*). The questionable political attitudes those effects were designed to reinforce (e.g. the acceptance, even enjoyment, of one's own powerlessness before the ruler) are not probed.

Rosenblum's effort in this essay, as in his past writings, is directed toward dismantling the old dichotomy that classified the art of the period as either Neo-Classical or Romantic. By now, he has pretty much killed those categories. In their place he has put a new, more varied set—primitivism, medieval subjects, love-death subjects, propagandistic images of the

emperor, etc.—all of which can be empirically demonstrated. But because the focus is usually on describing them and their immediate esthetic effects, on convincing the reader of their existence as esthetic categories, the concrete experience that prompted them necessarily becomes secondary and even irrelevant to the main task at hand. That is, the kind of categorical thinking Rosenblum employs inherently precludes understanding the art dialectically, in relation to historical experience. The emphasis is on esthetic distinctions, not dialectical relationships.

The inner logic of this approach, by no means unique to Rosenblum, implicitly fosters the illusion that social and political experience affect people's thought, feeling and expression only in obvious and highly circumscribed ways. That is, "political art," because it is treated separately, becomes a roped-off exception, leaving other art presumably untouched by political and social values. Whether or not its author intends this effect, it accords with the 20th-century predisposition to regard public, social and collective aspects of experience as separate from and even opposed to what is personal, private and individually felt, the latter being considered the more significant form of consciousness and the true source of art. The social and political powerlessness of the modern individual thus becomes rationalized and even advocated as a cultural value, a precondition of the esthetic experience. Rosenblum alludes to history often enough to suggest that art-making was more than the production of objects that fit into one or another descriptive category. But the historical experience that once gave these works urgent meanings cannot be developed dialectically without endangering the separate esthetic character of each category.

But Rosenblum is really better than his approach. He almost always knows more than his esthetic categories admit as relevant. His descriptions often touch upon the historical circumstances within which art is generated. Highly responsive to expressive content, he especially senses the ambivalent intentions of a work, its bad faith, the way it strains to convince. To account for what he sees and feels, he is often forced to refer to history, and in a few words he frequently characterizes historical tensions and pressures better than many writers who set out to evoke them. But in the end, it is not historical experience, with all its unresolved conflicts, that he seeks to recreate. On the contrary, he is after resolution, resolution in esthetic experience. Thus, in his description of *Napoleon at Saint Bernard* by David, while at first he is skep-

tical of the lie, he ends up going with it, adopting its voice, suspending critical judgment:

> Represented crossing the precarious mountain pass not on a mule, as was actually the case . . . but rather, in the Consul's own words, on a fiery steed . . . Napoleon suddenly looms up as a passionate heir to a long tradition of equestrian figures that echo across history from the processions of classical antiquity through the baroque energies of rearing horses and royal riders by a Bernini, a Rubens, a Falconet. There is, to be sure, something willful, and hence artificial about David's message. A great man has come from nowhere to fulfill an historical destiny, which is not his by genealogical right, but by virtue of his duplication of the great deeds of the past and by virtue of the almost supernatural energy and control that he promises as the great new leader of France. Resolutely, he masters his horse and his will as he points upwards against a dramatic cresendo of icy winds and stormy sky that act as a romantic foil of wild nature against his firm exercise of reason and discipline.

Rosenblum's second essay treats the years from 1814 to 1830, the years in which the restored Bourbon Monarchy tried to recreate the pre-Revolutionary social order. It is by far the best essay in the catalogue. The main effort here is directed less toward classifying art and more toward characterizing its ideological climate. He consistently pursues this not only in overt state propaganda but in other kinds of expression less obviously determined by political interests. He emphasizes the emptiness of official Bourbon ideals to artists, who, disillusioned with public life, turned inward and projected into their art restless, often dolorous feelings. The painting of this period, he writes, favored themes that "seemed to be increasingly shrouded in an aura of nocturnal mystery that turned substance to shadow, public myth to private reverie." Hence, Delacroix's *Christ in the Garden of Olives* (1827), like other church-commissioned paintings of this time, speaks more of the artist's personal feelings than of collective religious beliefs. The malaise, the feelings of powerlessness and the growing privatism of the period following the fall of the Empire became apparent in the art itself, especially when it ostensibly propagandizes for the established order:

> The exploration of human beings reduced to a state of animal despair, unguided by ideals embodied in great heroes or in high-minded sacred or secular beliefs, was a recurrent motif in painting. . . . Even when Ary Sheffer tells us of Saint Thomas Aquinas' faith in God during a storm, we are somehow more impressed by human terror than by divine benevolence.

In these and other observations, Rosenblum conveys a feeling for these works as living responses of individuals to a

shared historical experience. Although that experience is only suggested in brief asides, masterpieces of the period by Géricault, Delacroix and others begin to come alive, not merely as well-formulated instances of one or another esthetic, but as emotional and ideological "hits"; statements that gave shape to real feelings that pressed for conscious expression. But in his conclusion, Rosenblum reaches again for art-historical resolution and subordinates historical reality to that purpose. The period ends, he writes, with landscape painting and other "lower" genres challenging history painting. It is a conflict between "the preservation of inherited attitudes and the quiet search for an almost naive truth." "The future of French painting" would be in the latter rather than in

the perpetuation of the grandiose historical rhetoric that, in the painting of Ingres and Delacroix and their lesser satellites, reached by 1830, a passionate climax, but one that was as retrospective as the monarchy itself. In the decades that followed the July Revolution, the artistic conflicts of the Bourbon Restoration were finally to be resolved in favor of immediate personal truths rather than inherited public myths, of the urgent new demands of the 19th-century present rather than the veneration of a long-lost historical past.

Certainly various modes of realism would thrive in the future, but the kind of "truth" they reflected depended very much upon the social class to which one belonged and the sort of facts one's ideology acknowledged. At the same time, paintings with pretentions to the grand tradition would be produced throughout the 19th century. In any case, to associate public and social experience with "myth" and defunct traditions and to link "truth" and relevancy to personal experience implies that old categorical separation again, a separation that denies the very fusion of personal and social feeling that characterizes some of the best art of the 19th century (Daumier, Courbet).

In fact, the period of history that followed the Revolution of 1830 gave cause for such feeling. It did not resolve things, either in art or in society. The Revolution of 1830 did not extend privileges to the many, and Delacroix's *Liberty Leading the People,* far from being retrospective in 1830, as Rosenblum suggests, remained a frightening and offensive specter of democracy to good bourgeois citizens right into the Second Empire—that is, when it could be seen. Officials of both the July Monarchy and the Second Empire kept it out of sight most of the time. When it was brought out at the 1855 World's Fair (at Delacroix's instigation), that image of Liberty

as a woman of the people leading the people was as inspiring and upsetting as it had been in 1831, when many critics had complained about the commonness of Liberty and her unclean friends. It was returned to the museum storeroom (the state had bought it in 1831) and remained there until the 1860s and the liberalizing policies of the later Second Empire.[15]

By then, Delacroix was becoming acknowledged as a great French artist. His vision of the Revolution of 1830 (a benign affair compared to events of 1848 and 1849) would be seen increasingly as a work of art, an expression of individual genius. The vision of liberation and the still-unresolved social reality of which it was born was becoming merely the "subject matter" of a masterpiece whose real significance resides in its affirmation of the values of individualism. Delacroix, long since withdrawn from politics, and always an aspirant to the grand tradition, must have watched the fate of his painting with a certain ambivalence. In any case, the character of Salons and museum exhibitions was rapidly changing. The extraordinary development of a mass press and the appearance of photography were making the museum a different kind of place; the public was increasingly provided with other representations of reality than those given by artists. The museum was becoming what it is today—the kind of space in which this exhibition was held.

In the physical space of the museum, as in the constructs of art history, reality—past and present—is easier to take. Not least among the treasures museums preserve is the illusion that one can step away from the "grim" facts of reality. For those who are privileged to frequent them and who are initiated to their uses, the gracious galleries of the museum constitute a special kind of space where history is distilled into a series of individual and cultural achievements. Just as religious frescoes once articulated the meaning of halls consecrated to religious ceremonies, so in the museum, art objects function as architectural decoration: they articulate the meaning of a space consecrated to the ceremony of esthetic detachment. They occasion—and, in the modern era are normally conceived as—a mode of apprehending reality that sublimates its grim facts by transforming them into subject matter. But where religious frescoes marked enclosures consecrated to collective experience, the rooms furnished by art objects or acts promote private consciousness, confirm social passivity and acclaim the values of individual experience. In the seemingly ahistorical space of the museum or gallery, the

alienated modern spirit, self-consciously individual, anx-
iously seeks relief from the insecurities, hurts and conflicts
outside, desiring above all a feeling of resolution.

NOTES

1. The Metropolitan Museum did not commit to the exhibition the
funds necessary to bring it here in its entirety; evidently it was un-
willing to invest in a show that would not be as strong a crowd-
getter as "The Impressionist Epoch."
2. Male Enlightenment thinkers generally agreed that motherhood was
both the destiny and the fulfillment of women (see my "Happy Moth-
ers and Other New Ideas in French Art," *Art Bulletin,* December,
1973, reprinted in this volume, pp. 3–26).
3. Philippe Ariès, *Centuries of Childhood,* New York, 1962, pp. 30–31.
4. For a related interpretation of the Oedipus theme, see James R. Rubin,
"Oedipus, Antigone and Exiles in Post-Revolutionary French Paint-
ing," *Art Quarterly,* Autumn, 1973, pp. 141–71.
5. David V. Erdman, *Blake: Prophet Against Empire,* Princeton, N. J.,
1954, and J. Bronowski, *William Blake, 1757–1827: A Man Without a
Mask,* Penguin Books, 1954.
6. Patriarchal authority and the traditional father role were being crit-
icized then as too authoritarian and severe. Before David's paintings,
Greuze's fathers had also been apologist images (see my "Happy
Mothers").
7. Needless to say, women lost rather than gained rights in the new
bourgeois order. The authority of fathers over their sons was not
abolished, but legally regulated by the state (see Louis Delzons, *La
Famille française et son évolution,* Paris, 1913, pp. 15–25).
8. Michael Fried's discussion of action in late 18th- and early 19th-
century history painting is relevant here ("Thomas Couture and the
Theatricalization of Action in 19th-Century French Painting," *Art-
forum,* June, 1970, pp. 41–43 and notes).
9. Peter Gay, *The Enlightenment,* New York, 1968, pp. 17–19 and *passim.*
10. James A. Leith, *The Idea of Art as Propaganda in France, 1750–1799,*
University of Toronto, 1965, pp. 116–118.
11. Lloyd D. Dowd, *Pageant-Master of the Republic, Jacques-Louis David
and the French Revolution,* Lincoln, Nebraska, 1948; and Robert Her-
bert, *David, Voltaire, Brutus and the French Revolution,* New York,
1973, p. 68 and 94–112.
12. I. Collins, *The Government and the Newspaper Press in France, 1814–
1881.* London, 1959, p. 17 and *passim;* and C. Ledré, *La Presse à l'assaut
de la monarchie, 1815–1848,* p. 18 and *passim.*
13. Herbert, *David,* pp. 55–56.
14. For example, in 1810, the artist Franque painted an allegory of the
political situation in 1799—the eve of Napoleon's advent to national
leadership. Rosenblum's essay, as well as the catalogue entry, dwells
on the style of this large, ambitious work and relates it to other,
earlier works made for Napoleon. But what the historical situation

was in 1799—or, more to the point, in 1810, when the work was made—is not discussed or related to the image.

15. As T. J. Clark notes, "the King had bought it as a gesture to the Left and then had never dared to put it on show." (*The Absolute Bourgeois*, Greenwich, Conn., 1973, p. 20).

MAKING AN ART OF WORK

A calendar illustrated with art and an art exhibition, both the creations of trade unions, raise some interesting questions about unions and art. What does one have to do with the other? And what can one do *for* the other?

The more expensive of the two projects is the exhibition *Images of Labor,* conceived by Moe Foner of District 1199 of the National Union of Hospital and Health Care Employees. Funded by the National Endowment for the Humanities, the Ford Foundation and other big grant givers, *Images of Labor* is an exhibition of paintings, drawings and sculptures by 32 professional artists. It is now on view at Gallery 1199 in New York and has been booked for a two-year national tour by the Smithsonian. In addition, all 32 works have been reproduced in color in a handsome 9 × 12 catalogue (Pilgrim Press) for wide distribution.

The catalogue makes some strong claims about the show's content and purposes. Irving Howe's introduction, Joan Mondale's preface and statements by prominent figures from the art world, labor and the media all play on the same theme: *Images of Labor* brings us "the true voices of working men and women . . . and the art inspired by their daily work." (Studs Terkel) "Working people have never been presented with such artistic force." (Joyce Miller) "The dignity and sacrifice of human labor is portrayed with compassion and without condescension." (Henry Geldzahler)

As Howe points out, American culture has hardly acknowledged the centrality of labor in American life. This is certainly true for the visual arts, especially prestigious gallery and museum art, whose dominant traditions eschew even the human figure, let alone the theme of work. How then did

This essay was first published in *In These Times* (June 3, 1981), 19. It is reprinted here by permission of the Institute for Public Affairs.

the show's organizers suddenly produce a body of art that (according to the catalogue) breaks through tradition so suddenly and thoroughly?

They proceeded in the same way big business proceeds. They decided what they wanted, designed the job and hired the labor. They gathered quotations about labor (from trade union leaders, presidents, poets, the Bible), lined up a group of professional artists and assigned a quotation to each one.

Of the show's 32 works, there are at most half a dozen in which people are actually laboring, and most of these are among the weakest pieces. An exception is Edward Sorel's drawing of youthful miners, one of the show's few small-scale pieces that has some punch and holds its own amid the larger, more ambitious works of the painters and sculptors. In general portraits, often of famous figures, outnumber—and out-quality—pictures of people working. By and large, those who labor remain hidden, or are barely glimpsed as victims. Often they recede into abstractions or are represented through symbols.

But how could it be otherwise? *Images of Labor* is, after all, an exhibition of professional modern artists. They bring with them their own concerns as professionals, concerns that are shaped by one of the most competitive and demanding labor markets. Whatever they may wish to espress as artists, in order to be visible as serious professionals they must demonstrate their capacity to produce distinctive and unique objects. For an artist, work is very much a matter of proving one's uniqueness, of devising ways to objectify it in objects. Without uniqueness, a work can have no identity or use as high art, and therefore no value in the art market. Uniqueness makes a work useful and valuable as an icon of individualism, a symbolic display of individual freedom.

To accomplish this, professional artists must emphasize their own work as artists, not the work experience of others. From the time they are art students, they learn that the best modern artists—Cézanne, Picasso, Rothko—call attention in their work to the uniqueness of their own labor process, to their formal inventions or distinctive use of symbols. Critics, galleries and museums promote and enforce this idea of art in ever new ways, controlling what becomes visible as art and as art history. When artists grumble that their world is "fixed," they know whereof they speak.

More than anything else, *Images of Labor* testifies to these market demands, and no work does it better than the one chosen for the catalogue cover. It depicts three ice-cream-

colored hardhats—lime green, lemon yellow and blueberry blue—carefully arranged on a red ground bordered in black. The work is exclusively about the artist's choices as an artist, the inventiveness of his composition and the play of the bright, clean hat shapes on the field of hot red. The hardhats become simply and purely cleverly placed shapes. In demonstrating his skill, the artist aggressively and knowingly denies the other meanings and associations hardhats have. Accompanying the work is this quotation from Woody Guthrie: "You may call the workers' phrases vulgar and untrained, but to me their forms of speech are much more clear, more powerful, with more courage and poetry than all your schools in which our leaders smile to see us learn empty grammar." One wonders who will smile at this work.

Meanwhile, another union, the United Auto Workers, asked for art from its own membership. A contest announced in *Solidarity,* the union magazine, attracted 1,500 entries. Twenty-one were selected for reproduction in the 1981 UAW calendar, published by the UAW Local Union Press Association.

The calendar project was so successful that not only is the UAW producing another one next year, but also workers have asked that the deadline be moved up to July 30 so they could produce work especially for the contest. Locals in Racine, Wisc., and Marion, Ind., have started their own local contests. Nancy Brigham at the UAW said, "Most of these artists hadn't been active in their unions until this happened. Many are now doing art and cartoons for their locals and our international publications."

These works, too, are accompanied by statements—by the artists themselves. Guthrie was right. If some of these people are technically untrained (a lot of them are highly skilled), they know what they want to say, and out of that need they find the artistic means. Though some paint animals or family portraits, most of the paintings, drawings and sculptures in the calendar are about work—working people, work places, machines, work boots and lunch pails.

It is art that comes directly out of the experience of workers. Some of it is made literally on the shop floor, as creative resistance to the boredom of work. All of it assumes an audience with like experience and much of it speaks of other workers with sympathy, sensitivity and intelligence.

The work on the cover, a painting by Catherine Doll of Local 72, Kenosha, Wisc., entitled "Dept. 828, American Motors Final Assembly," catches something of relations in

163

the workplace. Her panoramic view of the line is filled with activity—workers working, a boss bossing and the steward Doll called "if things got too out of hand." Another work, a drawing by Marcellus Williams of Local 550, Region 3, Indianapolis, Ind., brings us close to the Drift Line at Chrysler, where three helmeted men, one of them the artist, wrestle with engine blocks. The drawing jumps with energy. Williams packed it with strong, contrasting shapes, bold lines, straining bodies and scores of round things—bolts, valves, goggles and knobs—that pop out from everywhere.

These and other works understand the transforming power of labor, seen in the concentration and bodily efforts of workers. These industrial workers know that they can make the things that make the world go. "We're an industrialized society and it's time to show what's for real," writes watercolorist George Williams, of Local 51, Region 1B, Detroit. The power of labor is even suggested in a watercolor of an empty, shut-down work area by Robert Murphy of Local 444, Windsor, Ontario, a laid-off Chrysler worker. "The stilled-life objects and absence of human activity are symbolic of the recent announcement to close the plant indefinitely."

1199 tried to command images of labor out of artists whose own survival concerns are far removed from the world of 1199's workers. The UAW reminds us that working people have the intelligence, imagination and artistic ability to express themselves. The fact that their work as well as their art is not visible from the heights of the high art world does not mean that it isn't there, right in the center of American life.

IN THE EYE OF THE SOLDIER

Richard Strandberg is a Vietnam veteran from Minnesota who has long been disturbed by the silence surrounding the war. He is also an artist. An extraordinary art exhibition, *The Vietnam Experience,* is largely the result of his determination to locate other Viet vet artists and pull together a collective visual statement about life, death and survival in the war. Opening in St. Paul last year, the show came to New York this November, gaining breadth and depth in the move.

Many of the artists Strandberg found were combat soldiers. He also located journalists, Vietnamese artists and others who worked in Vietnam during the war. And he found Bernard Edelman, a vet and a photographer who helped curate the New York show. With other vet artists, Strandberg and Edelman founded Vietnam in the Arts (VITA), which scrounged funds for this show—whose future at the moment is unclear—and hopes to foster other such projects regionally.

The Vietnam Experience was remarkable because in every detail the exhibition context was controlled and run by vets. There were few accompanying words and no rhetoric about the war. An eloquent slide show, put together by Patrick Antiorio and Bernard Edelman, helped bring back some of the immediacy of the war experience. So did a soundtrack of '60s folk and rock music, played softly on hidden speakers.

The show consisted of 120 paintings, drawings, sculptures and photographs by 39 artists. Most of it was installed in a handsome gallery built by the artists and their friends inside an abandoned birdhouse in the Central Park Zoo. A neighboring building held the rest. There was very little *schlock,*

This essay was first published in *In These Times* (January 13, 1982), 24–25. It is reprinted here by permission of the Institute for Public Affairs.

and the curators also avoided a "smart," high art-world look. The purpose of the exhibition was not to showcase artists. Rather, the focus was firmly kept on the experience of the war as lived and remembered by those who were in it. What came through was not one but many Vietnam experiences.

The 20-minute slide show stated forcefully many of the exhibition's themes. Using two projectors simultaneously, but no words, it chronicled an epic in which a spectacularly beautiful country becomes a nightmare of blackened skies and shattered villages. Drawings and photographs show the war engulfing both sides in confusion, pain and degradation: the burned flesh of a child, the missing arm of a G.I., bombed temples, scarred and defoliated fields. Young and old, Asian, black and white, wait, scurry for cover, fire weapons, comfort each other and try to make a living or just stay alive in circumstances they did not choose. Near the end, haggard G.I.'s with peace buttons on their fatigues rally against the war.

On the gallery walls, superb photographs by Bob Kunes, James Kesselgrave, Edelman and others magnified some of these moments. Their many images of Vietnamese children and worried-looking, battle-weary G.I.'s not only record the effects of the war. They also show the anguish of the photographers observing it.

In the exhibition, as in Vietnam, the very identity of the enemy remained vague. But some of the works recreate the weirdness of being in Vietnam as part of the "American presence." A vet who had been stationed in Saigon told me, pointing to a painting, "That's exactly how it was." "That" was a large, striking oil, John Martin's *Cyclo Driver.* Sprawled across its width and blocking our entry is a three-wheeled motorcycle ornately decorated in bright colors. A Vietnamese man of indeterminate age squats on its back wheel and stares at us from behind sunglasses. The confrontation is not comfortable. Beyond is Saigon street traffic, including a passing bar girl in a mini-skirt. The image thrusts upon us a world of indigestible incongruities that cannot be entered confidently, least of all by the alien G.I.

Richard Strandberg's drawing, *Along the Banks of the Co Chien,* is a similar confrontation. It takes place in an area in which the Viet Cong moved freely. Through the gaze of the G.I., we see a Vietnamese woman and four old-looking children who together out-scrutinize us. They are not exactly unfriendly, but they keep their distance. The tensions of the situation are acknowledged, not only in the ambiguous

expressions of the figures, but also in the unstable, impossible-to-enter space around them.

Most of the painters and sculptors in the show seem to have been combat soldiers. Their experience of combat created powerful feelings of identity with and dependence upon the other men in their units. Their work is haunted by images of men wounded, men blown away, men rescuing or protecting each other. To my eyes, some of these pieces, especially the many little bronzes by ex-marines, romanticize war.

But the vets who crowded the show often lingered before them. For them, such images mediate difficult memories and still-living fears. The theme of the wounded or dead "brother" objectifies in a tolerable form fears about one's own death. Likewise the many rescue scenes in which anguished men struggle desperately to save a fallen buddy. The latter theme must speak to—and also appease—the sickening guilt often experienced by those who survive. Wrote one vet in the guest book, "I learned to live but yet I died some. Thank you for making others aware."

Some of the most interesting work avoids both the drama and the pathos of combat and tries to isolate hard-to-get-at feelings. One artist, John Plunkett, uses fantasy to focus on the everpresent fear of the combat soldier and also his sense of the absurdity of war. He argues that war is a game in which people become their weapons.

In his whimsical drawings, lethal weapons seem to live a life of their own. They also fear for their lives. The men presumably carrying them are always hidden by something else in the picture so that all we see are their guns. These cautiously sneak through tall grass or stand in frozen silence behind trees. In *Bunker at Night (Front View),* the face of a bunker bristling with guns and ringed with mines becomes the portrait of a disembodied, waiting fear. Plunkett is expressing the fear, but he also can't quite believe it happened and, in a cartoon-like style, comically displaces it onto objects. But the scale of the drawings—they are all on large canvases—and the sober, carefully worked surfaces tell us that he is not kidding.

In another mood, Richard Strandberg also strips down war to the always imminent possibility of death, but so quietly that it takes a while to see, especially if you were never there. *"PJ"* (Fig. 10.1) is one of several drawings and oils that remembers life on the navy river patrol boat on which Strandberg served. The work watches PJ, a fellow crew member, eating from a tin with great concentration. The simple, dig-

167

nified movement, the still, sparse setting and the patiently observed form gives this work a serene feel—if you forget the guns. Two of them, one wrapped in its cover, bracket PJ's body, reminding us of where he is and what could happen to him.

The organizers purposely avoided imposing a point of view on their contributors. Nor did they attempt to draw conclusions for the visitor. They presented us with a broad range of experiences, some of them contradictory, and also showed us the many ways in which Vietnam vets are now dealing with their experience. Rarely are modern artists given the context to communicate in this way about issues so central to modern experience.

10.1 Richard Strandberg, *"PJ"*, 1980, drawing.

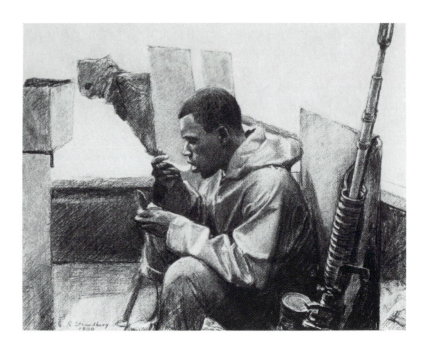

WHO RULES THE ART WORLD?

A little over a decade ago, the art press announced a new trend in modern painting, photorealism. All of the artists involved used photographic images at some point in their work process. At the time, most high-art galleries were showing totally abstract or conceptual works. It was therefore startling to see work that thrust upon us highly resolved images of the modern world. One work in particular caught my attention. It depicted a family of four on a Florida beach. The group looked like the kind of all-American families in contemporary Wonder Bread ads, except that the image had the feel of a posed snapshot in which everyone self-consciously tried to look their role as a member of a happy, fun-loving family. Thus the father—a Dick Nixon look-alike—grins too much as he plays with his son's toy car, while his wife overindicates her amusement. The work's cool, detached surface, clean-edged forms, and bright colors magnified the emptiness of the family cliché that the figures act out.

A couple of years later, I was introduced to the artist. I told him how much I liked his work. He was, of course, pleased. Then I made the mistake of saying more—something about his deadpan way of presenting such an uncomfortable image. The moment I mentioned the image, he had a fit. His painting, he insisted, was not about the cliché of the family nor anything else "in" the image. It was solely about the painted surface as an arrangement of color and form. He himself was totally indifferent to the content of the photos he used for his paintings and selected them only on the basis of their color and composition. In other words, his work was exclusively "about" art—art as it was then defined by the

This essay was first published in *Socialist Review* 13 (July–August 1983), 99–119. It is reprinted here by permission of the Center for Social Research and Education.

dominant high-art-world critics. I did not try to argue with him. The need to assert a critically validated artistic intention is not unusual among professional high artists. Nor is the desperation.

Art criticism is one of the subjects of this essay. By art criticism I mean the criticism of high art that appears in the most prestigious art-world magazines—*Artforum, Art in America, Arts Magazine, October,* and a few others. Occasionally, this criticism also appears in exhibition catalogues, anthologies, and other publications. At the outset something obvious but important should be noted: most of this criticism promotes very modern art that is not understood, liked, or even seen by most people. Which is also to say that very few people read serious art criticism. Conversely, the kind of art that is most often made and bought—the art you see in modest galleries or even street fairs—is never the subject of serious art criticism. Most people get along with art or something they consider art on their own terms without the slightest help from high-art criticism.

Yet, judging from the amount produced annually, art criticism is a necessary component of the high-art world. And art critics appear to have enormous power within that world, especially in the eyes of artists. What then is the power of art criticism? What does it do and for whom does it do it? In what follows, I want to explore these and other questions. Above all, I am interested in the role criticism plays in regulating the social relations of the art world, how it mediates both the production and use of high art.

The people who consume art criticism—those who buy the art magazines and attend lectures and panels on criticism—are usually directly involved in the production of high art. They are members of the high-art world. That world can be described in many ways—as a magnet for creative talent, an elitist enclave, a zone of personal freedom, a community of the alienated. Whatever else it is, however, the modern world of high art is an international market centered in New York City and emanating out to rival centers in Paris, London, Milan, Tokyo, and the other great centers of capitalism. Like any market, it is organized around the production and use of commodities, in this case luxury objects produced by small manufacturers.

In between the artist-producers and their buyers are layers of middlemen and women providing various services: salespeople, critics, consultants, museum personnel, art teachers,

and professors. This army of professionals classifies, explains, promotes, and displays art work and also recruits and trains new personnel. Many people do more than one thing; for example, they may produce work and also teach in an art school. Art-history professors sometimes write criticism and curate exhibitions. Since photography has now become high art in a big way, the market includes increasing numbers of photographer-artists and buyers of high photography, and also a growing number of mediators who explain, teach, and so on. Together, these people form the network of social relations within which art is produced and its use determined.

Artists make works, but they do not make art in the social sense. Their work becomes art only when it is made visible within an art context. In fact, people everywhere make things they regard as art. What they make at home may even look like art to their friends and neighbors. But most of these people are artists only within the limits of their immediate communities. The New York high-art world is no local community among other art communities. It is the most socially visible art community and, at present, the summit art community in the Western world. It appears as a set of spaces set apart for the display of high-art products. The most noticeable of these spaces are the prestigious big-city museums. The Museum of Modern Art, the Metropolitan Museum of Art, the Guggenheim, and the Whitney are perhaps the supreme spaces of the high-art world. Here, the public may see work that is considered the most authentic, achieved, and authoritative high art. Works shown in these spaces validate other works like them shown elsewhere.

Radiating out from these centers is a sprawling network of supporting high-art spaces that reinforce the authority of the great museums—a handful of "important" commercial galleries; some private collections, watched by market insiders; small or university museums with an eye for new art trends; and a host of lesser, fringe, and so-called "alternative" spaces. Some of these function as launching stages from which new work can be catapulted into the higher reaches of the market, although most of the smaller museums are content to follow the lead of the centers.

The majority of people who make art never come near any of these spaces, at least not as art suppliers. Others prefer or are kept in the fringe spaces, many of which are funded by the state or by corporate money and sometimes allow a

greater margin of personal freedom and experimentation than the centers.

In order to become visible in this world, an artist must make work that in some way addresses the high-art community or some segment of it. I am, of course, assuming an art school or art department-trained individual, someone whose notion of artistic labor has already been shaped with an orientation toward the high-art market. There are, in the New York area alone, thousands of such people—painters, sculptors, photographers, printmakers, art performers, and others—competing with each other to become visible in this market. There are as many more who live elsewhere, often in university towns where they teach art or are married to those who teach. Together, all of these people make hundreds of thousands of works that are intelligible as art to only a handful of buyers, critics, dealers, and curators. This glut of art and artists is the normal condition of the art market.

Artists make works, but they do not have the power to make their work visible as art in the high-art world. Their work becomes high art when someone with authority in that world treats it as art. This happens in essentially three ways: the work is exhibited in a high-art space, it is noticed in the high-art press, or it is purchased by a high-art collector. The most splendid demonstration that the high-art world values an artist's work is when an important museum buys a chunk of it and hangs it up for everyone to see. But before this happens, artists usually must collect validation over a period of time in the other ways. Visibility normally begins when a recognized high-art dealer or a curator in one of the museums that count includes them in a show or gives them a one-person show of their own. By doing so, the dealer demonstrates publicly that the artist's work has art quality for him or her. When dealers or curators exhibit work, they are staking their professional judgments and reputations on it. If the work is validated elsewhere or finds a buyer, the exhibitor maintains or even gains in validating power.

Finally, the work becomes high art when a critic treats it as such in the high-art press or in some other public forum. But getting critics' attention, let alone favorable attention from an able critic, does not follow automatically from getting exhibited, although an exhibition usually provides critics with the occasion to write about an artist. Much depends upon where one is exhibited. Only a handful of "in" galleries can assume that their shows will be noticed. Of course, a one-person show in a big museum—the ultimate recogni-

tion—is sure to produce critical response. But by the time artists get such shows, they have already achieved significant visibility in the market.

Good critics validate work as high art by publicly testifying that it has art quality for them. They put into words their experience of a work, identifying the ideas and feelings the work evokes in them and describing the specific way the artist produces that effect. Critics thus demonstrate that the work has some transcendent meaning to them, that it gives shape to or illuminates some feeling, value, or truth that they hold to be significant, and that it does so in a form that seems appropriate. The quality of the critic's work can be more or less tested in the looking: either you see and value the meaning he or she points to or you don't. In this way critics, together with dealers and curators, create an art context for work. They surround it with mediating discourse and also with a physical context that prompts its reading as art.

By testifying to a work's art value, the critic also augments the market value of a work. When he successfully communicates his own experience of the work, he gives it meaning and therefore value in the eyes of others. The critic thus helps build the artist's reputation and also gives that reputation specific content. In the process the work absorbs value created by the critic's labor. In practice, then, the aesthetic and the economic value of a work ride on the same judgment. Because of this, critics—when they are not being courted by artists—are often looked upon with resentment and are especially open to charges of collusion and self-interest (many of them also have sizable art collections). These charges are often well deserved, but most critics do not have the autonomous power artists attribute to them. As we shall see, whatever power they wield is ultimately limited by the buyer's needs.

Nevertheless, criticism plays a crucial role. Criticism sorts, labels, and measures the worth of artists, ranking them in relation to each other within one of the ever-shifting trends that waft through the market: pop, figurative, abstract lyricism, minimal, neorealism, conceptual, performance, pattern-painting, punk, new wave, neoexpressionism, and so on. At the same time, individual critics make their own bids for attention by championing or inventing one or more of these often transient art trends. Whether or not they like it or want to admit it, most professional artists are forced to keep an eye on the market. They know what trends are cur-

rently receiving critical support. They know who is showing in what gallery, who has a retrospective at the Whitney, who is on this month's cover of what magazine, who got reviewed on the inside and how many lines of print they got. They know who is selling for what at auction. Since art-school days, artists learn that recognition means becoming visible in these contexts, and many artists measure their own value according to how much of this visibility they achieve. Central to their career objectives is the fact that they must compete with each other through their work even as they seek from each other the companionship and support of fellow professionals.

Criticism thus guards the door to all available high-art spaces, sets the terms for entry, scouts the fringe spaces for new talent, and tirelessly readjusts current criteria to emergent art modes. Criticism is the mediating veil in all art-world transactions. It is the alchemy, the invisible, seemingly magic wand that converts potential art into the real thing. It mediates not only the buying of art, but also its production and use. Criticism can decide which of many possible meanings a work will have and can suppress others, affecting how past works are seen and experienced in the present.

Artists practice criticism as much as critics. Their ideas about what is possible and good in art are shaped by the same tradition—learned in art school—that shapes the views of critics, curators, and publishers. However, artists cannot validate their own work. Their testimony is considered biased by their interests as producers in a highly competitive market. Critical writings by artists or exhibitions curated by them do not have the same market clout as regular criticism and exhibitions, even though some artists talk about their own and others' work with more insight and intelligence than the critic. The critic may discover or emphasize meanings that the artist doesn't see. The artist may think her work refers to her experience as a mother or a lover or to some philosophical idea. The critic may talk only about how the work uses color or materials. Conversely, the critic may praise the artist for communicating something about nature or female experience, while the artist may declare that her aim is only to explore spatial relationships or the qualities of paint. Generally, artists learn to speak of their work in accepted critical terms. If you paint figures when figure painting is out, you may very well find more to say about your use of color or the surface play of form than about the human beings you

depict. It is, however, irrelevant whether or not an artist agrees with what a critic says about her work. What matters is whether or not her work is noticed. Most artists accept the validation process in principle and wish only that the critical winds would blow their way. Meanwhile, they make the rounds of the dealers, invite critics to their lofts, and eat their bile as they watch others take away from themselves portions of the limited available critical attention.

Individual critics feel themselves to be no more powerful than artists. Most of them are enthusiasts of modern art trying to bring to public attention the art they admire. They are no more biased toward their friends than artists are. And they are as likely as artists to complain about the museum-gallery-publishing establishment that advances only "safe" or pre-tested art. Many dealers tell the same story: they can't afford to show what they'd like because it won't get reviewed in the art press. And on it goes. Everyone feels caught up in a "system" whose controlling power is everywhere but in no one in particular.

That perception is fairly close to the truth. The art world is hardly a consciously organized conspiracy. There are only individual people, acting in the belief that they are doing something good: advancing the cause of art. The controlling force in the high-art market is not in any individual critic, curator, or dealer but in criticism itself. And criticism is everywhere—in the judgments of dealers, curators, and critics, in the art strategies of artists, in the lectures of art-history professors, and in the decisions of art editors. Criticism is the all-pervasive force that makes possible and unifies the market system. Its influence is felt from the moment of production, in the minds of artists, and continuously thereafter when the work is seen by its high-art audience. Criticism is the art world's form of quality control.

Quality is a word often used in art-world discussions about art. Or, more precisely, it is a word that usually ends discussion. That is because quality, although understood as the ultimate basis of all critical judgments, is thought to be an undefinable and universal essence. But quality in art work is no different from quality in any other man- or woman-made object. The quality of labor in anything is that which gives it its specific use. Art, like other things, embodies quality for someone when it meets his or her wants—to be entertained, moved, flattered, enlightened, charmed, awed, or any of the other things people value in art. We may value a work because

we find its colors pleasing, or because it reminds us of our childhood home, or makes us feel tension or joy or surprise. We may buy a work because we think it will enhance our social standing or because it gives us back a piece of our experience in the world in a heightened form. We may like a work simply because we admire the artist's skill in rendering textures or flesh.

Modern high art can do all of these and many other things. But to have the quality of high art, it must also do something else. This something else gives it its use-value as high art.

What then constitutes quality in modern high art; what is its use? And to whose needs is this use addressed? The main use to which modern high art is put is ideological. This use can best be seen in the high-art world's supreme space, the museum. In the museum high art is most fully used as high art. It is in the museum that we see works that have been given the highest validation and have absorbed the most critical labor. There, each work, reverently isolated and carefully illuminated, is made to stand as a moment of artistic freedom, a freedom evidenced in the artist's capacity for innovation and uniqueness. Numerous mediators have explicated, documented, and personally testified to those qualities. Articles, books, exhibition catalogues, and films demonstrate the formal inventiveness of this or that artist, his special iconography, his distinctive use of symbols, textures, or materials, the risks he took, and the sacrifices he made in achieving these qualities. Innovation and uniqueness are ideologically useful because they demonstrate the artist's individual freedom as an artist; and *that* freedom comes to stand for human freedom in general. By celebrating artistic freedom, art-world institutions "prove" that ours is a society in which all freedom is cherished and protected—since, in our society, all freedom is conceived as individual freedom. Modernist works, as celebrated instances of freedom, thus function as icons of individualism, objects that silently turn the abstractions of liberal ideology into visible and concrete experience.

In the art market, then, artistic innovation and uniqueness are the coin of the realm. Professional artists, competing with each other for limited high-art space, know very well that they must call attention in their work to the uniqueness of their own artistic labor if their work is to have market value. But uniqueness only registers when it appears in accepted art-world forms. Thus artists must signal their intentionality to make modern high art by addressing the viewer in one or another of the validated high-art modes that criticism de-

mands. They must declare themselves high artists first and last. Which does not mean that they cannot also say other things. Indeed, some artists are very intent upon expressing their beliefs, ideas, and experiences as human beings beyond the art world. But if they want to say those things *in* the high-art world, they must also demonstrate sufficient amounts of "purely artistic" intentionality or keep the life experience very personal, "universal," or ambiguous. Or they must build into their work certain strategies: critical bypasses around the "non-art" content or clever "aesthetic" resolutions in which the art part subsumes the rest. Claus Oldenberg, Andy Warhol, Hans Haacke, and George Segal are some of the artists who, in very different ways, have figured out how to pay the art world's price of admission and also manage to comment about life beyond the art world—although not all their work may communicate in that world beyond, especially when the artist's struggle to say something through the barrier of high-art form is part of the work's content. Of course, there are artists who look at the world very critically and make that vision highly accessible in their work. Leon Golub is probably the best example. Such artists get respect from other artists and critics, but the non-art part of their work is too violent, raw, or politically up-setting to sit easily in accepted critical categories or in the cool, "universal" spaces of the high-art world, and their work is not well known, even within the art world. In general, the more you want to communicate to the outside world, the less likely your work will be seen by a larger public. Criticism, always on the lookout for what is ideologically useful, demands not simply innovation and uniqueness but *artistic* innovation and uniqueness, and it wants those qualities to stand out over and above the other possible readings of a work. Still, in some sections of the art world, liberal and even left-wing sentiments are not unwelcome—another proof that freedom is honored. But if those other meanings are too intrusive or specific, the work cannot be useful. To have the quality of high art, the work must, above all, force-fully demonstrate the artist's individual artistic inventiveness. The work must remind us that how it's said is ultimately more significant than what is said.

The state has learned to understand very well this meaning of modern art. A few years ago, Eva Cockcroft documented the use of modernist art by the State Department, which, using the Museum of Modern Art as a front, secretly funded

overseas exhibitions of Abstract Expressionism in order to convince European intellectuals that in America freedom thrives and is honored.[1] More recently, Francis Pohl explored how Ben Shahn has been used to the same end.[2] It is, I believe, ultimately for the same reasons that both corporate and state funds support some of the more adventurous fringe and alternative spaces in the art world. At present, three New York banks, including the Chase Manhattan, are funding a series of installations in their lobbies. At least one of these installations (by Mimi Smith) is intentionally critical of modern capitalism. The bank officers may or may not notice its content—the entire affair was arranged by an art-world mediator. In any case, the work's critical content will come encased in a recognizable art envelope, and that installation, like the others, will demonstrate the bank's support of artistic freedom and, by implication, freedom in general.[3] Wishing to appear modern in the Western sense, the Shah of Iran set up a modern museum in Tehran before he was ousted—a museum stuffed with American art and staffed by American personnel.

Modernist art thus constitutes the official art of liberal Western states and also of states wishing to appear as such to others. Accompanying this art is an official history of modern art and also a force of credentialed art historians whose job it is to preach, revise, and demonstrate the central truth of that history. In this, the labor of the art historian is hardly distinguishable from that of the critic. Critics and art historians train and teach in the same institutions, publish in the same journals, and employ the same critical language as they re-sift the art of the past, examine it for its potential use, and rediscover or redefine its place in art history. Like the art market itself, art history is always in flux as the dead and dying artifacts of other eras—works whose original meaning has faded—are given new use by the living labor of the critic-scholar.

Alan Wallach and I have explored this official history of art in its most authoritative presentation, the Museum of Modern Art's permanent collection.[4] We found that art given the highest value is art that renounces common experience and the language and visual modes that evoke that experience. Cézanne, Cubism, Mondrian, Kandinsky, Miró, the Abstract Expressionists—these are some of the highlights of modern art history. Traditional, premodern art, whatever else it did, affirmed the existence of an external reality. However much it distorted or idealized that reality, traditional art acknowl-

edged through it the possibilities of biological need, emotional attachment, and moral and political action. Eighteenth- and nineteenth-century art—David, Géricault, Delacroix— addressed you not simply as an individual but as an individual citizen (although most people were not), a member of a social and political community with a historical past that gave meaning to the present. The history of modern art, as constructed in museums, classrooms, and textbooks, is a history in which this earlier bourgeois concept of individualism shrinks to an idea of the private self, while its corollary notions of the external world are, piece by piece, rejected as a realm of value. The heroes of modern art negated the common experience of this world and found within themselves a new subjective world which they simultaneously invented and explored.[5] Little by little, they rid their art of narrative, illusionism, representation, and, finally, of the picture frame itself. In place of these traditional visual conventions, they created new forms to evoke an increasingly pure and subjective realm. These innovations are the "sacrifices," "risks," and "break-throughs," the leaps to ever greater purity, abstraction, and inner depth that critical-scholarly writing coaches us to see as the inexorable mission and achievement of modernism. Art and discourse in the nineteenth century distorted and idealized the external world and celebrated it as Beauty. Modern art celebrates alienation from that world and idealizes it as Freedom.

Art history and criticism thus celebrate the artist as the ideal modern individual. Opposed to and unappreciated by the materialist world and its old-fashioned culture, the modern artist-antagonist acts out symbolically and on the cultural plane the conflict between the individual and society. In the end, he triumphs over the world through a vision that transcends and leaves behind its social and material conditions. His is a triumph of the spirit. Indeed, as he appears in the literature, the modern artist is a combination of the ascetic saint and the virile, daring folk hero. His unconventional art bears witness to both his heroic renunciation of the world and his manly opposition to it. In appreciating those qualities, viewers can live them vicariously.

I am not suggesting that criticism exaggerates the extraordinary imagination of the best modern masters. On the contrary, their work negates the world and its emotional, moral, and political possibilities with inspired conviction. They demonstrate the reality of the subjective realm with an in-

ventiveness, a fullness of expression, and an economy of means seldom matched by other twentieth-century artists. This holds not only for the heroes of the early twentieth century—Matisse, Picasso, Kandinsky, and the others—but also for the gallery stars of later years—artists such as Rothko, Johns, Stella, Judd, and Serra. But we must also recognize that great artists, like star baseball players, appear in the context of a system designed to produce and discover them. Selected from among hundreds of competitors, those who become visible are those whose talents best accord with the demands of the game.

My point then is not that the wrong "great" artists have been selected; there is no alternative high-art tradition to speak of. Nor am I protesting the fact of an art market. I am pointing to the nature of the needs that control that market, needs that organize vast amounts of imaginative labor and spill most of it down the drain in order to get a little of it to show in a few places for the benefit of a few people. We can measure the waste not only in the thousands of "failed" artists—artists whose market failure is necessary to the success of the few—but also in the millions whose creative potential is never touched. Let us also count the labor of the mediators who conscientiously police high-art space and maintain its order.

I began by saying that the world of high art addresses only a small segment of the population. It nevertheless plays a crucial ideological role since it is this segment that controls industry, education, and communications. Besides the super rich—those who might actually form significant art collections—the high-art audience includes affluent and educated professionals, those whose class loyalty and skills are necessary for managing industry and the state and, directly or indirectly, controlling the classes below them. In modernist art these people may confirm their social identities as members, or would-be members, of the privileged few. It is they who can enjoy the aesthetic detachment and the spiritual adventure that modernist art offers. They are the ones with the life opportunities and incomes that give substance to modernism's claims of freedom. Above all, it is they who are free to transcend the conflicts of everyday life. And no other group is better prepared educationally and by situation to understand and respond to the visual cues of modernism. It is to the elect and the many who identify with it that modern art delivers its spiritual load. Modernism gives comfort to worn and troubled minds. Sealed off from the horrors of daily life—

the unsettling events on the nightly news, the danger, disorder, and pollution in the world outside and feelings of loneliness and alienation within—modernist art reconciles us to modern life by showing us a realm of calm, resolution, and order. Modernist art redeems the spirit, confirms its existence, and provides a safe place for the exercise of emotions.

But most people do not like modern art. Years ago, when I took my driver's test, the inspector who put me through my paces asked me what I did for a living. Upon discovering that I taught art history, he felt compelled to tell me of his dislike for Picasso, probably the only modern artist he could name. For a good fifteen minutes, while I did my turns and stops, he complained steadily about modern art. "I'm not stupid," he kept saying, "but that art doesn't say anything to me." Indeed, there was nothing stupid about him. But he felt that someone was telling him he *was* stupid by holding up for his admiration expensive and apparently meaningful objects he could not comprehend. Students in the state college where I teach often indicate such resentment—or else they are full of apology for not liking modern art.

In his remarkable essay of 1926, "The Dehumanization of Art," Ortega y Gasset offered a sociological explanation of the unpopularity of modern art that still holds. "The new art," he wrote, "obviously addresses itself not to everybody . . . but to a specially gifted minority"—in fact, a minority of culturally alienated individuals.

When a man dislikes a work of art, but understands it, he feels superior to it; and there is no reason for indignation. But when his dislike is due to his failure to understand, he feels vaguely humiliated and this rankling sense of inferiority must be counter-balanced by indignant self-assertion.

In effect, the new art reminds "the average citizen" of his inferiority to the privileged few—an effect that Ortega, a man of the Right, relished. For him the new art gives the lie to the ideal of democracy. It tells the masses who they really are: "inert matter of the historical process, a secondary factor in the cosmos of spiritual life." But it also "helps the elite to recognize themselves and one another in the drab mass of society and to learn their mission, which consists in being few and holding their own against the many."[6]

From a historical point of view, there is nothing very abnormal in the way modern society organizes, limits, and uses

the labor of artists. Throughout history the production of art and art codes has always been controlled by and geared to the needs of those who do control society. Princes, kings, and bishops—those who embodied the state—usually got the art and the artists they needed. If the right artists were not immediately available, they or their work were shipped in— to Persepolis, Athens, Rome, Versailles, or Tehran. Or the necessary labor was created locally, in royal schools or workshops. With rare exceptions high artists have had little choice but to labor for the ruling classes of their times. Even when, as in our society, other classes also use art, the individual trained as a high artist is hard put to find users beyond the ruling classes for his specialized products.

We know a lot about how the great patrons of the past communicated their needs to artists. Typically, Cosimo de' Medici, Louis XIV, and Napoleon closely watched their architects and artists and, when necessary, directly intervened in their work. The princes and popes of the Renaissance also retained advisors, "court humanists," or special agents, who suggested programs for decorative schemes or scouted potential art talent. Colbert, Louis XIV's First Minister, often acted as the king's executive art supervisor and also created the Royal Academy and its art school to ensure the king the quantity and kind of art he needed.

In our own century the direct intervention of the patron is rare except in architecture where the traditional artist-patron relationship is still viable. When it comes to objects— paintings, sculpture, or photography—the old relationship has been completely transformed. Patrons who once commanded such works directly from the artist now go to the free market and buy them ready-made and ready-mediated. Instead of retaining personal agents, they now endow art-history departments or fund museum exhibitions. Nevertheless, the patron's needs remain the governing force in high-art production, although—as mediated by criticism—those needs now appear as seemingly autonomous art ideologies.

I have stressed the way the constraints of the art world shape and limit the lives of professional artists only because high art is so surrounded by claims of freedom and universality. The idea of art as a realm of freedom and universality is central not only in the dominant liberal tradition, but also among left critics of that tradition who have their own versions of it. Here, art is often given a liberating mission or conceived as a moment in which ideology is transcended. Such ideas, although abundant in philosophy, are difficult to

find in historical reality. In history real artists and not The Artist as an abstraction have had to survive within the social relations of art production. With rare exceptions they have had to work for someone. And most working artists have not significantly transcended either the dominant ideologies or the established art modes of their time. Those who did often had the support of an emerging social class whose values were not notably more liberating than those they were displacing. As for the liberating power of art, one can argue as easily that art, far from being liberating, tends to be oppressive, that it mystifies and distorts the world in the interests of the few or, like ritual, it objectifies socially dangerous impulses only to contain them in a harmless and symbolic form. In fact, much of the monumental art of the past does just this. But this is not to say that all art, by definition, is oppressive. My point is that art is not a closed category with inherent and fixed qualities, good or bad, liberating or oppressive.

Nevertheless, there have been artists who significantly opposed the ruling values and beliefs of their day. Nowhere is this opposition more widespread than in nineteenth-century Paris, the then capital of the Western art market. Artists such as Manet, Degas, Pissarro, Monet, Van Gogh, and Seurat stripped their work of received ideas and created new art languages closer to their own alienated life experience. The isolation and poverty that some of these men endured is well known. But their situation was historically abnormal. In most societies ruling powers know how to attract, organize, and use the best artistic talent. The careers of the Impressionists and Post-Impressionists unfolded in a period of rapid and far-reaching economic and social change. Finance capital was just in the process of becoming dominant and had not yet learned to recognize its particular needs in art. Still, even in the 1870s, what little patronage the Impressionists had came from this emergent group.[7] By 1905 the situation was more normal: progressive capitalists now understood how they could use the unconventional spirit of the avant-garde.[8] From this point on, the modern art market took shape as a haven for alienated, expatriated, and idealistic talent—but a haven whose freedoms would be limited by the needs of its adventurous capitalist supporters. Therein lies the struggle of the modern artist. In the early decades of the twentieth century, the heyday of vanguardism, it seemed easier to beat the system. But the contradictions and ambivalences were always there.

Already in the teens, avant-garde artists made attempts to

control the meaning of their freedom and the use of their work. They began booby-trapping it. They painted outrageous, vulgar, or "low" art subjects intended to repel high-art audiences, put junk into their work, made things that self-destructed, or refused to make objects altogether. I refer, of course, to the more aggressive anti-art moments of the avant-garde—to the collage, Futurism, and, above all, the antics of Dada. The anti-art objects and events hatched by Duchamp, Man Ray, Kurt Schwitters, and the German Dadaists were pointedly conceived as art occasions that could *not* result in expensive, high-art commodities. Designed as art for artists, much of it was literally destroyed in the using.

But as it turned out, in the modern art world, to break the rules is to follow them. The avant-garde was already a market where symbolic acts of freedom, irreverence, or absurdity were valued and turned into objects of exchange. From the beginning, antagonism toward established high art, including yesterday's avant-garde art, was a necessary attribute of the modern artist, a sign of his or her free, innovative spirit. Thus, in struggling against their constraints, artists tightened the knots. Their own survival interests, their alienation from traditional culture, and all the needs that made them artists in the first place dovetailed with the market's appetite for thrilling and symbolic adventure. Together, artists, critics, dealers, and buyers found ways to commodify even artists' rebellion against the market. In museums today, we can see Dada objects or replicas of intentionally destroyed ones reverently installed in glass cases like so many strange little artifacts. Many years after Dada, New York artists would rediscover similar strategies. Happenings, conceptual and performance art would recapitulate much the same drama. Relics of these movements, too, can be seen in the museums, properly displayed as high art. Thus, even when artists have protested the use to which high art is put and have built that protest into their art, their interventions have had only temporary or limited effect. For all their vaunted freedom, high artists, if they are to be visible as high artists, have little choice about how their work is used; and that is because, as high artists, they cannot choose which class they will serve.

To be sure, the notion that avant-garde art is inherently oppositional cannot be entirely dismissed. But we must recognize that artists' struggles to control the meaning of their work are not a class struggle between capitalists and a proletariat. High artists are small, independent manufacturers of

luxury goods. For the most part, their struggle is not so much against the system but for survival within it. Unable to challenge the controlling power of the market, most of them seek to convince the market of the value, meaning, and high-art use of their products.

But artists are also individualists who are often alienated from established high-art culture. Their opposition—if not political—is genuinely felt and expressed as an impulse to negate the idea of "art" itself. And it is this cultural opposition that is endemic in almost all modernist art, including recent art made for a market controlled by corporate patronage. In one way or another, almost all of the movements of mainstream modernism, including Abstract Expressionism and Pop, declared themselves against accepted art values. Even Minimal art, which dominated the museum-gallery establishment in the sixties and seventies, began with an impulse to negate. Its best practitioners insisted that there was nothing *in* their work beyond the literal forms themselves—no affirmation of the "humanist" values of Abstract Expressionism.[9] Accordingly, critics instantly seized upon the new style and touted it as an affirmation of the idea of art itself. They hailed its clean, cool forms as moments of a pure, absolute, and perfectly empty freedom. Perhaps nothing better than Minimal documents the contradictions high artists live: the necessity imposed by the market to commodify the spirit; the artist's impulse to protest that commodification; and finally, the commodification of that impulse to protest. But while Dada set out to beat the system by not producing commodities, Minimal and the other trends like it admitted impotence from the start and mutely handed over the goods.

There is also a long and interesting adversary tradition in criticism. Since the eighteenth century, from Diderot to our own time, certain writers have set themselves in opposition to established art practices and the artistic codes they embody. Most of those critics remembered today championed new or emergent art styles that were struggling for high-art recognition. Like the artists they advocated, they are portrayed by art history as antagonist heroes whose judgments history would bear out. According to that history, their final vindication is a matter of aesthetics or taste or some mysterious *je ne sais quoi* that enabled them to divine the genius of this or that artist or group. This explanation, as far as it goes, is true. Thoré, Baudelaire, Zola, Roger Fry, Harold Rosenberg, and the others could see qualities and values in the work of

certain artists that had no meaning or use for others—in the work of the Naturalists, Manet, Cubism, and Abstract Expressionism. They not only picked the winners of future art history, they also articulated new art ideologies. But if history vindicated their judgments, it was because dominant social groups, old or newly arrived, found that art relevant to their changing interests, experience, and ideological needs. And their social power enabled them to shape high culture in their own image. What pleased, convinced, and moved them thus became "universal"—at least for a time.

The history of art criticism, then, is very much a part of the history of the bourgeoisie. We can see that history in sharpest detail in France, the international center of art production in the Western world up until the 1940s. The critic first appeared there as significant cultural force in the later eighteenth century, at precisely the moment when the bourgeoisie was ready to make a decisive bid for state power. Criticism thus appeared as part of a struggle in which the emergent bourgeoisie sought to appropriate high art for its own use. For decades the battleground was the Academy, and the point of contention was whose needs academic art would serve. Increasingly, Salon art found ways to speak to and for the bourgeoisie, whose growing armies of critics patrolled its exhibitions and hawked their pamphlets at the door.

Around the middle of the nineteenth century a second front began opening up, the infant gallery system. At first it was adjunct to the Academy, an old-fashioned corporate structure but still the chief source of validation. Eventually, the gallery would suck validating power away from the Academy. The decisive moment was the Impressionist boycott of the official Salon in the 1870s and the coincidental rise of Durand-Ruel and the other important dealers. From then on, the dominant social relations of art production would be organized around a free, competitive market system. The Academy quickly withered away as a significant institution in the production of high art.

At this point, too, the role of the critic as a specialized mediator between producer and user grew into a profession in its own right. Of the critics I have mentioned here, Roger Fry was the first who made a good living as a full-time mediator of both modern and older art. J. P. Morgan, when he ran the Metropolitan Museum, even sent for him to put the museum into shape. The relationship did not last long, but it anticipated the next major victory of modern art: its

definitive reconquest of museum space. An important early moment in that battle was the opening of the Museum of Modern Art's new building in 1939, followed, after World War II, by a virtual flowering of other modern museums and modern wings in older museums. We are still in that expanding phase. At the same time that modern art conquered in the museum, it also invaded the art schools and university art-history departments, the places that train high artists, high-art mediators and high-art users. These developments, too, chronicle the growth of capitalism and its rival sectors, personified by Morgan, the Rockefellers, the Mellons, and now IBM, Exxon, Mobil, and the other great patrons who "give" us high art.

In all of these struggles criticism has fought not against high art but for control over it, while those whose values it promoted struggled for control over other aspects of society. These various struggles, each necessary to the other, have been different sides in the same battle. For now as in the past, high art exists largely at the will and for the use of wealth and power—and I would add that it exists for the most part as a means of keeping that power in place.

The high-art world monopolizes high-art prestige, but it does not organize all creative labor. Even within its shifting spaces, there are pockets of contradiction and fringe areas worth fighting for—if that's where you are and if you can afford to choose your compromises. There is also art space outside its jurisdiction.

Recently, I saw an exhibition about the Vietnam War consisting mostly of work by Vietnam veterans trained as artists.[10] The entire event came about because of the determination of its initial organizer, the artist and Vietnam vet Richard Strandberg, to find other vet artists and make a collective visual statement about their war experience. Rather than showcasing artists, the exhibition's focus was kept on the varied and contradictory ways people survived the war—physically, emotionally, and morally. Some of the exhibiting artists, many of whom are struggling in the market, were reluctant to show these particular works—images of soldiers, Saigon children, wounded friends, guns and grenades—until they learned who controlled the show's context and for what purpose. They understood that in the high-art world the meaning of these works was likely to become distorted and the experience within them exploited in the name of art. They recognized, however, that this exhibition created a context

in which their needs could appear, not simply as professional high artists but as men who lived the trauma and pain of Vietnam *in* Vietnam, who now want to speak of that experience, and whose means of expression happen to be the visual arts. Rarely can artists address us in this way about issues so central to modern life.

That such efforts are rare is not the fault of artists. When the rest of us not only make new demands on art but also help create new contexts, new channels of distribution, and new modes of support, we shall have art we can use.

NOTES

1. Eva Cockcroft, "Abstract Expressionism, Weapon of the Cold War," *Artforum,* June 1974, pp. 39–41.
2. Frances K. Pohl, "An American in Venice: Ben Shahn and United States Foreign Policy at the 1954 Venice Biennale," *Art History,* vol. 4, no. 1.
3. See Hans Haacke, "Working Conditions," *Artforum,* Summer 1981, pp. 56–61, for a superb analysis of the impact of corporate needs on the art world.
4. Carol Duncan and Alan Wallach, "The Museum of Modern Art as Late Capitalist Ritual," *Marxist Perspectives,* Winter 1978, pp. 28–51.
5. For a thorough discussion of this new subjectivity and the modern conditions in which it arises, see Eli Zaretsky, *Capitalism, the Family, and Personal Life* (New York: Harper Colophon, 1976).
6. Jose Ortega y Gasset, *The Dehumanization of Art* (New York: Anchor Books, 1966), pp. 6–7.
7. Michel Melot, "Pissarro: An Anarchistic Artist in 1880," *Marxist Perspectives,* Winter 1978, pp. 22–54.
8. Renato Poggioli, *The Theory of the Avant-garde,* trans. Gerald Fitzgerald (New York: Icon Editions, 1971).
9. "Questions to Stella and Judd," interview by Bruce Glaser, ed. by Lucy Lippard, in Gregory Battcock, ed., *Minimal Art* (New York: Dutton, 1968), pp. 148–164.
10. See my report, "In the Eye of the Soldier," *In These Times,* 13–19 January 1982, reprinted in this volume, pp. 165–8.

THE MoMA'S HOT MAMAS

The theme of this issue of *Art Journal* is Images of Rule. The objects that my essay discusses, well-known works of art, are not images of rule in any literal sense—they do not depict a ruling power. They are, nevertheless, effective and impressive *artifacts* of rule. Rather than directly picturing power or its symbols, they invite viewers to an experience that dramatizes and confirms the social superiority of male over female identity. This function, however, is obscured and even denied by the environments that surround the works, the physical environment of the museum and the verbal environment of art history. In what follows, I try to uncover this hidden function.

When The Museum of Modern Art opened its newly installed and much-enlarged permanent collection in 1984, critics were struck with how little things had changed. In the new installation, as in the old,[1] modern art is once again a progression of formally distinct styles. As before, certain moments in this progression are given greater importance than others: Cézanne, the first painter one sees, announces modern art's beginnings. Picasso's dramatically installed *Demoiselles d'Avignon* (Fig. 4.9) signifies the coming of Cubism—the first giant step twentieth-century art took and the one from which much of the history of modern art proceeds. From Cubism unfolds the other notable avant-garde movements: German Expressionism, Futurism, and so on, through Dada-Surrealism. Finally come the American Abstract Expressionists. After purifying their work of a residue of Surrealist representation, they made the final breakthrough into the realm of absolute spirit, manifested as absolute formal and nonrepresentational purity. It is in reference to their achieve-

This essay was first published in *Art Journal* (Summer 1989), 171–178. It is reprinted here by permission of The College Art Association, Inc.

ment that, according to the MoMA (in its large, new, final gallery), all later significant art in one way or another continues to measure its ambitions and scale.

Probably more than any other institution, the MoMA has promoted this "mainstream modernism," greatly augmenting its authority and prestige through acquisitions, exhibitions, and publications. To be sure, the MoMA's managers did not independently invent the museum's strictly linear and highly formalist art-historical narrative; but they have embraced it tenaciously, and it is no accident that one can retrace that history in its galleries better and more fully than in any other collection. For some, the museum's retrospective character is a regrettable turnaround from its original role as champion of the new. But the MoMA remains enormously important for the role it plays in maintaining in the present a particular version of the art-historical past. Indeed, for much of the academic world as for the larger art public, the kind of art history it narrates still constitutes the definitive history of modern art.

Yet, in the MoMA's permanent collection, more meets the eye than this history admits to. According to the established narrative, the history of art is made up of a progression of styles and unfolds along certain irreversible lines: from style to style, it gradually emancipates itself from the imperative to represent convincingly or coherently a natural, presumably objective world. Integral to this narrative is a model of moral action, exemplified by individual artists. As they become liberated from traditional representation, they achieve greater subjectivity and hence greater artistic freedom and autonomy of spirit. As the literature of modern art portrays it, their progressive renunciation of representation, repeatedly and minutely documented in monographs, catalogues, and critical journals, is often achieved through painful or self-sacrificing searching or courageous risk-taking. The disruption of space, the denial of volume, the overthrow of traditional compositional schemes, the discovery of painting as an autonomous surface, the emancipation of color, line, or texture, the occasional transgressions and reaffirmations of the boundaries of art (as in the adaptation of junk or non-high art materials), and so on through the liberation of painting from frame and stretcher and thence from the wall itself—all of these advances translate into moments of moral as well as artistic choice. As a consequence of his spiritual struggle, the artist finds a new realm of energy and truth beyond the material, visible world that once preoccupied art—as in Cubism's reconstruction of

the "fourth dimension," as Apollinaire called the power of thought itself; Mondrian's or Kandinsky's visual analogues of abstract, universal forces; Robert Delaunay's discovery of cosmic energy; or Miró's recreations of a limitless and potent psychic field. Ideally and to the extent to which they have assimilated this history, museum visitors reenact these artistic—and hence spiritual—struggles. In this way they ritually perform a drama of enlightenment in which freedom is won by repeatedly overcoming and moving beyond the visible, material world.

And yet, despite the meaning and value given to such transcendent realms, the history of modern art, as it is written and as it is seen in the MoMA and elsewhere, is positively crowded with images—and most of them are of women. Despite their numbers, their variety is remarkably small. Most often they are simply female bodies, or parts of bodies, with no identity beyond their female anatomy—those ever-present "Women" or "Seated Women" or "Reclining Nudes." Or, they are tarts, prostitutes, artist's models, or low-life entertainers—highly identifiable socially, but at the bottom of the social scale. In the MoMA's authoritative collection, Picasso's *Demoiselles d'Avignon,* Léger's *Grand Déjeuner,* Kirchner's scenes of street walkers, Duchamp's *Bride,* Severini's Bal Tabarin dancer, de Kooning's *Woman I,* and many other works are often monumental in scale and conspicuously placed. Most critical and art-historical writing give them comparable importance.

To be sure, modern artists have often chosen to make "big" philosophical or artistic statements via the nude. If the MoMA exaggerates this tradition or overstates some aspects of it, it is nevertheless an exaggeration or overstatement of something pervasive in modern art history—as it is represented and illustrated in the literature. Why then has art history not accounted for this intense preoccupation with socially and sexually available female bodies? What, if anything, do nudes and whores have to do with modern art's heroic renunciation of representation? And why is this imagery accorded such prestige and authority within art history—why is it associated with the highest artistic ambition?

In theory, museums are public spaces dedicated to the spiritual enhancement of all who visit there. In practice, however, museums are prestigious and powerful engines of ideology. They are modern ritual settings in which visitors enact complex and often deep psychic dramas about identity—dramas

that the museum's stated, consciously intended programs do not and cannot acknowledge overtly. Like all great museums, the MoMA's ritual transmits a complex ideological signal. My concern here is with only a portion of that signal—the portion that addresses sexual identity. I shall argue that the collection's recurrent images of sexualized female bodies actively masculinize the museum as a social environment. Silently and surreptitiously, they specify the museum's ritual of spiritual quest as a male quest, just as they mark the larger project of modern art as primarily a male endeavor.

If we understand the modern-art museum as a ritual of male transcendence, if we see it as organized around male fears, fantasies, and desires, then the quest for spiritual transcendence on the one hand and the obsession with a sexualized female body on the other, rather than appearing unrelated or contradictory, can be seen as parts of a larger, psychologically integrated whole.

How very often images of women in modern art speak of male fears. Many of the works I just mentioned feature distorted or dangerous-looking creatures, potentially overpowering, devouring, or castrating. Indeed, the MoMA's collection of monstrous, threatening females is exceptional: Picasso's *Demoiselles* and *Seated Bather* (the latter a giant praying mantis), the frozen, metallic odalisques in Léger's *Grand Déjeuner,* several early female figures by Giacometti, sculpture by Gonzales and Lipschitz, and Baziotes's *Dwarf,* a mean-looking creature with saw teeth, a single large eye, and a prominent, visible uterus—to name only some. (One could easily expand the category to include works by Kirchner, Severini, Rouault, and others who depicted decadent, corrupt—and therefore *morally* monstrous—women.) In different ways, each of these works testifies to a pervasive fear of and ambivalence about woman. Openly expressed on the plane of culture, it seems to me that this fear and ambivalence makes the central moral of modern art more intelligible—whether or not it tells us anything about the individual psyches of those who produced these works.

Even work that eschews such imagery and gives itself entirely to the drive for abstract, transcendent truth may also speak of these fears in the very act of fleeing the realm of matter (*mater*) and biological need that is woman's traditional domain. How often modern masters have sought to make their work speak of *higher* realms—of air, light, the mind, the cosmos—realms that exist above a female, biological earth. Cubism, Kandinsky, Mondrian, the Futurists, Miró,

the Abstract Expressionists—all drew artistic life from some nonmaterial energy of the self or the universe. (Léger's ideal of a rational, mechanical order can also be understood as opposed to—and a defense against—the unruly world of nature that it seeks to control.) The peculiar iconoclasm of much modern art, its renunciation of representation and the material world behind it, seems at least in part based in an impulse, common among modern males, to escape not the mother in any literal sense, but a psychic image of woman and her earthly domain that seems rooted in infant or childish notions of the mother. Philip Slater noted an "unusual emphasis on mobility and flight as attributes of the hero who struggles against the menacing mother."[2] In the museum's ritual, the recurrent image of a menacing woman adds urgency to such flights to "higher" realms. Hence also the frequent appearance in written art history of monstrous or threatening women or, what is their obverse, powerless or vanquished women. Whether man-killer or murder victim, whether Picasso's deadly *Seated Bather* or Giacometti's *Woman with Her Throat Cut*, their presence both in the museum ritual and in the written (and illustrated) mythology is necessary. In both contexts, they provide the reason for the spiritual and mental flight. Confrontation and escape from them constitutes the ordeal's dark center, a darkness that gives meaning and motive to the quest for enlightenment.

Since the heroes of this ordeal are generically men, the presence of women artists in this mythology can be only an anomaly. Women artists, especially if they exceed the standard token number, tend to degender the ritual ordeal. Accordingly, in the MoMA and other museums, their numbers are kept well below the point where they might effectively dilute its masculinity. The female presence is necessary only in the form of imagery. Of course, men, too, are occasionally represented. But unlike women, who are seen primarily as sexually accessible bodies, men are portrayed as physically and mentally active beings who creatively shape their world and ponder its meanings. They make music and art, they stride, work, build cities, conquer the air through flight, think, and engage in sports (Cézanne, Rodin, Picasso, Matisse, Léger, La Fresnaye, Boccioni). When male sexuality is broached, it is often presented as the experience of highly self-conscious, psychologically complex beings whose sexual feelings are leavened with poetic pain, poignant frustration, heroic fear, protective irony, or the drive to make art (Picasso, De Chirico, Duchamp, Balthus, Delvaux, Bacon, Lindner).

De Kooning's *Woman I* (Fig. 12.3) and Picasso's *Demoiselles d'Avignon* (Fig. 4.9) are two of art history's most important female images. They are also key objects in the MoMA's collection and highly effective in maintaining the museum's masculinized environment.

The museum has always hung these works with precise attention to their strategic roles in the story of modern art. Both before and after the 1984 expansion, de Kooning's *Woman I* hung at the threshold to the spaces containing *the* big Abstract Expressionist "breakthroughs"—the New York School's final collective leap into absolutely pure, abstract, nonreferential transcendence: Pollock's artistic and psychic free flights, Rothko's sojourns in the luminous depths of a universal self, Newman's heroic confrontations with the sublime, Still's lonely journeys into the back beyond of culture and consciousness, Reinhardt's solemn and sardonic negations of all that is not Art, and so on. And always seated at the doorway to these moments of ultimate freedom and purity and literally helping to frame them has been *Woman I* (Fig. 12.1). So important is her presence just there, that when she has to go on loan, *Woman II* appears to take her place (Fig. 12.2). With good reason. De Kooning's *Women* are exceptionally successful ritual artifacts and masculinize the museum's space with great efficiency.

The woman figure had been emerging gradually in de Kooning's work in the course of the 1940s. By 1951–52, it fully revealed itself in *Woman I* (Fig. 12.3) as a big, bad

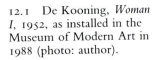

12.1 De Kooning, *Woman I*, 1952, as installed in the Museum of Modern Art in 1988 (photo: author).

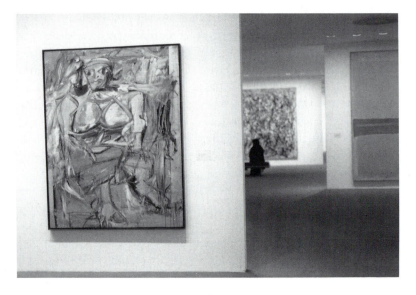

mama—vulgar, sexual, and dangerous. De Kooning imagines her facing us with iconic frontality, large, bulging eyes, open, toothy mouth, massive breasts. The suggestive pose is just a knee movement away from open-thighed display of the vagina, the self-exposing gesture of mainstream pornography.

These features are not unique in the history of art. They appear in ancient and tribal cultures as well as in modern pornography and graffiti. Together, they constitute a well-known figure type.[3] The Gorgon of ancient Greek art (Fig. 12.4), an instance of that type, bears a striking resemblance to de Kooning's *Woman I,* and, like her, simultaneously suggests and avoids the explicit act of sexual self-display that elsewhere characterizes the type. An Etruscan example (Fig. 12.5) states more of its essential components as they appeared in a wide range of archaic and tribal cultures—not only the display of genitals, but also the flanking animals that point to her origins as a fertility or mother goddess.[4] Obviously, the configuration, with or without animals, carries complex symbolic possibilities and can convey many-sided, contradictory, and layered meanings. In her guise as the Gorgon

12.2 De Kooning, *Woman II*, 1952, as installed in the Museum of Modern Art in 1978 (photo: author).

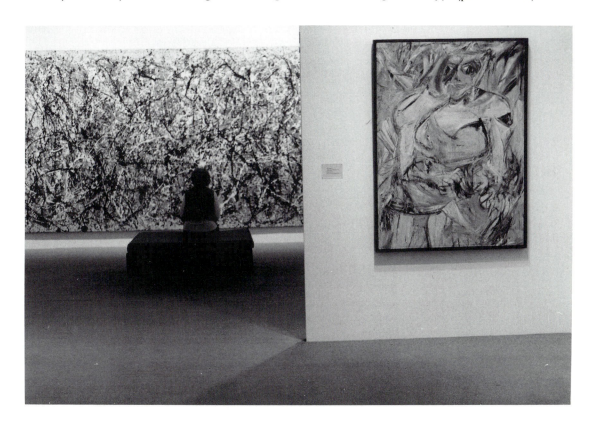

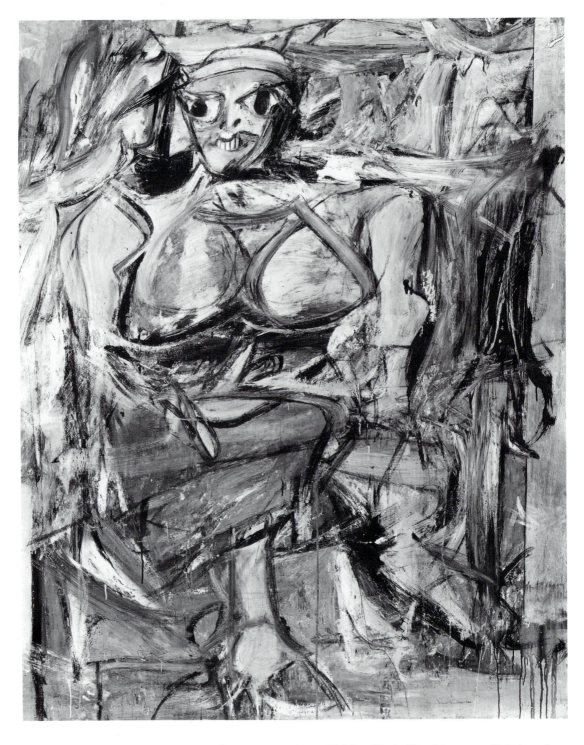

12.3 De Kooning, *Woman I*, 1952, oil on canvas, 76 × 58″. New York, The Museum of Modern Art (photo: museum).

witch, however, the terrible aspect of the mother goddess, her lust for blood and her deadly gaze, is emphasized. Especially today, when the myths and rituals that may have suggested other meanings have been lost—and when modern psychoanalytic ideas are likely to color any interpretation—the figure appears especially intended to conjure up infantile feelings of powerlessness before the mother and the dread of castration: in the open jaw can be read the *vagina dentata*—the idea of a dangerous, devouring vagina, too horrible to depict, and hence transposed to the toothy mouth.

Feelings of inadequacy and vulnerability before mature women are common (if not always salient) phenomena in male psychic development. Such myths as the story of Perseus and such visual images as the Gorgon can play a role in mediating that development by extending and re-creating on the cultural plane its core psychic experience and accompanying defenses.[5] Thus objectified and communally shared in imagery, myth, and ritual, such individual fears and desires may achieve the status of higher, universal truth. In this sense, the presence of Gorgons on Greek temples—important houses of cult worship (they also appeared on Christian church walls)[6]—is paralleled by *Woman I*'s presence in a high-cultural house of the modern world.

The head of de Kooning's *Woman I* is so like the archaic

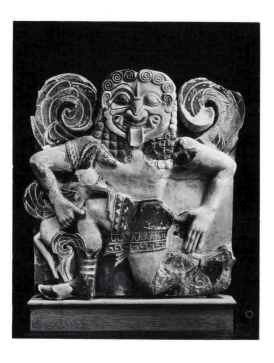

12.4 *Gorgon*, clay relief. Syracuse, National Museum (photo: Alinari/Art Resource).

Gorgon that the reference could well be intentional, especially since the artist and his friends placed great store in ancient myths and primitive images and likened themselves to archaic and tribal shamans. Writing about de Kooning's *Women,* Thomas Hess echoed this claim in a passage comparing de Kooning's artistic ordeal to that of Perseus, slayer of the Gorgon. Hess is arguing that de Kooning's *Women* grasp an elusive, dangerous truth "by the throat": "And truth can be touched only by complications, ambiguities and paradox, so, like the hero who looked for Medusa in the mirroring shield, he must study her flat, reflected image every inch of the way."[7]

But then again, the image type is so ubiquitous, we needn't try to assign de Kooning's *Woman I* to any particular source in ancient or primitive art. *Woman I* can call up the Medusa as easily as the other way around. Whatever he knew or sensed about the Gorgon's meanings, and however much or little he took from it, the image type is decidedly present in his work. Suffice it to say that de Kooning was aware, indeed, explicitly claimed, that his *Women* could be assimilated to the long history of goddess imagery.[8] By choosing to place such figures at the center of his most ambitious artistic efforts, he secured for his work an aura of ancient mystery and authority.

The *Woman* is not only monumental and iconic. In high-heeled shoes and brassiere, she is also lewd, her pose indecently teasing. De Kooning acknowledged her oscillating character, claiming for her a likeness not only to serious art— ancient icons and high-art nudes—but also to pinups and girlie pictures of the vulgar present. He saw her as simultaneously frightening and ludicrous.[9] The ambiguity of the figure, its power to resemble an awesome mother goddess

12.5 Etruscan Gorgon (drawing after a Bronze carriage-front), Museum antiker Kleinkunst, Munich.

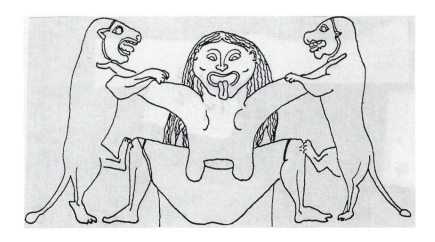

as well as a modern burlesque queen, provides a fine cultural, psychological, and artistic field in which to enact the modern myth of the artist-hero—the hero whose spiritual ordeal becomes the stuff of ritual in the public space of the museum. As a powerful and threatening woman, it is she who must be confronted and transcended—gotten past—on the way to enlightenment. At the same time, her vulgarity, her "girlie" side—de Kooning called it her "silliness"[10]—renders her harmless (or is it contemptible?) and denies the terror and dread of her Medusa features. The ambiguity of the image thus gives the artist (and the viewer) both the experience of danger and a feeling of overcoming it. Meanwhile, the suggestion of pornographic self-display—more explicit in his later work but certainly present here—specifically addresses itself to the male viewer. With it, de Kooning knowingly and assertively exercises his patriarchal privilege of objectifying male sexual fantasy as high culture.

An interesting drawing-photomontage by the California artist Robert Heinecken, *Invitation to Metamorphosis* (Fig. 12.6), similarly explores the ambiguities of a Gorgon-girlie

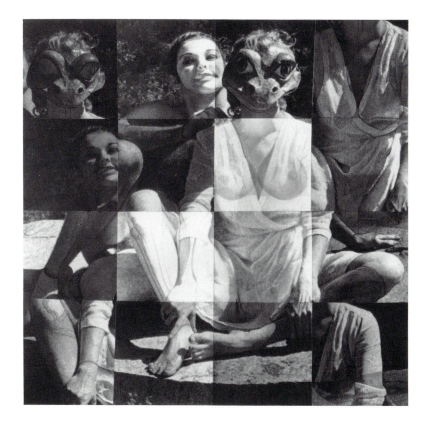

12.6 Robert Heinecken, *Invitation to Metamorphosis*, (emulsion on canvas and pastel chalk, 42 × 42"), 1975 (photo: artist).

image. Here the effect of ambiguity is achieved by the use of masks and by combining and superimposing separate negatives. Heinecken's version of the self-displaying woman is a composite consisting of a conventional pornographic nude and a Hollywood movie-type monster. A well-qualified Gorgon, her attributes include an open, toothy mouth, carnivorous animal jaws, huge bulging eyes, large breasts, exposed genitals, and one very nasty-looking claw. Her body is simultaneously naked and draped, enticing and repulsive, and the second head, to the left of the Gorgon head—the one with the seductive smile—also wears a mask. Like the de Kooning, Heinecken's *Invitation* sets up a psychologically unstable atmosphere fraught with deception, allure, danger, and wit. The image's various components continually disappear into and reappear out of one another. Behaving something like de Kooning's layered paint surfaces, they invite ever-shifting, multiple readings. In both works, what is covered becomes exposed, what is opaque becomes transparent, and what is revealed conceals something else. Both works fuse the terrible killer-witch with the willing and exhibitionist whore. Both fear and seek danger in desire, and both kid the danger.

Of course before de Kooning or Heinecken created ambiguous self-displaying women, there was Picasso's *Demoiselles d'Avignon* of 1907 (Fig. 4.9). The work was conceived as an extraordinarily ambitious statement—it aspires to revelation—about the meaning of Woman. In it, all women belong to a universal category of being existing across time and place. Picasso used ancient and tribal art to reveal her universal mystery: Egyptian and Iberian sculpture on the left and African art on the right. The figure on the lower right looks as if it were directly inspired by some primitive or archaic deity. Picasso would have known such figures from his visits to the ethnographic art collections in the Trocadero. A study for the work in Basel (Fig. 12.7) closely follows the type's symmetrical, self-displaying pose. Significantly, Picasso wanted her to be prominent—she is the nearest and largest of all the figures. At this stage, Picasso also planned to include a male student on the left and, in the axial center of the composition, a sailor—a figure of horniness incarnate. The self-displaying woman was to have faced him, her display of genitals turned away from the viewer.

In the finished work, the male presence has been removed from the image and relocated in the viewing space before it.

What began as a depicted male-female confrontation thus became a confrontation between viewer and image. The relocation has pulled the lower right-hand figure completely around so that her stare and her sexually inciting act, although not detailed and less symmetrical than before, are now directed outward. Picasso thus isolated and monumentalized the ultimate men-only situation. As restructured, the work forcefully asserts to both men and women the privileged status of male viewers—they alone are intended to experience the full impact of this most revelatory moment.[11] It also assigns women to a visitors' gallery where they may watch but not enter the central arena of high culture.

Finally, the mystery that Picasso unveils about women is also an art-historical lesson. In the finished work, the women have become stylistically differentiated so that one looks not only at present-tense whores but also back down into the ancient and primitive past, with the art of "darkest Africa" and works representing the beginnings of Western Culture (Egyptian and Iberian idols) placed on a single spectrum. Thus does Picasso use art history to argue his thesis: that the awesome goddess, the terrible witch, and the lewd whore are but facets of a single many-sided creature, in turn threatening and seductive, imposing and self-abasing, dominating and powerless—and always the psychic property of a male imagination. Picasso also implies that truly great, powerful,

12.7 Picasso, *Study for "Les Demoiselles d'Avignon"* (charcoal and pastel, 18½ × 24⅝"), 1907. Basel, Oeffentliche Kunstsammlung, Kupferstichkabinett (photo: Kunstsammlung).

and revelatory art has always been and must always be built upon such exclusively male property.

The museum's installation amplifies the already powerful meanings of the work. Mounted on a free-standing wall in the center of the first Cubist gallery, it seizes your attention the moment you turn into the room—the placement of the doorway makes it appear suddenly and dramatically. Physically dominating this intimately scaled gallery, its installation dramatizes its role as progenitor of the surrounding Cubism and its subsequent art-historical issue. So central is the work to the structure of MoMA's program that recently, when it was on loan, the museum felt compelled to post a notice on its wall explaining its absence—but also invoking its presence. In a gesture unusual for the MoMA, the notice was illustrated by a tiny color reproduction of the missing monument.

The works I have discussed by de Kooning and Heinecken, along with similar works by many other modern artists, benefit from and reinforce the status won by the *Demoiselles*. They also develop its theme, drawing out different emphases. One of the elements they develop more explicitly than Picasso is the element of pornography. By way of exploring how that pornographic element works in the museum context, I want to look first at how it works outside the museum.

Last year, an advertisement for *Penthouse* magazine appeared on New York City bus shelters (Fig. 12.8). New York City bus shelters are often decorated with near-naked women and sometimes men advertising everything from underwear to real estate. But this was an ad for pornographic images as such; that is, images designed not to sell perfume or bathing suits but to stimulate erotic desire, primarily in men. Given its provocative intent, the image generates very different and—I think for almost everyone—more charged meanings than the ads for underwear. At least one passerby had already recorded in red spray-paint a terse, but coherent response: "For Pigs."

Having a camera with me, I decided to take a shot of it. But as I set about focusing, I began to feel uncomfortable and self-conscious. As I realized only later, I was experiencing some prohibition in my own conditioning, activated not simply by the nature of the ad, but by the act of photographing such an ad in public. Even though the anonymous inscription had made it socially safer to photograph—it placed it in a conscious and critical discourse about gender—to photograph

it was still to appropriate openly a kind of image that middle-class morality says I'm not supposed to look at or have. But before I could sort that out, a group of boys jumped into the frame. Plainly, they intended to intervene. Did I know what I was doing?, one asked me with an air I can only call stern, while another admonished me that I was photographing a *Penthouse* ad—as if I would not knowingly do such a thing.

Apparently, the same culture that had conditioned me to feel uneasy about what I was doing also made *them* uneasy about it. Boys this age know very well what's in *Penthouse*. Knowing what's in *Penthouse* is knowing something meant for men to know; therefore, knowing *Penthouse* is a way of knowing oneself to be a man, or at least a man-to-be, at precisely an age when one needs all the help one can get. I think these boys were trying to protect the capacity of the ad to empower them as men by preventing me from appropriating an image of it. For them, as for many men, the chief (if not the only) value and use of pornography is this power to confirm gender identity and, with that, gender superiority. Pornography affirms their manliness to themselves and to others and proclaims the greater social power of men. Like

12.8 Bus shelter on 57th Street, New York City, 1988, with advertisement for *Penthouse* magazine. (photo: author).

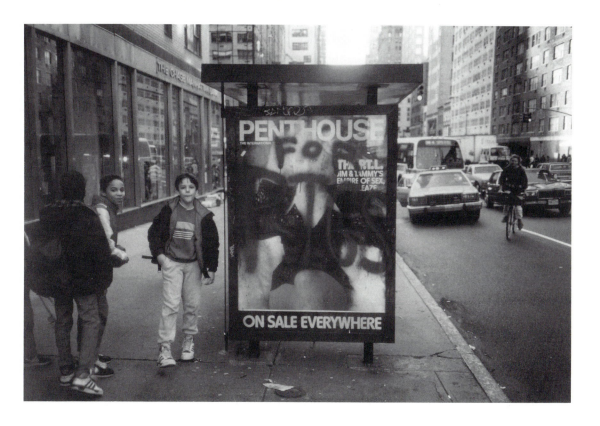

some ancient and primitive objects forbidden to the female gaze, the ability of pornography to give its users a feeling of superior male status depends on its being owned or controlled by men and forbidden to, shunned by, or hidden from women. In other words, in certain situations a female gaze can *pollute* pornography. These boys, already imprinted with the rudimentary gender codes of the culture, knew an infringement when they saw one. (Perhaps they suspected me of defacing the ad.) Their harassment of me constituted an attempt at gender policing, something adult men routinely do to women on city streets.

Not so long ago, such magazines were sold only in sleazy porn stores. Today ads for them can decorate midtown thoroughfares. Of course, the ad, as well as the magazine cover, cannot itself be pornography and still be legal (in practice, that tends to mean it can't show genitals), but to work as an ad it must *suggest* it. For different reasons, works of art like de Kooning's *Woman I* or Heinecken's *Invitation* also refer to without actually being pornography—they depend on the viewer "getting" the reference but must stop there. Given these requirements, it shouldn't surprise us that the artists' visual strategies have parallels in the ad (Fig. 12.9). *Woman I* shares a number of features with the ad. Both present frontal, iconic, massive figures seen close up—they fill, even overflow, the picture surface. The photograph's low camera angle

12.9 Advertisement for *Penthouse*, April 1988.

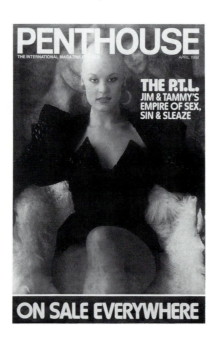

and the painting's scale and composition monumentalize and elevate the figures, literally or imaginatively dwarfing the viewer. Painting and photograph alike concentrate attention on head, breasts, and torso. Arms serve to frame the body, while legs are either cropped or, in the de Kooning, under-sized and feeble. The figures thus appear powerful and pow-erless at the same time, with massive bodies made to rest on unstable, weakly rendered, tentatively placed legs. And with both, the viewer is positioned to see it all should the thighs open. And of course, on *Penthouse* pages, thighs do little else but open. But de Kooning's hot mama has a very different purpose and cultural status from a *Penthouse* "pet."

De Kooning's *Woman I* conveys much more complex and emotionally ambivalent meanings. The work acknowledges more openly the fear of and flight from as well as a quest for the woman. Moreover de Kooning's *Woman I* is always up-staged by the artist's self-display *as an artist*. The manifest purpose of a *Penthouse* photo is, presumably, to arouse desire. If the de Kooning awakens desire in relation to the female body it does so in order to deflate or conquer its power of attraction and escape its danger. The viewer is invited to relive a struggle in which the realm of art provides escape from the female's degraded allure. As mediated by art criticism, de Kooning's work speaks ultimately not of male fear but of the triumph of art and a self-creating spirit. In the critical liter-ature, the *Women* figures themselves become catalysts or structural supports for the work's more significant meanings: the artist's heroic self-searching, his existentialist courage, his pursuit of a new pictorial structure or some other artistic or transcendent end.[12]

The work's pornographic moment, now subsumed to its high-cultural import, may (unlike the *Penthouse* ad) do its ideological work with unchallenged prestige and authority. In building their works on a pornographic base and triggering in both men and women deep-seated feelings about gender identity and difference, de Kooning, Heinecken, and other artists (most notoriously, David Salle) exercise a privilege that our society has traditionally conferred upon men only. Through their imagery, they lay claim to public space as a realm under masculine control. Transformed into art and displayed in the public space of the museum, the self-displaying poses affirm to male viewers their membership in the more powerful gender group. They also remind women that their status as members of the community, their right

to its public space, their share in the common, culturally defined identity, is not quite the same—is somehow less equal—than men's. But these signals must be covert, hidden under the myth of the transcendent artist-hero. Even de Kooning's later *Women* figures, which more openly invite comparison to pornographic photography and graffiti (Fig. 5.4), qualify the reference; the closer to pornography, the more overlaid they must be with unambiguously "artistic" gestures and philosophically significant impastos.

Nevertheless, what is true in the street may not be so untrue in the museum, even though different rules of decorum may make it seem so. Inside or outside, such images wield great authority, structuring and reinforcing the psychic codes that determine and differentiate the real possibilities of women and men.

NOTES

1. For an analysis of the older MoMA, see: Carol Duncan and Alan Wallach, "The Museum of Modern Art as Late Capitalist Ritual," *Marxist Perspectives,* 4 (Winter 1978), pp. 28–51.

2. Philip Slater, *The Glory of Hera,* Boston, 1968, p. 321.

3. See: Douglas Fraser, "The Heraldic Woman: A Study in Diffusion," in *The Many Faces of Primitive Art,* ed. D. Fraser, Englewood Cliffs, New Jersey, 1966, pp. 36–99; Arthur Frothingham, "Medusa, Apollo, and the Great Mother," *American Journal of Archaeology,* 15 (1911), pp. 349–77; Roman Ghirshman, *Iran: From the Earliest Times to the Islamic Conquest,* Harmondsworth, 1954, pp. 340–43; Bernard Goldman, "The Asiatic Ancestry of the Greek Gorgon," *Berytus,* 14 (1961), pp. 1–22; Clark Hopkins, "Assyrian Elements in the Perseus-Gorgon Story," *American Journal of Archaeology,* 38 (1934), pp. 341–58, and "The Sunny Side of the Greek Gorgon," *Berytus,* 14 (1961), pp. 25–32; and Philip Slater (cited n. 2), pp. 16–21, and 318 ff.

4. More ancient than the devouring Gorgon of Greece and pointing to a root meaning of the image type, a famous Louristan bronze pin in the David Weill Collection honors an older, life-giving Mother Goddess. Flanked by animals sacred to her, she is shown giving birth to a child and holding out her breasts. Objects of this kind appear to have been the votive offerings of women; see: Ghirshman (cited n. 3), pp. 102–4.

5. See: Slater (cited n. 2), pp. 308–36, on the Perseus myth, and pp. 449 ff., on the similarities between ancient Greek and middle-class American males.

6. See: Fraser (cited n. 3).

7. Thomas B. Hess, *Willem de Kooning,* New York, 1959, p. 7. See also: Hess, *Willem de Kooning: Drawings,* New York and Greenwich, Conn., 1972, p. 27, on a de Kooning drawing of Elaine de Kooning (c. 1942), in which the writer finds the features of Medusa—a "menacing" stare, intricate, animated "Medusa hair."

8. As he once said, "The *Women* had to do with the female painted through all the ages. . . . Painting the *Woman* is a thing in art that has been done over and over—the idol, Venus, the nude." Quoted in *Willem de Kooning. The North Atlantic Light, 1960–1983,* exh. cat., Stedelijk Museum, Amsterdam, Louisiana Museum of Modern Art, Humlebaek, and the Moderna Museet, Stockholm, 1983. Sally Yard, "Willem de Kooning's Women," *Arts,* 53 (November 1975), pp. 96–101, argues several sources for the *Women* paintings, including Cycladic idols, Sumerian votive figures, Byzantine icons, and Picasso's *Demoiselles.*

9. *North Atlantic Light* (cited n. 8), p. 77. See also: Hess, *de Kooning* 1959 (cited n. 7), pp. 21 and 29.

10. *North Atlantic Light* (cited n. 8), p. 77.

11. See, for example: Leo Steinberg, "The Philosophical Brothel," *Art News,* September 1972, pp. 25–26. In Steinberg's ground-breaking reading, the act of looking at these female figures visually re-creates the act of sexually penetrating a woman. The implication is that women are anatomically unequipped to experience the work's full meaning.

12. Very little has been written about de Kooning that does not do this. For one of the most bombastic treatments, see: Harold Rosenberg, *De Kooning,* New York, 1974.

THE LIFE AND WORKS OF CHERYL BERNSTEIN

Part Four

INTRODUCTION

Carol Duncan

We come now to Cheryl Bernstein. I include Cheryl's writing in this volume of my collected essays not to claim authorship of her texts—the concept of authorship has, in any case, become difficult to sustain—but because these texts appeared with my help and have helped me. Bernstein said things for me that I myself could not easily say. She brought difficult truths to light and then buried them again. Certainly she owes much to me, but whatever her debt, her life unfolded quite independently of mine. She established her own relationships (admittedly, they were one-way), entered into the discourse of art criticism, and helped more than one individual find his or her own critical or artistic path.

But who or what is Cheryl Bernstein? Was she a harbinger of post-structuralist art criticism or merely a hoax? Is she a representation with no fixed referent, an endlessly shifting signifier? Or is she an intending agent and an authentic subject in her own right? Was she subversive? Transgressive? Only time can answer some of these questions. What we can say with certainty at this point is that Bernstein evolved into a remarkable story. On the basis of only two published texts, she became a minor celebrity, a marginal but significant critical force in the art world, and, recently, the object of intense critical study. At present, the literature about her stretches several times the total length of her collected *oeuvre*. More interesting than her writing *per se* is Cheryl Bernstein the narrative construct.

Bernstein first appeared in the spring of 1970 in New York City, in the context of a conversation between myself and my (then) husband, the actor Andrew Duncan. Amused by the critical writing in *Artforum,* widely regarded as the most theoretically advanced art publication of the time, we invented Hank Herron, a white, Anglo-Saxon New Englander seeped in modernist art and criticism, and making a debut in

one of those stylish and expensive galleries that could count on critical attention from the high-art press. At the same time, we constructed Cheryl Bernstein, also ambitious, theoretically precocious, and born, so to speak, pen in hand. By the end of the evening, much of Bernstein's first text had been fashioned. Entitled "The Fake as More," it explored the critical significance of Herron's rather enigmatic oeuvre, which consisted solely of replicas of the entire work of Frank Stella. To this work, Bernstein applied concepts gleaned from some of the more difficult-to-read, mostly French philosophical texts currently in vogue in the higher reaches of the art-critical press. Bernstein used these concepts to demonstrate that the central significance of Herron's work was theoretical and linguistic. Indeed, so fully theorized was Herron's work, that its physical absence from the art world would become a positive asset in the elaboration of its meaning. Never at any time later would anyone wish to see the actual work or even wonder where it could be glimpsed.

As its authors, Andrew Duncan and I thought of "The Fake as More" as parody, but once released into the world of art criticism, the text established for itself a very different identity. First circulated in photocopy among friends, it was eventually seen by Gregory Battcock, who asked to include it in *Idea Art* (1973), an anthology of art criticism. At that point, Bernstein was given a birthplace (Roslyn, NY), some biography, a B.A. from Hofstra, and an M.A. in Art History from Hunter College. She was even given a master's thesis— a study of the the Belgian fin-de-siécle artist, Félicien Rops, entitled *The Tragedy of Misconception*.

Battcock's anthology was widely read. But virtually no one seems to have recognized Bernstein or Herron as parody. This failure at first appears surprising. Both figures were planted with numerous clues designed to arouse the reader's suspicion. Some of Bernstein's assertions could easily be read as obvious—even frankly corny—jokes (for example, the reworking of Jean-Paul Sartre's idea of "lived experience relived" into the notion of "the painted object repainted"). Herron was constructed almost completely out of suggestive signals. Of course later in the 1980s, he could (and would) be taken as a prophet and forerunner of Simulationism or Appropriation Art. But, in the early 70s, no such critical category existed, and one could reasonably expect people to find his artistic project (reproducing the entire work of another artist) too off-the-wall to take seriously. Despite these oddities, Bernstein and Herron were easily assimilated to art

world concerns of the day[1] and (as I gradually learned) in certain university art departments even became required reading for students.

When Andrew Duncan and I separated in 1975, I took custody of Bernstein by mutual agreement. I soon decided to give her a second publication. The occasion was the sensational kidnapping of Patty Hearst by a group calling itself the Symbionese Liberation Army (the SLA). While holding the young heiress hostage, the SLA had demanded the distribution of large quantities of food to the poor of the San Francisco Bay Area, robbed a bank, and led armies of FBI agents on wild-goose chases throughout the West. They were finally trapped in a little house in the middle of an Afro-American neighborhood in Los Angeles, surrounded by police, and burned to death (some of them) on a prime-time TV newscast in a fire started (accidently, it was alleged) by the police. Nearby houses—the modest homes of working people—also caught fire and burned down before live TV news cameras. Bernstein's new text, *Performance as News,* would represent these events as examples of performance art, the work of a highly sophisticated group that used the news media as vehicles of representation. A narrative in which formal (and conceptual) developments follow trajectories within art discourse with a seemingly autonomous and compelling force of their own provided the theoretical underpinning of the new text.[2] The essay appeared in a collection of papers by prominent theorists delivered at a conference on performance at the University of Wisconsin, Milwaukee.[3] As before, the text was published under Bernstein's name alone.

Even while this second publication was in press, however, the secret of Cheryl Bernstein was unexpectedly sealed by death. Michel Benamou, editor of the publication in which the SLA text appeared, succumbed to a heart attack, and soon after Gregory Battcock was mysteriously murdered while vacationing in the Caribbean.[4] These deaths left no one who could provide direct testimony or positive evidence that Bernstein and Herron did not exist as physical and intentional agents. They also introduced an interesting variant of the well-known post-structuralist notion of the death of the author, namely the death of the editor, which, rather than giving rise to the "reader," creates *carte blanche* for the critic.

Then, around the early 80s, Herron began to intrigue a number of young New York artists. His work, which dramatically denied the category of artistic originality, together with Bernstein's critical labor (which demonstrated Herron's

conceptual originality) was acquiring a new relevance. Herron was becoming recognized as a forerunner and inspiration of a new category of art practice, Appropriation Art. The names Bernstein and Herron began appearing in critically advanced sectors of the art press, most notably, *The Village Voice,*[5] and Herron's work was being talked about. Meanwhile, among critics of the media, Bernstein was becoming known as an astute, theoretically advanced critic[6] and a leader in non-originality.

But the secret of Cheryl Bernstein was not secure. In November of 1986, Calvin Tompkins' column in *The New Yorker* carried the story of Herron and Bernstein.[7] Tompkins had based his column on an essay by Thomas Crow, which exposed the pair as a hoax.[8] Curiously, the disclosure brought both Bernstein and Herron a moment of celebrity. Besides Tompkins' attention, the *Village Voice* renewed its interest in Bernstein and Herron. In a review by Kim Levin, a real-life Simulationist was unfavorably compared to Hank Herron. Not only had Herron simulated originals years before, she argued, but he also enjoyed theoretical advantages denied his flesh-and-blood successor: he himself had been a stylish simulation as was the critic who championed him.[9] In another review, Cindy Carr preferred Bernstein's reading of the Patty Hearst affair to a recently released film on the same subject.[10]

I have often been asked why, given her success as a critic, Bernstein stopped publishing, especially since the world of art and art criticism offered so much that seemed right for her special attention. Bernstein stopped publishing because her contributions were no longer needed—so many other writers equaled or surpassed her in what she did. Or, to put it another way, when parody and art criticism become indistinguishable, it is time to quit.

Nevertheless, perplexing questions remain about the meaning and status of the Bernstein texts. Perhaps we can best problematize the question by abandoning notions of parody and hoax altogether, notions which oppose a supposedly real intending agent to a false one (Bernstein). It is on this erroneous basis that Thomas Crow represents the Simulationist artists as having been taken in by a hoax. The implication is that their theoretical position would be stronger had Bernstein and Herron existed as persons and not simply as texts. But one can argue the opposite position with as much validity: the Simulationists' reading of the absent Herron's absent work as represented by the Bernstein text was precisely an act of deconstructive intersubjective and intertextual en-

gagement which both destabilized and reconfiscated the linguistic strategy of the original (non)original. Finally, to paraphrase Bernstein, this in no way obfuscates the mixture of post-Enlightenment moral vertigo and postmodernist intellectual dyslexia that finally situates Bernstein betwixt and between, both *either/or* and *both/and*.

NOTES

1. See for example the reaction of the art critic Barbara Reise, reviewing Battcock's anthology for *Studio International* (London), 1973. Reise took Bernstein's piece as typical of what was wrong with the whole collection.
2. This second Bernstein essay also owed much to the cartoon character Mr. Magoo, whose poor eyesight led him into seriously mistaken assumptions about where he was and what was happening around him.
3. The publication includes papers by Jean-François Lyotard, Ihab Hassan, Campbell Tatham, Régis Durand and others. I had given a paper at this conference but preferred to see Bernstein's piece published in the proceedings.
4. The death was widely reported in the press. This writer was also given firsthand information about the crime by Professor Servando Sacaluga, who knew Battcock as a neighbor in San Juan, Puerto Rico.
5. See Cindy Carr, "The Shock of the Old," *The Village Voice,* 30 October 1984, 103.
6. See, for example, the lengthy quotation from her text in David Marc, "Understanding Television," *The Atlantic Monthly,* August 1984, 41.
7. Calvin Tompkins, "The Art World, Between Neo- and Post-," *The New Yorker,* 24 November 1986, 104.
8. Thomas Crow, "The Return of Hank Herron," in *Endgame* [exh. cat., The Institute of Contemporary Art] (Boston, 1986). Although Crow did not identify by name either Andrew Duncan or myself, he nevertheless published privileged information given to him personally by the authors.
9. Kim Levin, "The Original as Less," *The Village Voice,* 26 January 1988, 83–84.
10. Cindy Carr, "Are You Now or Have You Ever Been?" *The Village Voice,* 1 November 1988, 38.

THE FAKE AS MORE

Cheryl Bernstein

"The most primordial phenomenon of truth is first shown by the existential–ontological foundation of uncovering."

Martin Heidegger

The current exhibition at the handsome new Uptown Gallery requires that we reconsider the whole of the artistic development within serious modernism over the last five years, for, like all new manifestations, this exhibition of the work of Hank Herron, by definitively breaking with that past, suddenly reveals it in a new aspect and allows us to apprehend it both analytically and dialectically.

Achieving what no one even three years ago could foresee as the necessary resolution to the dialectical impasse posed by the object-form critical dilemma, these pieces both assert and transcend objectness and formality; or, perhaps better stated, they represent a synthesis of the form and object into what might be called *form-object* art. Resolving at one master stroke the problem of content without compromising the purity of the nonreferential object as such, Mr. Herron's work, by reproducing the exact appearances of Frank Stella's entire *oeuvre,* nevertheless introduces new content and a new concept, in the total phenomenological sense, by actually representing the actions of someone other than Frank Stella. That is, in their real meaning, these objects are Stellas *plus,* Stellas and *more,* and the implications to be extracted from them will no doubt occupy a segment of the abstractionist artistic and critical community for months to come.

In their double orientation between past and present, they represent an advance in another respect; in no other form but the fake can the thing be so sharply distinguished from its

This essay was first published in *Idea Art,* ed. Gregory Battcock (New York: Dutton, 1973), 41–45.

self, the *an sich,* or essence, from the *für sich,* or reality. For by reproducing existing art forms the artist both receives the sanction of his predecessor and at the same time negates the attempt to observe any new formal development, thus shifting the entire phenomenon to a superior, that is, critical, level. What is at work here is, in Sartre's phrase, lived experience relived, or more accurately, the painted object repainted.

In spite of the apparent similarity in the work of the two men, there are some profound differences. The works faked by Mr. Herron were all executed by Mr. Stella over a ten-year period, whereas the works under review here were all completed within the year 1971. Looking at the works of Mr. Herron (whose first appearance in any exhibition this is), we see a lack of development in the artist's refusal to succumb to either a unilateral linear statement or an expression of complete circularity, but rather a synthesis of both in what might be called *circulinear* art, neither *either or* but *both and.*

Moreover, the above is made perceptually concrete to the observer through a process of heightened simultaneity. For on first viewing Mr. Herron's *oeuvre,* we are reminded of Wittgenstein's comment, "Seeing as . . . is not part of perception. And for that reason it is like seeing and again not like."[1] We are clearly in the presence of a dilemma. In answer to Wittgenstein's question, what is the criterion of the visual experience?, his obvious answer, "The representation of what is seen,"[2] simply will not do. In addition to what is seen, there is the known: the preordinate relationship of the subject-object synthesis paravisually determined in the Kantian sense.[3]

Self-clarification is obtained through the paintings themselves. Through serial repetition, the artist's search for a style and an ontology, an artistic expression of ontological ends, is consolidated in particular works that sum up the gains of painful and anxious exploration of viable form, at least temporarily. One such work, *Qué Pasa?*, with its monumental grid pattern adumbrating with a torquelike precision around a tension-filled center, reiterates the combinative passion of artist and critic that is the achievement and the ultimate responsibility of the modernist movement: in essence, the re-creative process. To say this is by no means to slight Stella as such. But any comparison of Herron and Stella would have to concede that the former's power and potentiality, his superior pictorial structure, his more exclusive visual mode, and lastly, his more fully depicted literal shape, based as they

are on the reproduction of the latter's work, vastly intensifies the conflict between them.

However, these are but stylistic differences, at best provisional. On second viewing, one begins to be more profoundly conscious of and receptive to a radically new and philosophical element in the work of Mr. Herron that is precluded in the work of Mr. Stella, i.e., the denial of originality, both in its most blatant manifestation (the fake as such) and in its subtle, insouciant undertones of static objectivity (the telescoping of time). As pointed out by Philip Leider, "The identity we all share in Stella's art as *our* art, the art of *our* time, is deepened, broadened, and made, of all things, joyous,"[4] whereas Mr. Herron's art is neither deepening nor broadening nor, if anything, joyous. On the contrary, it is surface, narrow, and, most especially, tragic, for one is forcefully reminded at every line and turn that it represents the ontological predicament of our time, indeed of every living being: inauthentic experience. They are, in a word, fakes.

NOTES

1. Ludwig Wittgenstein, *Philosophical Investigations* (New York: Macmillan Co., 1953), p. 197.
2. Ibid., p. 198.
3. As Merleau-Ponty has observed, "The essence of Kantianism is to admit only two types of experiences as possessing an *a priori* structure: that of a world of external objects, that of states of the inner sense, ..." *The Structure of Behavior,* trans. by Alden L. Fisher (Boston: Beacon Press, 1967), p. 171.
4. Philip Leider, "Literalism and Abstraction: Frank Stella's Retrospective at the Modern," *Artforum,* 8 (April, 1970): 51.

PERFORMANCE AS NEWS: NOTES ON AN INTERMEDIA GUERRILLA ART GROUP

Cheryl Bernstein

That the Symbionese Liberation Army until now has been undetected as a performance group is largely due to the somewhat overcharged rhetoric of their overt content as well as their deliberate avoidance of any recognizable art context in which their work might be framed. These notes are offered as a preliminary attempt to understand the significance of their work and its relationship to performance as it has been evolving over the last decade or so.

In an art-historical sense, the first segment of their long, still unfinished piece, the food sequence, was singularly retrospective, stressing the group's roots in vanguard tradition. On the formal level, it looked like just one more of the many "proposal" pieces of the late 60's and early 70's; but, typically for the SLA, this proposal both commented on and refuted the then-popular proposal form. The difference lay not only in the fact that this proposal was realized (the distribution of food), but also in the essential concept that without an active audience, the work could not be considered complete. Utilizing extremely simple, but effective, materials (a tape recorder and half of a driver's license), the piece not only mobilized the entire San Francisco Police Department, millions of Hearst dollars, several charity organizations, food wholesalers and, of course, scores of the needy, it also set into motion the whole of the communications industry. I will return to their choice of the news as their exclusive artistic medium, but for the moment, I want to focus on the very peculiar kind of risk they undertook at the outset of their work—a risk that set the aesthetic and art-historical terms in which the group would henceforth operate.

This essay was first published in *Performance in Postmodern Culture,* ed. Michel Benamou and Charles Caramello (Madison, Wis., Center for Twentieth Century Studies, University of Wisconsin—Milwaukee, 1977), 79–83.

In performance art, the artist is more exposed than ever before. The literal identification of artistic risk with the act of risking one's body or one's civil rights has become familiar lately in the work of such artists as Chris Burden, Rudolf Schwarzkogler, Tony Schafrazi and Jean Toche.[1] Of course, much earlier Marcel Duchamp risked—if not his life and freedom—the disclosure of his artistic intentions in a series of (usually incomplete or failed) endeavors that looked more like business ventures than art activities. The appearance of the SLA as a guerrilla political group both adopted the Duchampian gesture and escalated it—and in so doing directly addressed the still unresolved issue of art *vs.* non-art that has preoccupied the art world since the late 50's.

Among the most lucid expositions of the paradox of non-art, Allan Kaprow's well-known 1971 essay, "The Education of the Un-Artist," undoubtedly contributed to the atmosphere in which the SLA piece was conceived. In that essay, Kaprow examines the strategies of artists who seek to liberate themselves from the institutionalized art world. These are the artists who, some or all of the time, "operate outside the pale of the art establishment, that is, in their heads or in the daily or natural domain."[2] Such are the "earthworkers," "Happeners," and Conceptual artists. However, these "non-artists" always report their activities to the art establishment, which duly records them in its art pages. Thus, while they work outside the galleries or museums, they operate completely within the art world in the social sense. Without recognition from that world, their acts have no meaning. In this, they are as dependent on the established art context as were the Dadaists, who never left it in the first place.

To this tradition, Kaprow opposes the notion of the un-artist. Unlike the non-artists, un-artists would be socially invisible *as artists*. They would "give up all references to being artists of any kind what ever,"[3] would outwardly adopt other professions, and would utilize television and other media. Un-artists would still be vanguard artists, but by disguising rather than declaring their esthetic intentions, they would transcend the paradox of older non-art. Anyone familiar with the SLA piece must concede its debt to Kaprow's ideas, but the brilliant tactics of this intermedia guerrilla group and its refinement of the issues Kaprow raises (not to mention its solution to the problem of avoiding detection as an art group) places it squarely in the ambiance of the post-60's. Nevertheless, and not withstanding Kaprow's terms, the essential

point of reference here is still the Duchampian mode and the dialectics of art and non-art.

One of the most successful aspects of the SLA piece is its ability to be read as a completely autonomous event unrelated to any kind of art, complete with a politically self-explanatory intent. At the same time, its overt content functions as a unifying metaphor that resolves itself as a negation of political action—perhaps the only way that art can define its limits and maintain its identity in modern, bourgeois society. It is significant that the SLA chose the guise of a militant political group at the very moment when such militancy was demodé, ripe for un-artistic appropriation. The strategy here recalls early Pop art, whose iconography of cheap ads and comic book graphics was equally antithetical to serious art. And just as the Pop artists utilized these highly rhetorical forms in a way that contradicted their original purpose, the apparent content of the SLA piece functions as a self-subverting mask that signifies something other than its overt intent. The resultant negation, a classic vanguardist strategy long before Pop, points to the central meaning of modernist art, which aims inexorably at its own self-transcendence: the abolition of art. And like so much avant-garde art of recent years, the SLA evokes in order to liquidate the idea of art as communication. But the SLA's art practice goes beyond these other forms of vanguardism in its commitment to a self-imposed dichotomic model of perception that systematically develops the dissonant as both a necessity and reality.

The paradox is made evident not only by the un-art disguise, but—less transparently—by the multiple references and anticipations of recent avant-garde art.[4] The video segment (the bank robbery), which used the concept of planned chance (the "given" installation of the bank cameras), is perhaps the most obvious. The fire sequence, which, in Los Angeles, pre-empted national network news broadcasts, critically commented on the work of Chris Burden, Vito Acconci and other performance and body artists who engage in physical risk or "operate" on their own bodies[5] (Patty Hearst's prison operation also belongs in this category). Also noteworthy is the narrative element of the piece—the metaphor of the artist as fugitive and then prisoner is especially wry; and the theme of metamorphosis (the Duchampian disguises and false names) is pointedly apt. More subtle is the open-ended structure on which the narrative is hung. At this writing, it is still viable—Patty is still "news" and the legal fate

of those accused of harboring the fugitive artists in Pennsylvania is still unresolved.

The use of the press as a means of distribution for art also has precedents in vanguard art. Joseph Kosuth made extensive use of the ad form, renting space in the non-art as well as the art press. The SLA, however, reversed the relationship between the advertisement and the news item by becoming the news. The group thereby avoided the expense of advertising and at the same time made their work available to a vast audience, even "framing" it on the home TV screen. The strategy not only utilized television as a closed feed-back system, it also drew large numbers of people into the work as active participants. Indeed, the ongoing process initiated by the group involved not only Justice Department officials and law-enforcement agents, but numerous private citizens, most notably the hostages and the many "witnesses" who testified on television concerning the whereabouts of Patty Hearst and the Harrises during the flight sequence.

Another facet of the piece in which the SLA's particular style is revealed with special clarity is the FBI "wanted" poster. The self-conscious reference here of course is to Douglas Huebler's well-known *Duration Piece No. 15,* 1969.[6] That work consisted of an FBI "wanted" poster to which the artist attached a signed statement guaranteeing to pay a reward for information leading to the arrest of the suspect (the amount of the reward dwindled month by month, reaching zero in a year). Typically, the SLA both simplified its model and clarified its implications. Huebler carefully kept his identity distinct from that of the suspect (who, not incidentally, was wanted for armed bank robbery and worked sometimes as an artist). The SLA version, by suppressing the separate identity of the artist and firmly tying it to that of the suspect, literally enacts what, in the Huebler work, is barely a suggestion (the artist-as-outlaw theme). At the same time, the FBI is slyly engaged in the process of documenting the piece, which bears only one signature—that of FBI Director Clarence Kelly (Fig. 15.1).

The choice of the news as artistic form deserves closer scrutiny. On one level, the whole nation becomes art consumer; but more importantly, by accepting the news spectacle as it finally appears, the group could avoid the deceptive distortions that arise when the actuality of the work differs from its recorded form. Since the news itself is identical with the work, that is, since the SLA does not exist except as news, this distortion was impossible. Moreover, the multi-

plicity of news agents active as reporters insured the piece the shifting values and impermanent ground characteristic of performance art. The video segment, for example, recorded by the "found" or "readymade" feedback installation system of the bank, is actually a series of stills; but aired on national TV, it took on the classic look of grainy vanguard video. The point here is that without the news, this segment would have remained incomplete. Consistent with the overall strategy of the group, however, is the fact that while the press became an unknowing collaborator with the avant-garde, the SLA itself did not compromise its work by disclosing its identity as an art group.

Unlike other performance and conceptual artists who stress the abstract perceptual structures of their work by avoiding an "interesting" look, the SLA overlaid and disguised its commitment to abstraction with dramatic and moving information that partly obscured it. In the excitement of the FBI search, it was easy to miss the complex unfolding time-space structures that constitute the substance of the work. The widening geographic configuration of the piece became perceptible in the tracings inscribed on the map by mobile FBI agents, here transformed, in the spirit of Duchamp, into covert agents of art—in a sense, double agents. But the most brilliant stroke of all was the decision to make the funding of the work an integral part of it: the piece largely financed itself through the bank sequence and the ransom, the latter

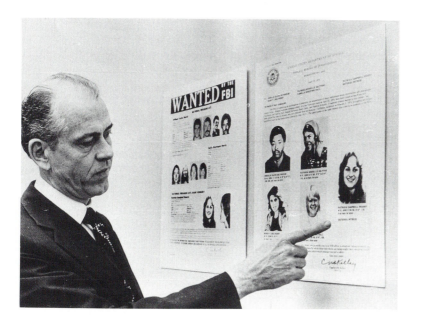

15.1 FBI installation of "Wanted" posters, exhibited to the press by Charles Bates, Special Agent in charge of the San Francisco office, January 31, 1974 (photo: UPI/The Bettman Archive).

a kind of parody of the conventional grant that funds so much of today's performance art.

More than any other feature of the work, however, the use of the news media as framing underscores the issue that the work as a whole dramatizes: the inability of modern art to signify its given content as truth. By adopting a set of political ideals that are transparently incredible, the SLA negated the idea that art can communicate life ideals at all. This becomes clear as the piece unfolds its meaning. To understand its deeper, formal significance, the viewer must first recognize that the group's apparent political identity is a camouflage. This recognition also involves a negation—a mental act of destruction (clarified by the fire sequence) in which the camouflage is stripped away—burned off, as it were. It constitutes the central dialectical moment of the piece as a whole, whose underlying time-space configurations triumph and emerge into full view only after having consumed the manifest political subject matter. Thus, art appears as a transcendence and dialectical resolution of political aspirations, and it attains its most absolute value only when we have fully recognized the futility of political action. Indeed, at that point, the point where we now find ourselves, political action itself can be no more than art performance. The many references to advanced art with which the SLA laced their work frankly avow what Roland Barthes has identified as the central paradox in the literary world: "In spite of the efforts made in our time, it has proved impossible successfully to liquidate literature entirely."[7] Indeed, the advanced consciousness and creative disobedience of the SLA points not to the liberation of art from this impasse, but to the problematic existence of art itself in the modern world.

NOTES

1. Chris Burden regularly endangers himself physically and legally (see Robert Horvitz, "Chris Burden," *Artforum*, May, 1976, 24–31). Schwarzkogler is the German performance artist best remembered for his last piece in which he mutilated himself sexually and, within hours, died from the wound. Schafrazi is the artist who defaced Picasso's *Guernica*. The artist Toche was arrested in March, 1974, by the FBI after he publicly acclaimed Schafrazi's act as a "conceptual art work" and called for the kidnapping of (unnamed) members of the museum establishment. The FBI acted on a complaint of Douglas Dillon, President of the Metropolitan Museum of Art (see *Artforum*, November, 1976, p. 8 [letters]).

2. Allan Kaprow, "The Education of the Un-Artist, Part I," *Art News,*
 February, 1971, 28.
3. Loc. cit., 30.
4. It is a little-known fact that Patty Hearst was an art history major at
 Berkeley at the time the SLA piece was begun.
5. Max Kozloff, "Pygmalion Reversed," *Artforum,* November, 1975, 30–
 37.
6. Reproduced in Ursula Meyer, *Conceptual Art,* New York, 1972, 138–
 39.
7. Roland Barthes, *Writing Degree Zero and Elements of Semiology,* Boston,
 1970, xxi–xxii.

INDEX

Locations of works of art are indicated by italics.